Atlas
of
Egyptian Art

E. PRISSE D'AVENNES

Originally published as: *Atlas de l'Histoire de l'Art Égyptien,*
d'après les monuments, depuis les temps les plus reculés jusqu'à la
domination romains, by E. Prisse d'Avennes. (Paris: A. Bertrand,
1868-78).

This edition reproduced from: *Atlas of Egyptian Art*, by E. Prisse
d'Avennes. (Cairo: Zeitouna, 1991).

This edition published in arrangement with The American
University in Cairo Press, 113 Kasr el Aini Street, Cairo, Egypt.

Plates are courtesy of the Institut Suisse de Recherches
Architecturales et Archéologiques de l"Ancienne Égypte, Cairo;
the Rijksmueum van Oudheden, Leiden; and The British
Library, London.

Atlas of Egyptian Art

E. PRISSE D'AVENNES

with an introduction by
Dr. Maarten J. Raven

and notes compiled by
Olaf E. Kaper

A Zeitouna Book

The American University in Cairo Press

PRISSE D'AVENNES:

BETWEEN FACTS & FICTION

Maarten J. Raven

The author of this beautiful album on Egyptian art, Emile Prisse d'Avennes, has rightly been dubbed "the most mysterious of all the great pioneer figures in Egyptology."[1] Undoubtedly, this aura of mystery is partly created by the inaccessibility of the documents left by Prisse. But it was his whimsical and uncompromising character that isolated Prisse from his contemporaries, leading them to form highly ambiguous and divergent judgements of his life and works. Until now, the two main sources of information on Prisse are a hagiography by Prisse's son Emile[2] and a devastating and most insinuative slander compiled by Maxime Du Camp in *Souvenirs Littéraires*.[3] Neither of these reports can be regarded as objective.

Of course, another major source is constituted by Prisse's own works, varying from the present *Atlas* and the equally wonderful plates of *L'Art arabe*, to the dozens of articles, notes, and learned reports published on a surprising variety of subjects. This collection of works demonstrates that Prisse was a remarkable scholar and an able draftsman. These are the admirable aspects of his character that should come first in any valuation of his life and work. Yet it cannot be denied that there was another side to his personality; an exactingness and imperiousness, an unremitting scrupulosity and a disdain for etiquette, that set him apart from his contemporaries.

None were in a better position to experience these less-magnified traits than Prisse's traveling companions during his two Egyptian expeditions: the Welsh historian and botanist George Lloyd of Brynestyn (1815-43) during the first journey, and the Dutch artist Willem de Famars Testas (1834-96) during the second. Both men remained relatively anonymous, until recently. The French scholar Michel Dewachter has published Prisse's moving account of his friend Lloyd's fatal accident at Thebes in 1843.[4] Dewachter has also searched the French archives—notably in the Bibliothèque Nationale, Paris, and in Avesnes-sur-Helpe[5]—for papers left by Prisse. And, in Leiden, the diaries and correspondence of Testas have turned up in the archives of the National Museum of Antiquities.[6] Testas' drawings and paintings have likewise been discovered in several Dutch collections.[7] Together, these dossiers shed much light on Prisse d'Avennes, on his previously ill-documented second stay in Egypt (1858-60), and on the genesis of the *Atlas*. The time has come to revise some opinions on Prisse and to correct a number of errors in earlier publications.

Achille Constant Théodose Emile Prisse was born at Avesnes-sur-Helpe in 1807. He was the son of a local inspector of the woods who died in 1814, leaving the young Emile to the care of a priest. From 1822-25, he received a thorough education as an architect and engineer at Châlons-sur-Marne, and the following year found him in Greece, where he joined the struggle for independence against the Turks. But soon he changed sides and followed the Egyptian commander Ibrahim Pasha to Alexandria, where he disembarked on April 28, 1827. Thanks to the enlightened government of Ibrahim's father, Turkish Viceroy Muhammad Ali, able young men like Prisse had a good chance to make a fortune in Egypt. The country was full of European—especially French—advisers, engineers, and administrators. Soon Prisse was one of them.

The following nine years were characterized by the two passions of his formative period: engineering and a noble concern for the future of the Orient. His association with Ibrahim led to his employment as tutor of the Pasha's children and as teacher of topography and fortification at various military institutions. He also had opportunity to study the problems connected with Egypt's poor infrastructure and to harass the viceroy with proposals for their improvement—all too grandiose for the contemporary Turkish administration. In the end, Prisse shared the fate of several other European courtiers and became unemployed due to a reorganization of the military schools in January 1836.

For a person with Prisse's disposition, such a blow was hardly decisive; it launched his career towards archaeology. Since his command of Arabic must have been perfect at the time, he simply dressed as a local sheikh, styled himself 'Idris Effendi,' and started traveling throughout Egypt and Nubia, and elsewhere in the Levant. At this time there was no protection for the ancient monuments. Whole temples were rapidly being demolished in order to serve as building material for the pasha's industrial projects; villagers lived in the pharaonic tombs and damaged the precious wall-paintings; and those intrepid travelers who visited Egypt as tourists never failed to cut out portions of sculptures or paintings and to leave their disgraceful graffiti all over the monuments. There were no scientific excavations and even major temples lay buried almost to the ceilings in the deposits of later habitation.

Between January 1836 and May 1844, Prisse devoted all his energy to improving the situation. Since he was well trained as an architectural draftsman and surveyor himself, he did not need the company of a whole range of specialists in order to accomplish his task. Mysteriously, he acquired a remarkable control of the hieroglyphic script, which had been deciphered only a few years earlier, in 1822. In addition to his interest in the monuments of

pharaonic Egypt, Prisse was captivated by the legacy of Egypt's Islamic past, and the manners and customs of the contemporary Orient.

The itinerary of Prisse's first travels through Egypt and Nubia is still largely unknown. From 1839-43, it seems he resided mainly in Luxor, with his friend George Lloyd, in some rooms at the rear of the vast temple at Karnak, and on the Theban west bank where the two companions lived in the tomb of Ahmose (tomb no. 83). They also enjoyed the hospitality of the Greek merchant and antiquities dealer Georgios Triantaphyllos, known as Wardi, who owned a house in the vicinity of the well-known tomb of Nakht. He also visited the oases, the Upper Egyptian and Nubian temples, the crocodile grottoes at Ma'abdah, and numerous other localities. His major exploits included the acquisition of a famous wisdom text on papyrus, believed at the time to be the oldest manuscript from Egypt. The text was donated to the Bibliothèque Nationale where it is still known as the "Papyrus Prisse." Another exploit was the dismantling of the Hall of the Ancestors from the temple of Tuthmosis III at Karnak; this, too, was donated to the Paris library and is now in the Louvre.

But Prisse did much more during his travels. In collaboration with the Englishman Henry Abbott, he founded the Association Litteraire in Cairo in 1842. He undertook several excavations and compiled quite a collection of antiquities. Foremost in his accomplishments are the vast number of drawings, water-colors, squeezes, and notes that he produced from sites all over Egypt and Nubia. Many concern monuments now lost or wall-paintings damaged beyond recognition, thereby constituting precious information for present-day Egyptology. Prisse's drawings, plans, and reconstructions of well-known monuments excel in their meticulous precision and daring originality and have lost nothing of their value.

Unfortunately, Prisse was unable to finish his work. His illegal dismantling of the Karnak king list in May 1843, followed by the tragic death of his companion George Lloyd, due to an accident with his rifle, on 10 October 1843, induced Prisse to return to France in 1844. There, he immediately took to editing at least part of his rich material for publications like *Les monuments égyptiens* (1847) and *Oriental Album: Characters, Costumes and Modes of Life in the Valley of the Nile* (1848-51). Throughout this period, he felt the urgent need to return to Egypt to compile additional material required for a proper publication of his numerous drawings.

Not only did the extensive documentation brought from Egypt prove to be lacunary, but Egyptology itself was rapidly changing. The days of the great expeditions were over, and Egypt had no place anymore for adventurers and collectors like Belzoni or Drovetti. After the death

of Muhammad Ali in 1849 and the anti-European interlude under his grandson Abbas, Egypt passed into the hands of Muhammad Ali's youngest son, Muhammad Sa'id (1854-63). This viceroy immediately resumed the policy of his father, aiming at the industrialization and modernization of the country. Europeans were welcome once again, tourism revived, and in turn stimulated interest in the ancient monuments. The pasha soon understood that something had to be done for the preservation of Egypt's heritage, or there would be no more wealthy visitors in the future.

At first sight, all this constituted a splendid opportunity for Prisse to resume his work in Egypt, but the situation was rather more complicated. First, his departure from Alexandria in 1844 had not been exactly honorable, and he was still living under the doom of his indiscretion connected with the smuggling of the king list. Second, his merciless comments on the work of his fellow Egyptologists had not procured him many friends or supporters for his cause. Third, the attention of the French government was concentrated on the quick rise of two other stars on the Egyptian firmament: Ferdinand de Lesseps, whose project for the Suez Canal was finally approved in 1855; and Auguste Mariette, whose successful excavations (from 1850 onwards) eventually made him founder of the Egyptian Antiquities Service and of the Egyptian Museum of Antiquities.

In spite of all these difficulties, Prisse finally managed to obtain the renewal of his official mission to Egypt, which he had lost as a result of the political vicissitudes of contemporary France. This official status included financial support by the Ministry of Education, a most essential condition for Prisse, who was never a wealthy man. With the happy days of free excavations and the easy formation of collections over, Prisse planned to concentrate instead on surveying and drawing anew, and correcting and collating the documentation of his first journey. On this occasion time was limited, so he decided to bring two assistants: a draftsman and a photographer.

Photography was new at the time: its invention by Niépce and Daguerre had been proclaimed in 1839. It is remarkable that the propagators of the new medium especially recommended its application for Egyptian archaeology: "In order to copy those millions of hieroglyphs that may be found on the inner and outer walls of the great monuments—Thebes, Memphis, and Karnak—very many years and innumerable draughtsmen are required. Yet one single person can accomplish this task by means of daguerrotype!"[8] Since the early photographic techniques were only successful in very strong light, Egypt, with its eternal sun, was an ideal test ground for new procedures and materials, requiring shorter exposures and ensuring better results than under European

skies. This had been clearly demonstrated by Vernet in 1839, Du Camp in 1849-51, and Teynard in 1851-52, and Prisse now revealed his revolutionary spirit by enlisting the young photographer A. Jarrot to accompany him during his Egyptian campaign.

Unfortunately, little is known about Jarrot. Much more is known about Prisse's other companion, Dutch artist Willem de Famars Testas. Some months prior to his departure, Prisse had been contacted by the Testas family, distant relatives of his from Holland, with the request to take young Willem with him to Egypt. Testas had been trained as a painter and draftsman at the Academy of Fine Arts in the Hague from 1851 to 1856 and was now looking for an opportunity to complete his studies abroad. Prisse's expedition was ideal since the Orient was becoming most popular in contemporary art. Prisse consented to take the young artist as a traveling-companion, provided he would pay for his own expenses and would not meddle with the expedition's work, but would pursue his own artistic objects; an agreement that suited both men perfectly.

Due to the unforeseen eclipse of Prisse's own artist, a French draftsman who did not appear at the expedition's departure from Marseilles on May 30, 1858, Testas unwillingly found himself obligated to assist Prisse and Jarrot. This led to much mutual distress, since Testas was not well versed in architectural or ornamental drawing, and Prisse's reactions were consequently very critical. Yet they gradually got used to each other, and thus Prisse contributed to Testas' training as Holland's only orientalist painter, a specialism that Testas would practice for almost forty years until his death in 1896. The diary of his travels with Prisse, and the letters he wrote from Egypt to his parents in Utrecht, offer a particularly vivid insight into the genesis of his fruitful career. These writings are the only consistent record on the itinerary of the expedition.

On June 6, 1858, Prisse arrived once again in Alexandria, the scene of his shameful escape fourteen years earlier. His indiscretion had since been forgiven, if not forgotten, and thanks to old friends and relations he managed to obtain a firman (concession) to travel and record, but not to excavate or collect antiquities. But, Prisse had the additional bad luck that just five days before, on June 1, his countryman, Auguste Mariette, had been appointed to the new post of Director of the Egyptian Antiquities. This meant that archeological work was now possible only with the explicit permission of the newly-founded Antiquities Service. Mariette immediately started an ambitious plan to excavate Egypt's major monuments and to enrich the national collection of antiquities.

On June 23, the expedition traveled to Cairo by means of the English railway inaugurated the year before. Prisse had planned a brief stay there, followed by a boat trip to Upper Egypt as soon as the Nile inundation ensured sufficient water for easy access to the various monuments; the total duration of the journey had been estimated at five months, and so he had told his two companions. Great was their dismay when the indefatigable Prisse kept them in Cairo for a full year. The delay was caused in part by the loss of precious work time due to the prolonged disease of his young companions and by their inexperience with the required techniques. But mainly, their long stay was due to Prisse himself, as he was irresolute and kept discovering new subjects to be drawn and recorded. Work concentrated mainly on Islamic architecture, and Testas complained that he was made to work very long days despite his illness, sketching ornaments in the semi-darkness of mosques only to be scolded by the critical Prisse upon his return in the evening. However, Prisse realized that many treasures of Islamic architecture were quickly disintegrating due to neglect (several monuments he knew from his first stay had completely vanished as a result of the earthquake of 1856), and this might be the last chance to record other items of Egypt's cultural heritage.

After living in Cairo a full year under rather primitive circumstances–in a rooftop lodging where the expedition was housed *à l'orientale*–the company finally embarked on a dahabiyeh on June 6, 1859. Joining them was the American adventurer Edwin Smith (1822-1906), an old acquaintance of Prisse's. The expedition sailed to Dendera, via Kom el-Ahmar, Beni Hassan, el-Bersheh, Amarna, and Akhmim, where Prisse and Jarrot recorded scenes in the rock-tombs while Testas remained aboard due to utter exhaustion. They spent a week working in the Temple of Dendera which Marriette had recently cleared. On August 8, the boat arrived at Luxor; Smith left the company, and the others pursued their journey southward. Prisse pressed on through Upper Egypt and Nubia, checking the state of the various monuments in order to plan the work needed during the return journey northward. He almost decided to leave Testas behind in Aswan, but since the Dutchman's health began to improve, Prisse changed his mind and brought him along to Abu Simbel, where the dahabiyeh arrived on September 6.

There the three men resumed their painstaking recording of reliefs and inscriptions, working in the extreme heat of the Nubian summer and the darkness of the temples. Testas once again proved to be a valuable assistant, as is revealed by his "List of works done for Mr. Prisse"[9] (now in Leiden). In one month, they visited all the major Nubian temples, checking them against Prisse's records and adding new details. On October 6, the dahabiyeh returned through the cataract of Aswan. From there, the company floated down the Nile, halting at Kom Ombo,

Silsileh, Edfu (which had since changed considerably as a result of Mariette's excavations), el-Kab, and Esna.

Upon arrival at Luxor, Prisse moved into his ancient quarters at the rear of the Karnak temple, where he found one of Mariette's numerous excavation parties active in and around the hypostyle hall. On November 25, the expedition moved to Wardi's house—now deserted—on the west bank, for work in the private and royal tombs and in the funerary temples. Again, Prisse noted that much of the work done in the 1840s could not be collated because the originals had vanished. On the other hand, there was so much new material available in Deir el-Bahri, where excavations had recently been started by Maunier, the local consul of France, and in Medinet Habu, where Prisse was allowed to direct the excavations for Mariette. He also undertook some small-scale digging for the exiled Prince of Orleans.

All this took the entire winter, and it was not until April 14 that the expedition finally set sail for Cairo. There, Prisse accepted the hospitality offered by Mariette in his house at Saqqara, and moved from there to the Giza pyramids, and finally finished by sketching some of the recent finds pouring into the Bulaq museum from Mariette's excavations. It is not surprising that Jarrot had a mental breakdown and had to be sent to France. Prisse and Testas followed, leaving Alexandria on June 12, 1860.

The result was that Jarrot immediately stopped his career as a photographer, Testas launched a career as a successful painter of oriental scenery, and Prisse would finally finish the publication project started 15 years earlier. He returned to Paris with a rich harvest of 300 drawings, 400 meters of squeezes, and 150 photographs. Before long, the first plates appeared of his monumental *Atlas de l'histoire de l'art égyptien, d'après les monuments, depuis les temps les plus reculés jusqu'à la domination romaine* and its complement *L'Art Arabe, d'après les monuments du Caire, depuis le VII^e siécle jusqu'à la fin du XVIII^e siécle*. The former project lasted until 1877, apparently having started with a few plates in 1858, nearly twenty years earlier. The latter took from 1867 to 1879. These 359 plates did not even represent the full amount of Prisse's records, and it was the death of their author in 1879 which robbed us of the rest (though the original drawings have been preserved, mainly in the Bibliothèque Nationale).

None of Prisse's contemporaries had the skill or endurance to bring such an endeavor to such a brilliant end. His combination of interests, with equal zeal for the Pharaonic and the Islamic periods, was quite unique. He was far ahead of his time in his awareness of the vulnerability of the monuments and the need to protect and record them. His were the first reliable drawings of Egyptian architecture and ornaments and the first plans and sections of constructions newly excavated. The present reprint of Prisse's *Atlas*, the plates of which have lost nothing of their value for modern Egyptology, is a fitting tribute to the memory of the great orientalist.

NOTES

1. W.R. Dawson and Uphill, E.P. *Who was who in Egyptology*, (London, 1972), 238.

2. E. Prisse d'Avennes fils, *Le papyrus à l'epoque pharaonique*, (Avesnes, 1926).

3. M. Du Camp, *Souvenirs littéraires*, (Paris, 1984), 110 ff.

4. M. Dewachter, *Un Avesnois: l'égyptologue Prisse d'Avennes (1807-1879)*, (Avesnes, 1988), 143 167.

5. M. Dewachter, "Exploitation des manuscrits d'un égyptologue du XIX^e siecle: Prisse d'Avennes," *Bulletin de la Société Française d'Égyptologie* n° 101, (1984), 49-71; on Avesnes-sur-Helpe, see the publication mentioned in note 4 above.

6. The first diary covering the travel with Prisse has now been published as M. J. Raven (ed.), *Willem de Famars Testas, Reisschetsen uit Egypte 1858-1860*, (Maarssen/The Hague, 1988). A publication of the second diary, concerning a travel through Egypt and the Near East in 1868, is in preparation.

7. A selection of these was shown at an exhibition in the Leiden Museum of Antiquities from December 12,1988 to March 12,1989.

8. Quoted from E. Eggebrecht, *Ägypten, Faszination und Abenteuer*, (Mainz, 1982), 11.

9. Published in Raven, *op. cit.*, 194-200.

Notes to the Plates

Compiled by Olaf E. Kaper

The following notes have been compiled especially for this edition. The original explanatory text was edited by P. Marchandon de la Faye from the notes of the author, and published as a companion to the Atlas under the title *Histoire de l'Art Égyptien, d'après les monuments, depuis les temps les plus reculés jusqu'a la domination romaine*, (Paris: A. Bertrand, 1879). As Egyptology has progressed, the views expressed in that volume have become outdated, and new historical information about the sites where Prisse visited has become available.

Due to the diverse nature of this work, a vast number of sources were consulted. Some of the factual material is drawn from Prisse's own notes, as presented in Marchandon's text. It would, however, be impractical to list all sources consulted as this edition is intended for a broad audience. For the specialist, a table of cross-reference with Porter & Moss is supplied in the Appendix.

ARCHITECTURE

PL. I.1 TOPOGRAPHICAL MAP OF THE RUINS OF THEBES

The ancient capital Thebes, present-day Luxor, lay on the east bank of the Nile facing the necropolis on the west. This map of one of Egypt's most extensive archeological sites marks the capital and its necropolis with their Greek names: *Diospolis* and *Memnonia*, respectively. All the monuments that were known in Prisse's day are on the map, often with the name of the pharaoh who had commissioned their construction. The map is from the original published by Sir J.G. Wilkinson in 1835.

PL. I.2 ISLAND OF PHILAE (General map of the ruins)

The cult of the goddess Isis outlived the cults of all other temples. At her temple, built in the Ptolemaic and Roman periods on the Island of Philae south of Aswan, services were held until the first half of the sixth century A.D.

The island was submerged following the building of the two dams at Aswan. The temples, however, were saved by the international campaign launched by UNESCO to preserve the endangered monuments.

PL. I.3 SECTION & DETAILS OF THE GREAT PYRAMID OF GIZA (Cheops or Khufu–4th Dynasty)

The Great Pyramid, the largest pyramid erected at Giza, was constructed for King Cheops around 2400 B.C. The King's Chamber, where the sarcophagus stands, is a darker shade in five of the sections. Two sections, *second from top and bottom right*, show a view of the chamber from *above*. On either side of the hieroglyphs, the King's Chamber is shown again, but with the series of compartments in which the inscriptions were found. These hieroglyphs, discovered in 1837, represent quarry marks left by the ancient builders of the pyramid, and contain the king's name in a cartouche.

PL. I.4 PLANS, SECTIONS & ELEVATIONS OF THE PYRAMIDS OF MEROE (Ptolemaic period)

Nearly fifty pyramids were erected near the city of Meroe, capital of the Meroite Kingdom, between 300 B.C. and A.D. 350. The idea of building a pyramid over a tomb was borrowed from Egypt, where the practice had long since been abandoned. These drawings, showing the superstructure of some royal tombs, are based on the work of French traveler F. Cailliaud, who visited Meroe in 1821, and K.R. Lepsius, whose expedition recorded Meroe in the 1840s. Prisse d'Avennes never visited the site himself.

PL. I.5 NECROPOLIS OF MEMPHIS (Tombs east of the Great Pyramid–4th Dynasty)

Snefrukha'ef—who lived around 2500 B.C.—was treasurer to the king of Lower Egypt and herdsman of the sacred Apis bull. *Above* the line are the plan, sections, and stela of the offering chapel of his tomb.
Below, also from the Old Kingdom, is the mastaba of Minzedef, an earlier treasurer to the king of Lower Egypt. The original decoration on the walls of the offering chapels was not rendered by the artist.

PL. I.6 SARCOPHAGI OF MENKAURE & AY (4th & 18th Dynasties)

The sarcophagus of King Menkaure' (or *Mycerinos*), was discovered in 1837 in the burial chamber of the third pyramid of Giza. The basalt chest *above* is decorated with a likeness of the walls of his palace. Notice that the cornice is part of the lid of the sarcophagus, unlike the sarcophagus *below* where the lid lies on top of the cornice. The basalt chest of Menkaure' was lost at sea during an attempt to ship the monument to Britain.

The lid of the second chest, that of King Ay from the New Kingdom, is drawn as a row of cobras. However, surviving fragments have been reconstructed and reveal no cobras. Ay's sarcophagus shows a protective goddess in each corner, as was customary of royal sarcophagi of the time. After this drawing was made, the red granite chest of Ay suffered damage from local antique dealers, and fragments were sold to European collectors. The sarcophagus now stands partly restored in the Cairo Museum.

PL. I.7 TOMBS OF THE NECROPOLIS OF MEMPHIS (Saqqara cemetery–5th Dynasty) [sic]

Architectural reconstructions of offering chapels from three tombs in Saqqara are presented here; the extensive wall decorations have been left out. From *left* the first and

third are Old Kingdom chapels, and are, respectively, the chapel of Sabu and the large chapel of Ra'shepses, chief justice and vizier during the reign of Isesi. Both monuments are located just north of the Step Pyramid at Saqqara. The second probably represents a chapel from the Middle Kingdom, one which lies next to the pyramid of King Teti. It belonged to Ihy, overseer of the royal stalls, who lived around 1900 B.C. The reconstructions are based on the work of Lepsius.

PL. I.8 NECROPOLIS OF THEBES; BIBAN EL-MOLOUK (Royal tombs—18th [sic] & 19th Dynasties)
In the mountainous necropolis of western Thebes, two places were reserved for royalty: the Valley of the Kings—Biban el-Molouk—for the pharaohs, and the Valley of the Queens for other members of the royal family. The two large tombs shown in plan and section were both carved in the rock at the Valley of the Kings: *above* that of Ramesses II and *below* that of Seti I. The third and smallest tomb *upper left*, carved in the rock in the Valley of the Queens, belonged to Queen Tyti, probably the daughter of Ramesses III. These tombs are from the 19th and 20th Dynasties.

PL. I.9 NECROPOLIS OF THEBES (Plan & section of the tomb of Grand Priest Petamounoph—18th Dynasty) [sic]
In the 26th Dynasty around 600 B.C., the size of the tombs of the nobles at Thebes grew to royal proportions. The expansive tomb of the prophet and grand priest Pedamenopet is exemplary of this evolution. The tomb, in the area now called el-Asasif, was largely carved in the rock, but its monumental entrance facing east, was built of mud-brick.

PL. I.10 TEMPLE OF DENDUR (Plan, longitudinal section & side door—reign of Augustus)
The Temple of Dendur was erected 80 kilometers south of Aswan during the reign of Emperor Augustus. *Below* a frontal view of part of the south face of the temple is shown with the omission of hieroglyphic inscriptions. *Below left and right respectively*, is a section and view of a wall surrounding a terrace in front if the temple.

The site of Dendur was lost after the building of the High Dam at Aswan; the temple now stands in the New York Metropolitan Museum as a donation of the Egyptian Government.

PL. I.11 PERIPTERAL TEMPLE OF AMENOPHIS III AT ELEPHANTINE (18th Dynasty)
King Amenophis III erected this small chapel on the Island of Elephantine around 1400 B.C. It was destroyed in A.D. 1822, before Prisse had a chance to record it. This drawing is based on the work of Napoleon's artists who recorded the chapel around 1800.

PL. I.12 ENTABLATURES OF INTERIOR DOORS (Thebes & Sedeinga—18th Dynasty)

It became popular during the New Kingdom to place this type of decoration *above* doorways. It occurs in two types of structures: tombs and temples, both represented here. The decoration *above* is from the Theban tomb of Kenamun, chief steward of Amenophis II. Its symmetrical design uses cats, papyrus umbels, and falcon heads.

The example *below* is from a temple built to honor Queen Teye, wife of Amenophis III, at Sedeinga. This entablature shows the queen as a lion, as well as four heads of the goddess Hathor, and the names of the king and queen, flanked by two cobras.

PL. I.13 ENTABLATURES & FLORAL FRIEZES (Necropolis of Thebes—18th & 20th Dynasties)
Flowers, like the blue lotus or the papyrus, are the main motif in these patterns. These flowers imitate actual wreaths used as decoration on the walls of houses of the period. The friezes shown in the corners *above* use the Khekeru pattern, a traditional decorative motif used along the top of walls throughout Egyptian history. These New Kingdom patterns are from private Theban tombs, and often formed the upper border of scenes painted in the first chamber.

PL. I.14 PILLARS OF TUTHMOSIS III AT KARNAK (18th Dynasty)
King Tuthmosis III commissioned extensive building projects at the temple of Amun in Thebes. One project was a vestibule preceding the sanctuary of the Temple at Karnak. The roof of this vestibule was supported by two monolith pillars, carved in red granite from Aswan. The pillar to the north had, on either side, a papyrus plant—symbol of Lower Egypt; the southern pillar a lily—symbol of Upper Egypt. The coloring is reconstructed in this plate.

PL. I.15 PILLARS FROM TOMBS OF ZAWYET EL-MAYITIN (18th Dynasty)-[sic]
Zawyet el-Mayitin, opposite Minya in Middle Egypt, is the site of the necropolis of Hebenu, an ancient provincial capital. The plate shows two of the nineteen tombs remaining at the ancient site. A pillar from each of the tombs, dating to the Old Kingdom, is shown directly *above* its plan. This plate, intended as a sequel to the previous one, demonstrates again the use of a floral decoration on either side of a pillar. The seated figure represents Khunes, the owner of the second tomb. (For another scene from his tomb, see Pl. II.12.)

PL. I.16 PILLARS OR SQUARE COLUMNS (Thebes—18th Dynasty)
Two pillars from Karnak represent a specific type of square column with a cornice at the top as if it were a capital. The two columns shown here are adorned with reliefs on all four sides. The column left, 5.33 meters in height, is from the interior of a small chapel built by Amenophis II. The second column, inscribed with the names of Amenophis III and Hathor, was 4 meters tall.

This plate is the only record of the column; according to Prisse, the chapel where it stood was lost in the industrial construction work of the pasha.

PL. I.17 CONSTRUCTION IN WOOD, SMALL COLUMNS FROM KIOSKS (4th [sic] & 18th Dynasties)
The following three plates constitute a collection of light wooden columns, recorded mostly from private tombs of the New Kingdom. The first column, *left to right*, was from a private Theban tomb; the second, an Old Kingdom example from the 5th Dynasty, comes from the famous mastaba of Ti in Saqqara. The third and fifth originate from tombs in Zawyet el-Mayitin; the latter is from the New Kingdom tomb of Nefersekheru. The fourth is from a wall relief in Semna West, the Nubian temple built by Tuthmosis III. (In the original scene, the column is part of a shrine housing a divinity.)

PL. I.18 CONSTRUCTION IN WOOD, SMALL COLUMNS FROM KIOSKS (18th & 19th Dynasties)
The first column *left* is from the tomb of Meryre II in Akhenaten's capital city, Tell el-Amarna. The second column dates from the reign of Amenophis III and was copied from a private tomb in Thebes. The third is inscribed with the royal name of Seti I, and supports a small kiosk used by the king; it was copied from the tomb of the vizier Paser. The fourth column is from the kiosk of Hathor whose head constitutes the capital. The fifth is supporting another kiosk carved in relief in the tomb of Kha'emhet during the reign of Amenophis III.

PL. I.19 SMALL WOODEN COLUMNS (Thebes—18th & 20th Dynasties)
The 18th Dynasty tomb of Nebamun, redecorated and used by Imiseba during the reign of Ramesses IX, constituted a rich source for Prisse. The coloring of the column *center* was added by the tomb's second owner. The column *right* is a painting from the tomb of Haremhab, scribe of the recruits from Tuthmosis III to Amenophis III.

PL. I.20 DETAILS OF SMALL WOODEN COLUMNS (From various tombs)
The column *above center* shows an Old Kingdom example from Zawyet el-Mayitin (see Pl. I.15). The capital in the upper *left* corner is from the Middle Kingdom tomb of Dhutihotep II in Deir el-Bersha, Middle Egypt. The hieroglyphs are added from another part of the same tomb. The capital in the *upper right corner* is from Beni Hasan, also from the Middle Kingdom. The two columns *below* are from the New Kingdom tomb of Kenamun, chief steward of Amenophis II. Both are supports for a kiosk; one for the god Osiris, the other for the king. The segment shown *center* represents the lower part of the column *left*.

PL. I.21 PAPYRIFORM COLUMNS OF TUTHMOSIS III, IN KARNAK (18th Dynasty)
During the New Kingdom, the column representing a bundle of papyrus stalks with closed umbels was popularly used in temple architecture. Prisse copied this column from the botanical garden, a room in the Great Temple of Amun in Karnak known for its wall reliefs representing exotic plants, birds, and animals. The column is drawn twice to demonstrate two layers of color; the coloring on the column *left* is the older of the two.

PL. I.22 PAPYRIFORM COLUMNS OF AMENOPHIS III, IN THEBES (18th Dynasty)
The columns here are similar to those of the previous plate, only slightly later in date. The column *left*, which Prisse claims came from Memphis, is carved from a single piece of red granite. *Right*, the example in limestone stands in the temple of Luxor, in the large traverse hall behind the sanctuary.

PL. I.23 COLUMN OF THE RAMESSEUM (Thebes)
Each New Kingdom pharaoh built a mortuary temple in western Thebes. There, Ramesses II erected the Ramesseum, where columns still retain some of the colors that Prisse recorded in this plate. This type of column represents a bundle of papyrus stalks, as did the columns of the previous plates, but with an opened umbel as its capital.

PL. I.24 CAPITALS FROM THE TEMPLES OF EDFU AND PHILAE (18th Dynasty) [sic]
The composite capital became popular during the Ptolemaic and Roman periods. It combines a wide range of different flowers and other plant forms in its design. The four examples in this plate show some of the many variations.

PL. I.25 COMPOSITE CAPITALS (Temple of Philae—18th Dynasty) [sic]
The plate shows a capital from the composite columns surrounding the birth house on the Island of Philae. It does not, however, show that the column is crowned by a second capital—the head of the goddess Hathor. The coloring presented here is a second layer; according to Prisse, the first layer showed blue leaves with green panicles.

PL. I.26 BOWL-SHAPED CAPITAL (18th Dynasty) [sic]
The peculiar bowl-shaped capital, composed of different leaf forms, was designed and occasionally used in the Ptolemaic and Roman periods.

PL. I.27 DACTYLIFORM CAPITALS (Philae—18th Dynasty) [sic]
Clustered palm branches inspired the shape of this capital; its look changed little from its first appearance in the Old Kingdom until the the end of its popularity in the Roman period. The two renditions here, both from the Temple of Philae, belong to the latter period. The capital *left*, from the colonnade in front of the temple, shows bunches of dates hanging from the tree.

PL. I.28 CEILING PATTERNS; SIMPLE DESIGNS (12th to 22nd Dynasties)

In the homes of ancient Egyptians, it was customary to cover the wooden ceilings with colored fabric; actual examples of these textiles have been found. These patterns were imitated in the painted ceilings of tombs. Prisse d'Avennes was the first to undertake a large-scale copying of decorated ceilings of private tombs in Thebes. He classified his collection according to the nature of the pattern. These are characteristic zigzag and chess patterns found from the Middle Kingdom onwards.

PL. I.29 CEILING PATTERNS; SPIRALS AND MEANDERS (Necropolis of Thebes—17th [sic] to 20th Dynasties)
The meander, commonly considered Greek in origin, was employed in Egypt long before, though it seems the design was developed independently in each country. These patterns, somewhat more complex than those of the previous plate, were all copied from Theban tombs.

PL. I.30 CEILING PATTERNS; LEGENDS & SYMBOLS (Necropolis of Thebes—18th Dynasty)
Neferhotep, who lived during the reign of Haremhab, had the pattern *above* in his tomb chapel. The pattern incorporates his name and title with geometric and vegetal forms, like the spiral and blue lotus. *Below*, this pattern, which no longer exists, was copied from a neighboring tomb in Thebes. The pattern uses the winged scarab with a sun disc, symbolizing rebirth after death.

PL. I.31 CEILING PATTERNS; FLORAL DESIGNS (Necropolis of Thebes—18th & 19th Dynasties)
The interlocking spirals of these patterns connect in various ways, forming spaces filled with colors and motifs such as the lotus flower. *Left to right from top*, four of the patterns—1, 2, 7, and 9—probably originate from the tomb of Pedamenopet of the 26th Dynasty; they no longer exist. The third and fifth were found in the tomb of Nebamun and Imiseba. The fourth is from the tomb of Neferhotep (see also Pl. I.30). The sixth pattern copies a ceiling from the New Kingdom tomb of Neferronpet, also named Kenro, and the eighth pattern is now lost.

PL. 1.32 CEILING PATTERNS; FLOWERS (Necropolis of Thebes—18th to 20th Dynasties)
Most of these ceiling patterns incorporate a floral motif as the main element. *Left to right from top*, patterns 1, 2, 4, and 5 are copied from the tomb of Nebamun and Imiseba; 2 and 5 decorate an architrave in this tomb. The third is from the tomb of Neferhotep (see Pl. 1.31). Patterns 6 and 8 are from the same unknown tomb.

The three examples *below* all date from the reign of Ramesses III. The patterns in the corners *below* are copied from the king's private chambers in the High Gate, (the entrance to the temple of Medinet Habu), where they were painted on the ceiling of window alcoves. The pattern *below center* is taken from the tomb of Ramesses III in the Valley of the Kings.

PL. I.33 CEILING PATTERNS; BOUKRANIA (Necropolis of Thebes—18th & 20th Dynasties)
A bull's head, surmounted by a sun disc or a flower captured in a frame of spirals, is the common element of these two patterns. The boukrania, as they are called, were also used to decorate vases (see Pl. II.76). *Above*, the pattern was found in the tomb of Nebamun. It incorporates the blue-lotus flower with buds in the design. *Below*, the pattern from the tomb of the priest Neferhotep uses the grasshopper as another decorative element.

PL. I.34 CEILING PATTERNS (Memphis & Thebes—26th Dynasty)
Left to right from top, the first and third patterns come from the tomb of the prophet Pedamenopet in Thebes. The second, from another Theban tomb, is now lost. *Below*, the vizier Bekenrenef had these three patterns painted on the ceiling of his tomb in Saqqara. All are from the 26th Dynasty.

This plate is signed by Willem de Famars Testas, the Dutch artist who traveled with Prisse on his 1858-60 expedition. Six plates appear herein with his name (see also "Between Facts and Fiction," pp. 4-6).

PL. I.35 CEILING PATTERNS (Memphis & Thebes— 18th to 30th Dynasties)
The vulture, often painted on ceilings of temple gateways, may also appear in a tomb as did the vultures in the pattern *above* from the tomb of Bekenrenef (see also Pl. I.34). *Below*, the pattern is a combination of vultures from two gateways in Philae: from the reigns of Ptolemy VIII Euergetes II *above*, and Nectanebo X *below*. The geese *center* are from the New Kingdom tomb of Nebamun and Imiseba.

PL. I.36 THE TEMPLE OF DEIR EL-MEDINA (Plans, sections & details—18th Dynasty) [sic]
The small temple of Deir el-Medina was built in western Thebes under the Ptolemies in honor of the goddess Hathor-Maat. Well preserved until today, Prisse did not need to ameliorate in this reconstruction of the monument. Details on the columns and windows are rendered in this otherwise architectural study. The Hathor column *lower right* is rendered in color in Plate I.37.

PL. I.37 HATHOR COLUMNS (18th Dynasty) [sic]
In temples and chapels dedicated to Hathor, columns were often crowned with a likeness of the goddess. The columns, used from the New Kingdom to the Roman period, evolved in style during the centuries.

Left, the column bears the names of Amenophis III and Hathor, and possibly originates from the same chapel as the lost column in Plate I.16. The crack in the stone indicates that it was found broken in two. The column *center* is from a painting in a Theban tomb, and the Hathor column *right* is from the Ptolemaic temple of Deir el-Medina (see Pl. I.36).

PL. I.38 MAP OF THE RUINS OF TELL EL-AMARNA (18th Dynasty)
Akhenaten moved his capital to the barren site of Tell el-Amarna, where a city was designed and built. Soon after his death, the town was abandoned and its stones were used elsewhere in building projects. This map, by G. Erbkam, an architect with the Lepsius expedition in the 1840s, was part of an extensive plan of the visible ruins of Tell el-Amarna. The reliefs in Plates I.39-41 are from tombs situated to the east of the area shown in this map.

PL. I.39 PLANS OF BUILDINGS IN TELL EL-AMARNA (Bas-reliefs from tombs—18th Dynasty)
The reliefs in this plate show depictions of temples from the tomb of Meryre I, high priest of the god Aten. The renditions, in accordance with ancient Egyptian conventions, emphasize parts of the building considered important, resulting in a distorted representation of the structure. The plate shows two different temples of the god Aten; both are entered from the *right*.

PL. I.40 PLAN OF A ROYAL VILLA (Bas-reliefs from a tomb in Tell el-Amarna—18th Dynasty)
A bird's-eye view of a royal residence shows a separate garden with a central pond. This relief is from the tomb of Meryre I.

PL. I.41 PLANS OF BUILDINGS IN TELL EL-AMARNA (Sculpted in the tombs—18th Dynasty)
Ay, a courtier of Akhenaten, later to become king (his royal sarcophagus is shown in Pl. I.6), had the scene *above* of a house or a palace carved on the wall of his tomb. The palace is lively with servants occupied in various tasks. The *left* part of the scene, separated by a dotted line, belongs to another relief within the same tomb, representing the same building. *Below*, a storehouse brimming with commodities is depicted in the tomb of Meryre' I.

PL. I.42 THE ROCK-CUT TEMPLE OF KALABSHA [sic] (Plan, section & details; Ramesses II—19th Dynasty)
The temple of Beit el-Wali, formerly known as the Rock-cut Temple of Kalabsha, is one of the many temples Ramesses II had built in Nubia. Prisse's reconstruction shows the relief decoration on the walls. In the open forecourt, the reliefs depict battle scenes of Ramesses fighting Syrians, Libyans and Bedouins. The statues inside the temple are also carved from the rock. Each statue shows the pharaoh between two gods; *above* between Horus and Isis, *below* between Khnum and Anukis. A third group in the sanctuary has not survived. The temple has been removed to an area south of the High Dam.

PL. I.43 COLUMN OF THE HYPOSTYLE HALL OF KARNAK (Thebes—19th Dynasty)
The hypostyle hall in the Temple of Karnak was supported by 134 columns. It was constructed by the first three pharaohs of the 19th Dynasty, to occupy the space of an open courtyard in front of the Temple of Amun built by King Haremhab. The two rows of columns along the axis of the hall rise to a height of more than 19 meters. The capital, shown here, has a diameter of almost 7 meters, and represents an open papyrus umbel.

PL. I.44 CARYATID PILLARS [SIC] OF THE TEMPLE OF RAMESSES III (Medinet Habu—20th Dynasty)
The temple of Medinet Habu in western Thebes was the mortuary temple for Ramesses III. In the first court of the building, seven pillars—the Osirid Pillars—stand in a row, with a statue of the king attached to each. (Strictly speaking, this is not a caryatid pillar—a supporting pillar carved in the shape of a human figure. These figures are attached to a square pillar which supports the roof.) The statues were badly damaged when the temple was converted into a church. To execute this study, Prisse collected various surviving parts from the seven statues and reconstructed one in its entirety. It shows the king with all the emblems of royal power. The god Amun, sitting on his shoulders, symbolizes "beloved of Amun."

PL. I.45 INTERIOR DECORATION OF RAMESSES III's HAREM [SIC] (Medinet Habu—20th Dynasty)
An impressive gateway, several stories high, marks the entrance to the Temple of Medinet Habu in western Thebes. In the upper stories, Ramesses III had personal rooms (not necessarily exclusively for women), decorated with wall reliefs. The floral friezes and relaxed poses of the king reveal the informal mood of the room. Ramesses is accompanied by his daughters and, possibly, ladies of his harem.

PL. I.46 NECROPOLIS OF THEBES (Tombs from the valley of el-Asasif—26th Dynasty)
Above, the small pyramid belonged to Pedeneith, chief steward of the divine adoratress Ankhnesneferebre. His son and successor, Sheshonk, lived during the reigns of Apries and Amasis. Sheshonk's tomb of mud-brick is shown *below*.

PL. I.47 COLUMNS OF THE TEMPLE OF NECTANEBO (Philae—30th Dynasty)
The porch of Nectanebo I in Philae was surrounded by Hathor columns representing the latest phase of their development (see Pl. I.37 for other examples). The head, shown on all four sides, surmounts a composite capital. Prisse did not copy all the scenes on the intercolumnar walls, he simply repeated one scene on each wall.

PL. I.48 THE TEMPLE OF EL-SEBUA' (Plan & section—Nubia)
The temple of el-Sebua', half carved in the existing rock and half built of stone, was part of Ramesses III's building program in Nubia, which included, among others, the temple of Beit el-Wali (see Pl. I.42). As the temple was still half-covered with sand, Prisse made this reconstruc-

tion from what could be seen on the surface.

PL. I.49 THE TEMPLE OF SETI I (Plan, section & elevation)
This funerary temple of Seti I, also known as the temple of Gurna, is the northern most in a series of mortuary temples built for the cult of the kings in western Thebes. The plan is flanked by two capitals: from the hypostyle hall *left*, and from the forecourt, *right*. The section is Prisse's reconstruction.

PL. I.50 TOPOGRAPHICAL MAP OF PART OF THE NECROPOLIS OF MEMPHIS (Pyramids of Giza)
The temple lying next to the Sphinx had recently been cleared by Mariette, and Prisse had assumed it was a tomb. Actually, it was the valley temple of the pyramid of Khephren, linked to it by a causeway. In drawing this detailed map of the site of the Giza pyramids, Prisse seems to have been more interested in the temples at the foot of the pyramids, drawn as architectural ground plans, than the rest, drawn as an aerial view.

PL. I.51 THE TEMPLE OF DAKKA, "PSELCIS" (Plan, section & perspective—Ptolemaic & Roman periods)
The Ptolemaic and Roman rulers of Egypt, and rulers of Meroe in the south, built this sanctuary at Dakka in Nubia, to honor a local form of the god Thoth. When the waters of Lake Nasser flooded the site, the temple was rebuilt at New el-Sebua', about 40 kilometers away. The building's entrance faces north.

PL. I.52 ELEVATION OF A PYLON & PLAN OF A HOUSE (From bas-reliefs)
The drawing *above*, of a relief made around 1000 B.C. in the Temple of Chonsu in Karnak, shows the facade of the Temple of Amun, as it must have looked at the time. Eight enormous flagpoles are clamped onto the face of what is now called the second pylon.

The scene *below* is from the rock-cut tomb of Mayor Renni at el-Kab, who lived during the reign of Amenophis I. It shows a house-like structure used during funeral ceremonies.

PL. I.53 DECORATION OF THE NICHE OF MAMMISI, IN DENDERA (Reign of Trajan)
Near the entrance to the temple complex at Dendera stands a small temple called the mammisi, or "birth house," where the birth of the divine child—in this case, Hathor's son—was celebrated.

This relief, from the time of Emperor Trajan, is in the sanctuary at a central point on the rear wall. It echoes a front view of the cult-shrine that stood freely in the center of the room. *Above* the cult shrine stood a separate kiosk supported by Hathor columns, and rimmed with cobras.

PL. I.54 FLORAL FRIEZES (Painted in the tombs)
The friezes in this plate were copied from private Theban tombs, and date to the New Kingdom (see Pl. I.13 for

other New Kingdom examples). The fourth example *left to right from top* is taken from the tomb of Neferhotep (see Pls. I.30-33). *Below*, the two patterns come from the tomb of Nebamun and Imiseba.

PL. I.55 DECORATION OF CORNICES (From various periods)
The cornice, a characteristic element of Egyptian architecture, varies widely in style. The three examples *above* display a type of feather decoration. *Left to right from top*, the first is from the tomb of Ti; the others are from two doorways erected by Tuthmosis III, south of the sanctuary of the Great Temple of Karnak. The second cornice is exceptional with its inlaid decoration made of stone or glass. The fifth and sixth, also from Karnak, are from the reigns of Tuthmosis III and Ramesses I, respectively. The fourth cornice adorns the entrance to the library decorated during the reign of Augustus, in the Temple of Philae. The seventh, also from Philae, forms part of the gate erected by Hadrian and Marcus Aurelius.

PL. I.56 CORNICES, BORDER DECORATIONS & DADOS (From various periods)
The frieze *above left* is from the Middle Kingdom tomb of Dhutihotep II in Deir el-Bersha. *Above right* is another Middle Kingdom frieze from a tomb in Beni Hasan. The others are from the New Kingdom. The frieze *above center* is from the tomb of the scribe Haremhab (see Pl. I.19). The other friezes use the long-stemmed lotus and papyrus in repetition. The two small fragments (numbered 4 and 5 by the artist) are from a private Theban tomb. The umbels *center* (numbered 6) decorate the dados in a temple built by Amenophis III in Karnak. The friezes with the lotus and papyrus growing in water (7 and 8) are from the temple of the god Monthu in North Karnak.

PL. I.57 DADOS (Ptolemaic & Roman periods)
The alternation of the lotus and papyrus was a simple, common method of decorating dados of walls or columns, and was used in endless variation. *Left to right from top*, the first and second are from the Temple of Dendur, built under Augustus, and the Temple of Dendera, respectively. The third, also from Dendera, is from a column in the pronaos—a large hall preceding the hypostyle hall. The fourth and fifth are from the interior rooms of the same temple. The sixth, added for comparison, shows a typical New Kingdom dado decoration. The last four are column dados: the two *below left* are of columns from the now destroyed temple at Armant; the two *below right* are from Esna.

PL. I.58 CAPITALS OF THE GREAT TEMPLE OF ISIS (At Philae—reign of Ptolemy VIII Euergetes II)
In these two composite capitals from the Temple of Isis, all the original coloring has been restored. (See Pls. I.24-27 for more examples from Philae.)

PL. I.59 CAPITALS OF THE COLONNADE, (At Philae—reign of Augustus) [sic]
Most of the composite capitals represented in this work are from the series of columns flanking the first court of the Temple of Isis, preceding the first pylon. The columns here, built after the reign of Augustus, are drawn from the western side of the colonnade. (For a plan of the island see Pl. I.2.)

PL. I.60 CAPITALS OF THE COLONNADE, (At Philae—reign of Augustus, Tiberius & Claudius)
Each of these capitals from the first court of the Temple of Isis (see Pl. I.59) has a unique design, combining flowers and various plant forms. All of the columns here are from the Roman period.

PL. I.61 CAPITALS OF DIFFERENT SHAPES
This sample of nine capitals from the Ptolemaic and Roman period can, for the most part, be classified as composite capitals. The column, *below center*, however, uses only one leaf-form: the palm leaf. The two capitals flanking it incorporate palm leaves in their design.

PL. I.62 OBELISK OF RAMESSES II (Removed from Luxor to Paris)
This is the western of two obelisks erected by Ramesses II in front of the Luxor Temple. In the 1830s, it was transported to Paris where it now stands in the Place de la Concorde. This reconstruction, however, shows the monument as it stood on its pedestal in Luxor, adorned with two rows of baboons. The baboons at its base are the traditional worshippers of the sun. One group of baboons came with the obelisk to Paris, and is exhibited in the Louvre. The obelisk, 22 meters high, erected in honor of the sun-god Amun-Re', is carved in red granite, and was probably gilded on the top. The scene shown *above center* was adapted from the eastern obelisk, still in Luxor.

DRAWING

PL. II. 1 CANON OF PROPORTIONS OF THE HUMAN BODY (In use from 5th to 26th Dynasties)
Prisse d'Avennes was among the first scholars to understand the purpose of the grid, used as a guideline for drawing the human figure, sometimes seen on unfinished artwork. He distinguished between two canons of proportions. The first canon—illustrated in this plate—was in use until the 25th Dynasty. It was based on the division of a standing figure into eighteen squares from the soles of the feet to the hairline; the figure could thus be drawn in any position. The examples *above, from left* are from the tombs of Dhutihotep II in Deir el-Bersha, Ra'shepses' tomb in Saqqara, and an unfinished tomb in Thebes from the reign of Seti I. The scene *center* is from the tomb of Ahmosi in el-Kab; the scene *below* is from the tomb of the royal butler Suemnut in Thebes. All scenes, except the first two, date to the New Kingdom.

PL. II.2 LATER CANON OF PROPORTIONS OF THE HUMAN BODY (In use from Psammetik I to Caracalla)
After the 25th Dynasty, the standing figure was divided into twenty-one squares between the soles of the feet and the upper eyelid. These renditions show drawings with the gridlines restored to their original state. *Above left*, the figure is from the Theban tomb of Karakhamun, from the 26th Dynasty. *Center*, a drawing represents Ptolemy VIII Euergetes II and his queen Cleopatra II in the temple of Thoth, or Qasr el-'Aguz, near Medinet Habu. The drawing *right* is from an edifice of Nectanebo north of the Great Temple at Karnak. *Below*, Marcus Aurelius is shown making an offering of incense and libation to Osiris and Isis. This relief is on the gate of Hadrian and Marcus Aurelius in Philae.

PL. II.3 FACSIMILE OF A REWORKED SKETCH (Necropolis of Thebes—18th Dynasty)
The following two plates were copied from the tomb of the vizier Ra'mosi in Thebes, who lived under the reign of Amenophis III and IV. The sketch depicts a row of foreigners in adoration before Amenophis IV. As was customary, the sketch was first drawn in red, then finished in black. In the case of Ra'mosi's tomb, the sketch was later to be carved in relief.

PL. II.4 FACSIMILE OF A SKETCH (Necropolis of Thebes—18th Dynasty)
This scene, from the same wall as the previous plate, shows foreign emissaries paying homage to Amenophis IV. Two Africans, an Asiatic, and a Libyan are characterized by their stereotypical physiognomy and clothing.

PL. II.5 SKETCH REPRESENTING SETI I (Necropolis of Thebes—19th Dynasty)
In 1817, the Italian adventurer Belzoni discovered the tomb of Seti I in the Valley of the Kings (see Pl.I.8 for a plan of the tomb). Prisse copied this sketch from a pillar in the first rooms of the tomb, where reliefs were never completed. It represents the king offering incense and libation to Osiris (not shown in this rendition). The layout had been executed in red, the final sketch was drawn in black.

PL. II.6 HUNTING IN THE MARSHES (17th [sic] & 18th Dynasties)
Prisse commissioned a French artist named Dupuy to copy these scenes from Theban tombs in 1827 or 1828. When Prisse returned to Thebes in 1859, the murals had been destroyed. The scene *above* was copied in the tomb of Antef, great herald of the king, during the reign of Hatshepsut and Tuthmosis III. It shows Antef and his family spearing a hippopotamus. *Below*, the scene, from an unknown tomb, depicts the sport of catching birds with throw-sticks.

PL. II.7 FEMALE MUSICIANS AND DANCERS
(Necropolis of Thebes—18th Dynasty)
George Lloyd, a Welsh botanist who traveled with Prisse
on his earlier visit to Thebes, copied the drawing *above*
from a Theban tomb. In 1859, the tomb could no longer be
found. It belonged to Mery, first prophet of Amun in the
time of Amenophis II. The scene *below* was copied from a
relief in an anonymous tomb dating to Tuthmosis III or IV.

PL. II.8 JUDGMENT OF THE DEAD IN THE COURT OF
OSIRIS (Funerary ritual—18th Dynasty) [sic]
A papyrus roll with magical spells was placed in tombs of
the New Kingdom onward to help the deceased in the
next world. The content of this Book of the Dead may
vary greatly, but the scene shown here is rarely omitted.

Osiris, judge of the dead, and his tribunal of forty-two
gods, preside over a set of scales in which the heart of the
deceased (on the *left* scale) is weighed against the symbol
of justice, Maat (on the *right* scale). The drawing is copied
from a Ptolemaic manuscript.

PL. II.9 FRAGMENTS OF SATIRICAL PAPYRI (Museums
of Turin & London)
The two examples illustrate stories apparently too well-
known to be written with the images. Animals behaving
like humans are taking part in humorous situations. In
the series *above*, a hippopotamus collects fruit from a tree
while a bird climbs a ladder. The theme of a battle
between cats and mice is known from other drawings,
but the story is lost. The papyrus is now kept in Turin.
The fragment *below* is part of a papyrus preserved in
London. The drawing is copied from a reconstruction of
the two papyri by Lepsius.

SCULPTURE

PL. II.10 HIPPOPOTAMUS HUNT IN THE MARSHES
(Memphis—6th Dynasty) [sic]
The hippopotamus, shown here in its natural setting, was
hunted because it posed a threat to both men and crops.
The theme of hunting in the marshes was frequent in
tomb decoration (see New Kingdom example, Pl. II.6.)
This scene is from the famous mastaba of Ti in Saqqara,
discovered by Mariette in 1855.

PL. II.11 CRANES & THE POULTRY YARD OF TI
(Necropolis of Memphis—5th Dynasty)
The tomb of Ti is considered among the richest for the
variety of themes represented on its walls. *Above* the relief
shows a procession of two kinds of cranes, driven before
Ti by two men. *Below*, birds are fed in a poultry yard
while a scribe oversees the work.

PL. II.12 BOATMEN IN A TILTING MATCH (Kom el-
Ahmar—6th Dynasty)
This scene is frequently included in the decoration of Old

Kingdom mastabas: four or five men stand in each boat,
holding punting poles to steer and attack other boats.
Falling in the water seems to be the most serious harm
ever shown in this popular game. The scene, divided in
two for practical reasons, is copied from the tomb of
Khunes in Zawyet el-Mayitin (see Pl. I.15).

PL. II.13 ANIMALS; FELINE SPECIES (Thebes—17th [sic]
& 18th Dynasties)
In 1858, a small part of the mortuary temple of Queen
Hatshepsut in Deir el-Bahri, on the west bank of Thebes,
had just been excavated by the French art dealer V. Galli
Maunier. Prisse and his artists, in Thebes at the time, were
the first to copy this wall. *Above*, the reliefs record a trad-
ing expedition sent by Hatshepsut to the land of Punt.
The two leopards and the panther were part of the goods
brought back to Egypt. The drawing *below* decorates the
base of a throne of Tuthmosis III, in a relief near the sanc-
tuary of the Great Temple at Karnak.

PL. II.14 TYPES & PORTRAITS (Necropolis of Thebes—
18th Dynasty)
All four portraits were copied from the walls of the Theban
tomb of Kha'emhet, also called Mahu. He was the royal
scribe and overseer of the granaries of Upper and Lower
Egypt during the reign of Amenophis III. He is depicted
three times in this plate, wearing an elaborate wig and jew-
elry, as well as a small ceremonial beard. The figure *above
left* is shown in full in Plate II.21. Prisse reversed the draw-
ing *below left* for the composition of the plate.

PL. II.15 SCRIBE & PRIESTESS OF AMUN (Necropolis of
Thebes—18th Dynasty)
Slightly later in date than the portraits shown previously,
this scene shows the chief scribe Neferhotep and his wife
Merytre', who lived during the reign of King Ay. The
relief is carved in the doorway of their tomb, a common
location for adoration scenes in Theban tombs. The scribe
is in adoration before the sun god; his wife holds a
sistrum and a peculiar necklace, both used as musical
instruments associated with the goddess Hathor.

PL. II.16 KING AKHENATEN SERVED BY THE QUEEN
(Tell el-Amarna—18th Dynasty)
In the new style of art imposed by Akhenaten, the royal
family was the main subject. The family is often shown in
an informal setting, as in this scene where the king is sit-
ting leisurely in a pavilion decorated with flowers, while
the queen pours him a drink through a drink-strainer.
The couple's children, servants and a female band are
also present. The relief is from the tomb of Meryre' II at
Tell el-Amarna.

PL. II.17 CAPTURE OF A FORTRESS BY RAMESSES II
(Thebes, Ramesseum—18th Dynasty) [sic]
Battle scenes were a regular feature of temple decoration
in the New Kingdom, particularly during the Ramesside

period. Ramesses II is shown charging a fortress in Syria. The pharaoh in his chariot appears invincible. Depicted on a gigantic scale, he seems to be fighting the enemy alone. The relief is part of the decoration of the hypostyle hall of the Ramesseum, mortuary temple of Ramesses II in Thebes.

PL. II.18 HOMAGE TO AMENOPHIS III (Tomb of Kha'emhet, intendant of the domains—18th Dynasty)
Like the portraits in Plate II.14, the following series of plates have been copied from the tomb of Kha'emhet in Thebes. Here, he is shown *center* bowing his head respectfully to Amenophis III, who is sitting in a kiosk on an elaborately decorated throne. Behind Kha'emhet are three groups of officials. A special reward is granted to the officials on the occasion of the first Sed festival, the king's 30-year jubilee. After Prisse's visit, the head of the king and the men on the *right* were removed and sold; they are now in Berlin.

PL. II.19 MEASURING THE FIELDS (Overseen by Kha'emhet, intendant of the domains—18th Dynasty)
Above, Kha'emhet oversees the measuring of the fields. Several men are handling ropes to measure the forthcoming harvest. Scribes register the results. *Below*, chariots wait while servants prepare food under the trees.

PL. II.20 AGRICULTURAL SCENES (Tomb of Kha'emhet, intendant of the domains—18th Dynasty)
From the same wall as the scene of the previous plate, this scene shows Kha'emhet as overseer of the granaries. Seated, he watches the farmers at work: ploughing, harvesting, threshing, and winnowing. Lively details, such as a boy with a flute and a sleeping man, enrich the scene. The head of Kha'emhet is rendered in more detail in Plate II.14.

PL. II.21 COUNTING THE OXEN (Tomb of Kha'emhet, intendant of the domains—18th Dynasty)
This scene, also in the tomb of Kha'emhet, forms part of a larger composition showing men leading cattle before Amenophis III. The king is not shown in this plate, but appears in a similar depiction in Plate II.18 from the same tomb. The portrait of one of the men leading the oxen appears in Plate II.14.

PL. II.22 PRINCELY CHARIOT (Tell el-Amarna—18th Dynasty)
Prisse recorded the details of a chariot and harness from the tomb of Meryre' I in Tell el-Amarna. The chariot, drawn by two horses, is equipped with a shaft to hold arrows. The chariot probably belongs to Meryre', depicted in the same scene (not shown here) receiving rewards from the king.

PL. II.23 FRAGMENTS OF BAS-RELIEFS; TEAMS OF HORSES (Thebes—18th Dynasty)
The relief *above* shows a war chariot with two occupants, each at his post. According to the military conventions of the time, one man is fighting while the other drives and holds a shield. The scene is copied from a reused block probably dating to the reign of Tutankhamun that Prisse saw in the western pylon of the Temple of Chonsu in Karnak.

The scene *below* shows a detail of Plate II.20. The chariot, of a simpler type, is in an everyday context. The driver has apparently fallen asleep.

PL. II.24 HUNTING WITH BOW & RUNNING DOGS (Necropolis of Thebes—18th Dynasty)
The scene is from the tomb of Amenemhet who lived during the reign of Tuthmosis III. It shows Amenemhet hunting wild animals in the desert. The animals are being driven by dogs into an enclosure set up in the hills. The animals include ostriches, wild bulls, hyenas, ibexes, hares, and even a hedgehog. Left, the slain animals are carried off by servants.

PL. II.25 STATUES OF A RAM (Temple of Mut & Chonsu—18th Dynasty)
The ram was considered a manifestation of the god Amun; statues of the animal adorned the principal temple of Amun at Karnak. This example was among a series flanking the southern approaches to Karnak and leading to the temples of Mut and Chonsu. Like sphinxes, they are guardians of the temple. Amenophis III, who commissioned the sculpture of the rams, is represented under the breast of the animal.

PL. II.26 ANDROSPHINX & CRIOSPHINX (Amenophis III—18th Dynasty) [sic]
The criosphinx *below* is a combination of ram and lion; a row of such creatures carved in limestone under Ramesses II lined the approach to the Great Temple at Karnak (shown in Pl. II.34).

Above the red granite androsphinx has a human head; it was sculpted for Amenophis III's mortuary temple in western Thebes. Discovered in 1825, it is now with an identical counterpart in the State Hermitage Museum in Leningrad.

PL. II.27 OFFERINGS TO THE SUN [sic] (Tombs of Tell el-Amarna—18th Dynasty)
Informal scenes featuring the royal family are characteristic of tombs at Tell el-Amarna (see Pl. II.16). In this scene, the royal family—Akhenaten, Nefertiti, and their children—are at a banquet with the queen-mother, Teye. The sun disc casts its rays over the scene, symbolizing the all-pervading presence of the sun god, Aten, considered the king's father. The scene is from the tomb of Huya, steward of the great royal wife Teye.

PL. II.28 TYPES & PORTRAITS (Women of various epochs)
The oldest portrait, *above left*, was copied from a ruined tomb at Saqqara. The portrait *above right* was carved on a

Middle Kingdom stela in Abydos under Amenemhet II. *Below*, the busts are from private New Kingdom tombs in Thebes. The woman *left*, probably from the tomb of the vizier Paser, represents his mother. The portrait *right* is from a tomb of the reign of Seti I.

PL. II.29 TYPES & PORTRAITS (Dignitaries of various epochs)

The four portraits span some 1500 years. The oldest, *above right*, is of Ti, from his 5th Dynasty mastaba in Saqqara. *Below left* is the portrait of the Middle Kingdom provincial governor Dhutihotep II in his tomb at Deir el-Bersha. *Above left* is the New Kingdom vizier, Rekhmire'.

Below right, the prophet Pedamenopet of the 26th Dynasty is portrayed in his Theban tomb; after Prisse's visit, the sculpture was removed and is presently in the Brussels Museum.

PL. II.30 STATUE OF QUEEN AMENARDAIS (Cairo Museum)

Amenardais, daughter of the Nubian king Kashta who conquered southern Egypt around 740 B.C. was installed in Thebes as "God's Wife of Amun," the principal priestly title of the time. Her statue was found in 1858, near the entrance to a chapel of Osiris, erected by Amenardais in northern Karnak. The 1.47 meter statue is made of alabaster with a granite base. The plate was drawn in the Bulaq Museum by Willem de Famars Testas.

PL. II.31 STUDIES OF HEADS BASED ON THE CANON OF PROPORTION (Workshops of Memphis & Thebes)

Ancient Egyptian sculptors applied the same methods of establishing proportions as were used in drawing (see PL. II.1 and II.2). A grid and side views of the figure were drawn on the stone before it was cut and polished. The different stages of the process are illustrated by a series of unfinished portraits from the Late period. The two finished heads, *middle row center and right,* and the head of the pharaoh, *below left*, were sculpted in Thebes; the others are from a group of trial pieces found at Saqqara. All pieces are now in the Cairo Museum.

PL. II.32 STATUE OF RANOFER (Limestone painted red)

In 1860, while excavating the mastaba of Ranofer in Saqqara, Mariette found three statues in their original position. Two represented Ranofer, high priest of Ptah and greatest of craftsmen; the third probably depicts his wife Heknu. The statues are now in the Cairo Museum. The height of this statue is 1.70 meters, and its original colors are well preserved. The name and titles of Ranofer are carved on the base.

PL. II.33 FRAGMENTS OF STATUES (From different epochs)

In 1858, Prisse photographed a limestone head in the possession of A. Harris, a British merchant and collector of antiquities in Alexandria. The drawings *above* were made

from the photographs. The head had been found in the ruins of Memphis, near the temple of Ptah. Later it was sold to the British Museum. The two pieces *below* represent a queen, probably from the 25th Dynasty, and a man from the Old Kingdom. Both are in the Cairo Museum.

PL. II.34 DROMOS OF THE GREAT TEMPLE AT KARNAK

The western approach to the Great Temple of Amun in Thebes is lined with ram-sphinxes. This reconstruction is a view from the entrance of the temple looking west toward a platform, where the god appeared to the people during processions. In the distance are the Nile and the desert beyond.

PL. II.35 TYPES OF SPHINXES (From various monuments)

The sphinx with an African head was recorded in Armant, and is probably from the New Kingdom. It is the only known example of its kind; its present location is unknown. The sphinxes with falcon heads are, *above center*, from Karnak bearing the name of Amenophis II, and *right*, from Kom Ombo where it adorns a column in the outer hypostyle of the temple. Female sphinxes were in vogue during the New Kingdom. *Left*, from a casket in the Abbott Collection, a sphinx is in adoration before the name of Queen Hatshepsut.

The female sphinx *right* decorates a vase (shown in Pl. II.97). Two sphinxes represent Amenophis III trampling his enemies; each decorates a side of a throne in the tomb of Kha'emhet (see Pl. II.18). The sphinx *below left*, now lost, was copied from a block in the fowl yard of the Great Temple at Karnak, and represents either Psammetik I or King Apries. The last sphinx *below right*, representing Hekau, god of the desert, dates from the Late period. It was found reused in the town of Esna, but is now lost.

PL. II.36 ANIMALS; OVINE & BOVINE SPECIES (Cairo Museum)

The relief *above* is from Saqqara, and the bull *below* was found in Tanis in the Delta. Traces of the grid used in sketching the bull still exist, but were not reproduced by Prisse. The three studies are carved on small pieces of limestone, roughly 13 x 20 centimeters. They are from the Late period or the Ptolemaic Dynasty and were copied at the Bulaq Museum. [The original plate caption states that the reliefs are drawn actual size; in this edition, however, they are reduced. -Ed.]

PL. II.37 GREAT TEMPLE OF ABESHEK [sic] (Nubia)

Ramesses II had two temples constructed at Abu Simbel. In comparison with the other, this one is usually referred to as the "small temple." It was dedicated to the goddess Hathor of Abeshek and to his principal queen, Nefertari. The statues of the queen and the royal family are carved in stone on the facade of the monument. Hathor appears only in a small scene over the doorway. The drawing was made from a photograph.

PL. II.38 ROYAL PORTRAITS (Thebes—18th, 19th & 25th Dynasties)

A selection of portraits from Theban tombs and temples reveals that, contrary to the belief of Prisse's contemporaries, the facial features of all royalty were not depicted in the same manner. The figure *above left* represents Haremhab from the tenth pylon of the temple of Karnak. Facing him is Tausert, wife of Seti II from her tomb in the Valley of the Kings. *Below* are figures of Nubian royalty. The woman *left*, depicted in the tomb-chapel of Princess Amenardais I–god's wife of Amun–is possibly the princess herself. The portrait of King Taharqa *right*, of the same family, appears on the columns of the eastern colonnade he had erected at Karnak.

PL. II.39 THE CAMP OF RAMESSES II IN HIS CAMPAIGN AGAINST THE HITTITES (Thebes, Ramesseum—19th Dynasty)

The many temples built by Ramesses II preserve scenes of his battle at Kadesh against the Hittites, fought early in his reign. This scene adorns the first pylon of the Ramesseum, the king's mortuary temple in western Thebes. In the camp, Egyptian soldiers are preparing for the battle; in the *center*, near the royal tent, Hittite spies are being beaten to confess the enemy's position. *Above right*, Hittite chariots are attacking the Egyptian camp.

PL. II.40 RAMESSES II's BATTLE AGAINST THE HITTITES ON THE BANKS OF THE ORONTES (Thebes Ramesseum—19th Dynasty)

Steering from his waist and shooting at the Hittites, Ramesses II is portrayed as hero of the battle of Kadesh. The battle took place close to the river Orontes, shown at the bottom of the scene, but the fort of Kadesh is omitted here. The dress, harness, and chariot equipment are reconstructed in elaborate detail and in their full original color The scene is from the second pylon of the Ramesseum in Thebes (see Pl. II.17 for another battle scene from the same temple).

PL. II.41 THE COMBAT OF SETI I AGAINST THE CHIEFS OF THE THEHENU (Thebes, Karnak—19th Dynasty)

Seti I, descended from his chariot, is engaged in combat with two Libyan chiefs. The Libyans, called Thehenu by the ancient Egyptians, are characterized by their dress with a phallus-sheath, and a side-lock and ostrich feathers on the head. Seti is wielding a lance against them; one has been struck and the other wounded by an arrow. Lances were carried on chariots in a special shaft (see Pl. II.40).

PL. II.42 THE GODDESS ANUKIS & RAMESSES II (Talmis—19th Dynasty)

In this relief, using imagery from everyday life, Ramesses' relationship to the gods is made clear. The goddess Anukis, who was a popular goddess in Nubia, is represented here suckling the king. This scene was taken from the sanctuary of Beit el-Wali, a rock-cut temple erected by Ramesses II in Nubia, on a site close to Kalabsha—formerly known as Talmis (see Plate I.42).

PL. II.43 COLOSSUS OF RAMESSES II (Memphis—19th Dynasty)

This limestone statue of Ramesses II once measured 14 meters high. It now lies where it once stood at the south gate of the Great Temple of Ptah in Memphis. Its back is damaged from irrigation waters, and a small figure of one of Ramesses' daughters, carved behind his left leg, has all but disappeared. The feet and pedestal here were added by Prisse.

PL. II.44 FRAGMENTS OF MILITARY SCENES (Abeshek & Thebes—19th Dynasty)

The scene *above* shows a chariot used in the battle of Kadesh, as depicted in the Great Temple of Ramesses II at Abu Simbel. The chariot appears with an umbrella over it, similar to the Nubian chariot in Pl. II.54. The relief *below*, a sequence to the Combat of Seti I with the Libyans (Pl. II.41), shows the defeated foes piled in the chariot, as the king returns home. Only the horses' hind hoofs touch the ground, a style typical of the period.

PL. II.45 FRAGMENTS OF FUNERARY BAS-RELIEFS (Necropolis of Thebes 19th Dynasty) [sic]

The relief *above* shows the funeral of Amenemopet Ipy, chief steward of Amun in Thebes, from his tomb-chapel. The mummy in front of the tomb is bewailed by a group of women, while the funerary rituals are carried out by priests, *left*. In a contrasting scene of rejoicing *below*, women dance with tambourines while two nude girls dance with clappers in their hands. The occasion is not clear, as only a fragment of the relief survives. Found in Saqqara in 1859, it is now in the Cairo Museum.

PAINTING

PL. II.46 PORTRAIT OF TI AND HIS WIFE (Necropolis of Memphis—5th Dynasty)

This portrait of Ti and his wife Neferhetpes, carved in shallow relief on the wall of his mastaba in Saqqara, was copied by Willem de Famars Testas in its original color shortly after its discovery. Its interest lies in the painted details in the background, representing a tent-like structure. The hieroglyphs at the top give Ti's name and titles of honor.

PL. II.47 ARRIVAL OF AN ASIATIC FAMILY IN EGYPT (Beni Hasan—12th Dynasty)

This rare representation of Asiatics in Middle Kingdom art shows a group of captives brought from the Eastern Desert by Khnumhotep III, overseer of the eastern tribes. The inscription indicates there were thirty-seven in this group, and their leader, marching in front, is called Ibsha.

The scene appears in the tomb of Khnumhotep III in Beni Hasan.

PL. II.48 SCENES OF RURAL LIFE (Tombs of Beni Hasan—12th Dynasty)
The two Middle Kingdom paintings of cattle are also from the tomb of Khnumhotep III. Two fighting bulls are represented *above*; *below*, two men lead bulls and an ibex to Khnumhotep.

PL. II.49 RETURN OF A HUNTER ON A BARQUE [sic] (Beni Hasan—12th Dynasty)
The fisherman Hetep, identified from the inscription *above* his head, brings three European wigeons and two cranes in his yoke and a goose in his hand to Khnumhotep. This painting is on the same wall as the rural scenes in Plate II.48.

PL. II.50 NATIVE OF THE LAND OF PUNT (Thebes; 'Asasif—17th Dynasty) [sic]
This relief shows a typical rendition of a native of Punt. The incense tree was one of the products Egyptians imported from Punt. The painting was copied from the walls of Queen Hatshepsut's temple in Deir el-Bahari, uncovered during Prisse's stay in Luxor in 1858; the same temple was the source for Plate II.13.

PL. II.51 RETURN FROM THE HUNT (Necropolis of Thebes—17th Dynasty) [sic]
Prisse copied this scene in western Thebes during his earlier visit in the 1830s. When he returned in 1859, he found nothing of the scene remained. It is possibly from the tomb of Dhutimose from the reign of Tuthmosis III.

PL. II.52 PORTRAIT OF QUEEN TYTI (WIFE OF AMENOPHIS III [sic] (18th Dynasty) [sic]
Queen Tyti, probably a daughter of Ramesses III, lived during the later New Kingdom. In this portrait, taken from her tomb in the Valley of the Queens (shown in Pl. I.8), the queen stands in adoration before three divinities (not shown here). Her exquisite headgear is decorated with representations of the vulture-goddess Nekhbet.

PL. II.53 AMENOPHIS II & HIS WET-NURSE (Necropolis of Thebes—18th Dynasty)
Amenemopet, mother of Kenamun, had been the king's wet-nurse. Kenamun, chief steward of Amenophis II, proud to be the king's foster-brother, had the image of his mother nursing the king painted in his tomb. Paradoxically, Amenophis, represented in all his royal might and subduing Egypt's enemies, is being fondled in her lap. Instead of the royal falcon or vulture hovering over the king's head, this painting shows an unconventional goose.

PL. II.54 ARRIVAL OF AN ETHIOPIAN PRINCESS IN THEBES (During the reign of Tutankhamun—18th Dynasty)
Amenhotep Huy, viceroy of Kush and governor of the South Lands under Akhenaten and Tutankhamun, was responsible for the flow of goods from the southern regions. This spectacular display of gifts he had presented to Tutankhamun was depicted in his tomb in Thebes. In this section of the procession are African princes, gifts of gold and panther skins, and a princess protected by an umbrella of ostrich-feathers in an ox-drawn chariot.

PL. II.55 GOLDSMITHS' WORKSHOP OF THE RETJENU (Temple of Karnak [sic]—18th Dynasty)
The scene showing metal workers is part of a wall depicting different professions in the tomb of Rekhmire', vizier of Tuthmosis III and Amenophis II. *Above*, the fires are kept ablaze with foot-operated bellows; *below*, the men are casting bronze doors in a large mould. The inscription states that the bronze is brought from Asia, from the land of Retjenu.

PL . II.56 MANUFACTURING GOLD AND SILVER VASES (Necropolis of Thebes—18th Dynasty)
From the same wall as the scene of the previous plate, a group of metal workers is engaged in the making of vessels. After forging, *above left*, the craftsmen hammer the sheet metal with round pounders into the desired shape. Others are polishing and one man chisels an inscription onto a vessel. A finished vessel with a spout is carried off, *right*. The text, *above right*, states that gold and silver are being used.

PL. II.57 SCULPTORS' WORKSHOP (18th Dynasty)
This is the third in a series of plates showing craftsmen at work, from Rekhmire's tomb. Four colossal works are near completion: two royal statues, a sphinx, and an offering-table. The craftsmen are polishing the stone; the royal statue *right* is being inscribed on its back-pillar.

PL. II.58 TRANSPORT OF UTENSILS & PROVISIONS (Necropolis of Thebes—18th Dynasty)
The same tomb of Rekhmire' (source for Pls. II.55-59) provides an image of produce from different regions. The provisions, carried into storerooms, include wine, papyrus, and oil, brought from the delta, the oases, and even the land of Punt.

PL. II.59 CAPTIVES CONSTRUCTING A TEMPLE OF AMUN (Thebes—18th Dynasty)
A series of steps in the construction of a temple begins *above left*: mud is mixed with water from a pond; the mixture is pressed into molds and left in the sun to dry; the mud bricks are used in building a ramp to haul the large blocks of white limestone for the construction of a wall.

The workers are foreigners, probably Asiatics and Nubians; captives, as Prisse suggests, or immigrant workers attracted by Egypt's flourishing economy during the New Kingdom. This scene is also from the tomb of Rekhmire' (see Pl. II.55-58).

PL. II.60 LUTIST (Necropolis of Thebes—18th Dynasty)
The young woman is playing the lute for the king's nurse, Amenemopet (shown in Pl. II.53). Details of the girl's hair

are rendered with care. Noteworthy is the degree of freedom with which Egyptian artists drew minor figures of a scene, creating more realistic representations than with major characters where they adhered to strict convention. Prisse adds to this unconventionality by extending the drawing beyond its frame.

PL. II.61 TOMB DISCOVERED IN THE VALLEY OF 'ASASIF (Thebes)
In 1823, Italian excavator and collector G. Passalacqua discovered the tomb of the steward Mentuhotep in western Thebes. He published a drawing of the tomb's interior as it appeared at the moment of its discovery; it was the first record of an undisturbed tomb and it inspired the colored reconstruction in this plate. Next to the sarcophagus, which dates to the late 12th Dynasty, we see wooden statuettes of boats and female servants, and pots containing provisions for the deceased. The contents of the tomb are now in Berlin.

PL. II.62 PLANTS & FLOWERS (From various monuments)
This collection of different plant forms is copied from Theban paintings. The decorative papyrus plants *above* are from private tombs. The plants growing on hillocks *below* are from paintings in a small storeroom in the first part of Ramesses III's tomb at the Valley of the Kings.

PL. II.63 PORTRAIT OF PRINCE MONTUHERKHEP-SHEF (Son of Ramesses II [sic]—19th [sic] Dynasty)
This portrait was copied from the small unfinished tomb of a son of Ramesses IX of the 20th Dynasty, in the eastern end of the Valley of the Kings. The prince was commander of the army; his side-lock, adorned with a decorative blue and gold band, is indicative of his princely status.

PL. II.64 PORTRAIT OF RAMESSES II (19th Dynasty)
In 1843, Prisse d'Avennes copied this painting from a private tomb behind the Ramesseum in Thebes. When he returned in 1859, the tomb had disappeared. It portrays the young Ramesses II, wearing the side-lock of a royal prince and a panther-skin. He is holding a grain of incense to be thrown in the fire.

PL. II.65 PORTRAIT OF KING MERNEPTAH (Necropolis of Thebes—19th Dynasty)
The pharaoh is dressed in an elaborate royal costume with a false beard and three streamers of red cloth on his back. He is extending his hand to the sun god, Re-Harakhti (not shown). This portrait of Merneptah, Ramesses II's successor is in the entrance corridor of his tomb in the Valley of the Kings.

PL. II.66 PORTRAIT OF QUEEN NEBTAWY (Daughter of Ramesses II—19th Dynasty)
Nebtawy, daughter of Ramesses II and sister or half-sister of King Merneptah, probably acted as the royal queen during the last years of her father's reign. Little about her is known except that a large tomb was constructed for her in the Valley of the Queens. Prisse copied the portrait from her tomb, which was later destroyed. The queen wears the special crown of a royal concubine, comparable with that of the women shown in Pl. I.45.

PL. II.67 OFFERING OF FLOWERS AND FRUITS (Necropolis of Thebes—19th Dynasty)
The two women bring offerings of lotus flowers, figs, and grapes to the tomb owner. Prisse copied the painting from a private Theban tomb of the 19th Dynasty. [The original plate title states that these renditions are actual size; this edition, however, shows the plate in reduced size. -Ed.]

PL. II.68 BOUQUETS PAINTED IN TOMBS (19th & 20th Dynasties)
In the artist's opinion, these are some of the most beautiful bouquets in Theban tombs. The two large bouquets are from a 19th Dynasty tomb behind the Ramesseum. The bouquet on the *right* is arranged around a staff in the shape of an ankh, symbol of life. The smaller ones are from two different tombs in Thebes.

PL. II.69 PORTRAIT OF RAMESSES III (Necropolis of Thebes—20th Dynasty)
This portrait of Ramesses III, elegantly dressed, appears near the entrance of his tomb in the Valley of the Kings. It may be compared with the portrait of King Merneptah (see Pl. II.65), since both are in an identical context. One marked difference is the large number of protective magical ornaments on the costume of Ramesses III, such as the falcons on his head and belt, and the cobras on the headdress and bracelets

PL. II.70 HARPERS OF RAMESSES III (Thebes—20th Dynasty)
The two blind musicians are playing intricately decorated harps for a group of gods. The harps' base is adorned with a likeness of the king with an elaborate collar and a blue-lotus flower. This painting is from the tomb of Ramesses III, uncovered in 1769 by the Scottish traveler James Bruce; the tomb became known as the Harpers' Tomb because of this unique image.

PL. II.71 OFFERING TO OSIRIS (Stela painted on a sarcophagus; necropolis of Thebes—20th Dynasty)
Pedekhons, a priest of Amun, is pouring a libation on an offering table before Osiris and Isis. This scene is painted on the bottom of a wooden sarcophagus that Prisse had taken back to France; sarcophagi of this kind were made during the late New Kingdom.

INDUSTRIAL ART

PL. II.72 SELECTION OF VASES CONTEMPORARY WITH THE PYRAMIDS (Necropolis of Memphis—4th [sic] & 5th Dynasties)

Two men in the scene *below* are using a variety of vessels to brew and store beer. The vessels *below and center* are from the tomb of Ti, except for the tall vase in the *center* from Ptahshepses' tomb. Other vases from the latter tomb are shown *above* with some vessels from the tomb of the vizier Ra'shepses. The three tombs are in Saqqara, and the vessels are of pottery, stone, and metal.

PL. II.73 VASES FROM THE REIGN OF TUTHMOSIS III (Thebes & Hermonthis—18th Dynasty)

The offering table *above* is included in this vase collection because Prisse admired the arrangement of the lotus flowers. Together with the two vases *below right*, they were copied from blocks of a destroyed temple in Armant, *Hermonthis* in Greek. The other three vases are part of a treasure presented to the god Amun by Tuthmosis III after his triumphant return from war in Asia. The treasure is carved in relief on a wall next to the sanctuary of the Great Temple at Karnak.

PL. II.74 VASES FROM THE REIGN OF TUTHMOSIS III (Thebes—18th Dynasty)

All thirty vases in this plate are of the same period, but reproduced from different monuments and on different scales. Most are part of the treasure described in the previous plate; the bowl with ibex heads is from the tomb of the vizier Rekhmire'. The remainder were copied from other parts of Karnak and the tombs of western Thebes.

PL. II.75 VASES FROM THE LAND OF KEFTIU, TRIBUTARY OF TUTHMOSIS III (Necropolis of Thebes—18th Dynasty)

In the tomb of the vizier Rekhmire', a scene shows the arrival of the Keftiu people (probably the Minoans from Crete), bearing tribute to the Egyptian king. The vases are adorned with animal heads, like the ibex; some, known as rhytons, are entirely formed in the shape of an animal head.

PL. II.76 VASES FROM THE TRIBUTARIES OF THE KEFTIU (Necropolis of Thebes—18th Dynasty)

Left to right from top, vases 3, 4, 5, 7, 8, and 10 are carried by the Keftiu (see previous plate) as part of their annual tribute, as in the preceding scene. Vases 2, 6, and 9, slightly earlier in date, are depicted in the tomb of Senenmut, chief steward under Queen Hatshepsut. The boukrania decoration on vase 9 is similar to that of the ceiling-pattern in Plate I.33 from roughly the same period.

PL. II.77 VASES FROM ASIATIC TRIBUTARIES (Necropolis of Thebes—18th Dynasty)

The six vases, part of the tribute brought by Asiatic chiefs to Tuthmosis IV, are recorded in the tomb of an anonymous officer who served Tuthmosis IV and Amenophis III. Prisse reconstructed the bull's head of the fourth vase from another drawing in the same tomb.

PL. II.78 VASES OF DIFFERENT MATERIALS (Necropolis of Thebes—18th & 20th Dynasties)

In the upper corners are two chalices in the shape of a blue lotus flower from an unknown tomb. The three vases *center*, copied from the tomb of the chief steward Kenamun, were part of his New Year's gift to Amenophis II. The three *below* are from scenes of craftsmen at work in the tomb of Mery, first prophet of Amun during the reign of Amenophis II.

PL. II.79 BOWL-SHAPED VASES (Necropolis of Thebes—18th & 20th Dynasties)

Most vases in this plate hold artificial flowers; all were copied from private tombs in western Thebes. The three bowls *above*, part of the tribute from Syria, are from the tomb of the vizier Rekhmire'. The sixth vase is from the same tomb. The vase *below left* is a New Year's gift to Tuthmosis IV from the tomb of Fanbearer on the Right of the King, Thenuna. The bowl on the stand *below center* is a Syrian tribute to Tutankhamun, from the tomb of Amenhotep Huy.

PL. II.80 VASES IN OPAQUE GLASS (Thebes—18th Dynasty)

All the objects of this plate are part of a New Year's gift to Amenophis II from his foster-brother Kenamun (see Pl. II.78.) Prisse thought these vessels were made of glass; (glass work had been introduced in Egypt around 1500 B.C.). The two vases in the *corners below*, however, are of a shape that was invariably executed in stone. The bowl in the shape of a duck with her young was possibly made of wood, since similar examples have been preserved. The spoon may have been made of wood or ivory.

PL. II.81 AMPHORAS, JARS & OTHER VASES (Thebes—18th & 19th Dynasties)

Inscriptions on the group of three jars *above* (from the reign of Tuthmosis III) describe their contents: water for one and two kinds of wine for the others. The two stone vases in the *corners above* are used to store oils and unguents. All these objects are recorded from private Theban tombs.

PL. II.82 JARS & AMPHORAS (Necropolis of Thebes—18th Dynasty)

The two amphoras *above* are water containers that resemble those still in use in Egypt. The image of a man polishing a jar is from the tomb of Suemnut, royal butler under Amenophis II. The wine jars *below* are decorated with grapes; painted flower wreaths give them a festive character. The three jars *left* are from the tomb of Amenhotep-si-se from the reign of Tuthmosis IV. The fourth is shown suspended on a yoke.

PL. II.83 VASES FROM THE REIGN OF RAMESSES III (Karnak and Medinet Habu—20th Dynasty)

Ramesses III presented the treasure on the *right*, together with a group of foreign captives from Asia and Libya, to the gods of Thebes: Amun, Mut and Chonsu. The occa-

sion was recorded on the walls of his mortuary temple at Medinet Habu. The vases *left* are probably drawn from different sources in Karnak.

PL. II.84 VASES FROM THE TOMB OF RAMESSES III (Thebes—20th Dynasty)

These objects were painted in a small storeroom in Ramesses III's tomb in the Valley of the Kings. Of particular interest are: *center*, a washing ewer standing in its basin; *below*, a basket decorated with the name of Ramesses, another with a running griffin and a third with gazelles; *next to them*, two small pots shaped like Mycenaean stirrup jars.

PL. II.85 SIX ENAMELED OR INLAID GOLD VASES (19th & 20th Dynasties)

The vases are from the tomb of Nebamun and Imiseba. The vase *above center* is inscribed with the name of Ramesses IX, who received this tribute. The vase *below* it combines flowers and ducks with the head of the god Bes. Prisse assumed the blue was either enamel or inlay.

PL. II.86 RHYTONS & OTHER VASES (Thebes—20th Dynasty)

The vases, all made of metal, are decorated with the god Bes and a griffin *above left*, a foreigner *above right* and a pair of horse heads. A rhyton is a vase or jug in the form of a head or an animal's horn. The rhyton with a panther head *above center* is suspended by a decorative handle; it appears in Plate II.83 among the vases of Ramesses III in Medinet Habu. The vases *below*, part of a foreign tribute, are depicted in the tomb of Nebamun and Imiseba.

PL. II.87 THRONES OF RAMESSES III (Necropolis of Thebes—20th Dynasty)

The paintings of this furniture, copied by Prisse in the tomb of Ramesses III (from the same room as the objects in Pl. II.84), no longer exist. The chairs are elaborately decorated with heraldic elements like the falcon and the lion, and with figures of foreign captives. The footstool was introduced in Egypt during the New Kingdom, in the reign of Amenophis III. Thick cushions, covered with fabric in geometrical patterns, were placed on the chairs and footstools.

PL. II.88 PALANQUINS (Necropolis of Thebes—20th Dynasty)

Two patron saints of the Theban necropolis, the deified king Amenophis I and his mother, Queen Ahmosi Nefertari, are represented in the tomb of Nebamun and Imiseba, as well as in other Theban tombs. These popular saints were occasionally carried out of their shrines in the portable palanquins shown in this plate. During these processions, offerings were made to the saints who could pronounce oracles. The king is shielded by a sunshade, the queen by a canopy.

PL. II.89 THRONES (Necropolis of Thebes—18th & 20th Dynasties)

The throne of Tuthmosis IV *above left* is called a "lion throne" because of the shape of its legs. This throne is depicted in the tomb of the royal scribe Haremhab. Other royal symbols appear on the throne: the unification of Upper and Lower Egypt is symbolized by the intertwining of its heraldic plants, the lily and the papyrus. *Below* are two examples of block thrones. *Right*, the throne of Amenophis IV, from the tomb of Ra'mosi, has a characteristic feather-decoration, the heraldic plants, and a backrest in the form of the vulture goddess Nekhbet. These four royal thrones were found in private Theban tombs.

PL. II.90 TEXTILES & EMBROIDERIES

The textiles in this plate are not within the scope of this book—ancient Egypt—since they date to the Christian period. However, Prisse saw similarities between these patterns and the textiles covering the cushions of the thrones of Ramesses III in the previous plate. The textiles were copied in the Louvre. [The textiles were copied actual size, but appear here in reduced format. -Ed.]

PL. II.91 JEWELRY OF DIFFERENT PERIODS (Egypt & Ethiopia) [sic]

Among this large collection of jewelry, consisting of bracelets, pectorals, girdles, rings, and earrings, the most noteworthy is the pectoral in the shape of a bird with a ram's head, made of gold with glass inlays. It was found by Mariette in 1851 in an intact burial chamber in the Serapeum of Saqqara. The pendant with three flies, from Queen Ahhotep's Theban tomb opened in 1859, was probably a military decoration awarded by the king. The three armlets *below* were found in Meroe (in modern day Sudan) in the pyramid of Queen Amanishakheto. They are made of gold with glass inlays, and date to the first century B.C. Today, these bracelets are divided between the museums of Berlin and Munich.

PL. II.92 COSMETIC BOXES & UTENSILS WITH HUMAN FORMS

Decorative spoons of this kind became popular in the New Kingdom; they were probably used for cosmetic purposes, or possibly religious ceremonies. Female musicians and servants, and a Nubian slave are the principal figures in this plate. Three spoons are made in the form of an ankh, the hieroglyph for life. All examples, except *above left*, were found in Thebes and are now in the Louvre. [The original plate portrayed these objects actual size; here, however, they are reduced. -Ed.]

PL II.93 COSMETIC BOXES & UTENSILS WITH VEGETAL FORMS

The cosmetic utensils, introduced in the previous plate with decorative human figures, were made with floral decorations, as well. Two examples are shaped in the form of a cartouche—the symbol that encircled a royal

name—and two in the form of an ankh. The handle of the spoon, *above left*, is in the shape of a duck, recalling the bowl shown in Pl. II.80. The large utensil, in the form of a bouquet, measures 29.5 centimeters; the largest lotus is the bowl of the container, with its lid intact. This container was found in Saqqara and is now in the Brooklyn Museum. Its condition has deteriorated since this drawing was made. [The original plate portrayed these objects actual size; here, however, they are reduced. -Ed.]

PL. II.94 SPOONS OF PAINTED WOOD (Utensils for perfume)
The function of these spoons, generally called "cosmetic spoons," remains uncertain. The reclining women, usually Egyptian or Nubian, are almost nude with an elaborate hairstyle. The container sometimes has the shape of a duck, as did the container *above* before it was damaged. The woman *below* holds a pond between her hands, also a frequent theme. Spoons of this type were used from the early New Kingdom to the Christian period. Examples exist in wood, ivory, glass and stone.

PL. II.95 VASES IN ENAMELED OR INLAID GOLD (Thebes——20th Dynasty)
The two vases *above* show African and Asiatic captives as decorative elements. *Below*, the decorative elements used are ibexes, birds, and a royal sphinx. The vases are part of the tribute brought by Nubians. All four vases are copied from the tomb of Nebamun and Imiseba.

PL. II.96 VASES IN ENAMELED GOLD (l9th & 20th Dynasties)
The six vases are elaborately decorated with ibexes, horses, foreigners, and the head of the god Bes. The two vases in the *corners above* are copied from a Theban tomb from the time of Ramesses III. The remainder are from the tomb of Nebamun and Imiseba.

PL. II.97 OFFERINGS OF SETI I AND RAMESSES II (Thebes—l9th Dynasty)
These vases are part of treasures presented by the king to the temple of Amun after a successful campaign abroad. The vase *above left* and the two vases *center left*, are gifts of Ramesses II to Amun; the others were presented by Seti I. The objects are adorned with foreigners, dogs, and sphinxes. All the vases were carved in relief on the outer walls of the Hypostyle Hall in the Great Temple of Karnak. Prisse reversed the rhyton *upper left* for the composition of the plate.

CROSS-REFERENCE *with* PORTER & MOSS

The following is a list cross-referencing the objects and monuments in the plates with the corresponding entry in *Topographical Bibliography of Ancient Egyptian Hieroglyphic Texts, Reliefs and Paintings*, 7 Vols. (Porter & Moss), by B. Porter, R.L. Moss, assisted by E.W. Burney, Oxford 1927-51. Any cross-references to The Theban Necropolis Vol I, Theban Temples Vol II, and Memphis Vol III, can be found in the second edition of those volumes, Oxford 1960-81, since 1971 ed. by J. Malek.

When a reference cited in Porter & Moss does not mention Prisse d'Avennes, it is indicated in bold type. When the plate depicts a Theban tomb the number of the tomb is added as (TT#).

ATLAS	PORTER & MOSS
Plate	*Vol: Page*

ARCHITECTURE

I.2	VI: 205
I.3	III.1: 13
I.4	**VII: 241-3**
I.5	III.1: 183, 203
I.6	I.2: 551; III.1: 34
I.7	III.2: 461, 494, 551
I.8	I.2: 505, 535, 756
I.9	I.1: 50 (TT 33)
I.10	VII: 28, 31
I.11	V: 227
I.12	1.1: 191 (TT 93); VII: 166
I.14	II: 91
I.15	IV: 135
I.16	II: 186
I.17	IV: 139; VII: 148
I.18	I.1: 172; 116 (TT 57), 221 (TT 106); IV: 213
I.19	I.1: 130 (TT 65),154 (TT 78)
I.20	I.1: 190, 191 (TT 93); IV, 135, 180
I.21	II: 121
I.22	II: 330
I.23	**II: 439**
I.24	**VI: 128,229**
I.25	VI: 229
I.27	VI : 208
I.30	I.1: 96 (TT 50)
I.31	I.1: **51** (TT 33),96 (TT 50), **131-2** (TT 65),284 (TT 178)
I.32	**I.1: 99** (TT 50), **131-2** (TT 65); **I.2: 518; II: 485**
I.33	I.1: 96 (TT 50), 132 (TT 65)
I.34	**I.1: 50-55** (TT 33); III..2: 590
I.35	I.1: 131 (TT 65); III.2: 590; VI: 217;VI: 231
I.36	II: 401-4
I.37	II: 402
I.38	IV: 192
I.39	IV: 216, 229
I.40	IV: 216
I.41	IV: 216, **229** (TT 10)
I.42	VII: 21-25
I.43	II: 51
I.44	II: **496**
I.45	II: 486, 487
I.46	I.1: 43 (TT 27), **302** (TT 197)
I.47	VI: 206, 207
I.48	**VII: 53**
I.49	II: 407, 409, 410
I.50	III:.1 10
I.51	VII: 40, 41
I.52	II: 231; V: 183
I.53	VI: 105
I.54	**I.1:.1:95** (TT 50), **131** (TT 65)
I.55	VI:221, 255
I.56	**I.1: 152-56** (TT 78); II: 9; **IV: 180-81**
I.57	V: 151; VI: 115
I.58	VI: 205
I.59	VI: 208
I.60	VI: 208, 210
I.61	VI: 208
I.62	II: 303

DESSIN

II.1	I.1: 188 (TT 92); III..2: 495; IV: 180; V: 182
II.2	I.1: 324 (TT 223); H: 528; VI: 254
II.4	I.1: 110 (TT 55)
II.5	I..2: 539
II.6	I.1: 263 (Tr 155)
II.7	I.1: 195 (1T 95), 244 (Tr 129)

SCULPTURE

II.10	III.2: 476
II.11	III.2: 474
II.12	IV: 134
II.13	II: 106, 346
II.14	I.1: 114, 115, 116 (TT 57)
II.15	I.1: 91 (TT 49)
II.16	IV: 213
II.17	II: 438
II.18	I.1: 116 (TT 57)
II.19	I.1: 116 (TT 57
II.20	I.1: 116 (TT 57)
II.21	I.1: 115 (TT 57)
II.22	IV: 216
II.23	I.1: 116 (TT 57); **II: 244**
II.24	I.1: 103 (TT 53)
II.25	II: 224
II.26	II: **22**, 454
II.27	IV: 211
II.28	I.1: 222 (TT 106)
II.29	I.1: 55 (TT 33), 213 (TT 100); IV: 181
II.30	II: 14
II.31	III.2: 828
II.32	III.2: 462
II.33	III.2: 848
II.34	II: 21
II.35	I.1: 115, 116 TT 57); II: 57, 222; V: 167; VI: 184
II.36	I.2: 829
II.37	VII: 111
II.38	I.2: 529; II: **209**
II.39	II: 433
II.40	II: 434
II.41	II:56
II.42	VII: 27
II.43	III.2: 836II.32

PEINTURE

II.46	III.2: 472
II.47	IV: 146
II.48	IV: 146,147
II.49	IV: 147
II.50	II: 345
II.51	I.1: 409 (TT 342)
II.52	I.2: 757
II.53	I.1: 192 (TT 93)
II.54	I.1: 76 (TT 40)
II.55	I.1: 211 (TT 100)
II.56	I.1: 211 (TT 100)
II.57	I.1: 212 (TT 100)
II.58	I.1: 210 (TT 100)
II.59	I.1: 211 (TT 10)
II.60	I.1: 192 (TT 93)
II.61	I.2: 622
II.62	I..2: 521
II.63	I.2: 546
II.65	I.2: 507
II.66	I.2: 761
II.69	I.2: 519
II.70	I.2: 521

ART INDUSTRIEL

II.72	III.2: 472, 494
II.73	II: 98; V: 160
II.74	I.1: 207 (TT 100); II:98
II.75	I.1: 207 (TT 100)
II.76	I.1: 140 (TT 71),207 (TT 100)
II.77	I.1: 187 (TT 91)
II.78	I.1: 191 (TT 93), 197 (TT 95)
II.79	I.1: 77 (TT 40), 150 (TT 76), 209 (TT 100)
II.80	I.1: 191 (TT 93)
II.82	I.1: 147 (TT 75),188 (TT 92)
II.83	I.1: 207 (TT 100); II: 505
II.84	I.2: 521,522
II.85	I.1: 129 (TT 65)
II.86	I.1: 129 (TT 65)
II.87	I.2: 522
II.88	PM I.1: 131 (TT 65
II.89	**I.1: 109** (TT 55), **154** (TT 78)
II.91	**I.2: 600; III.2: 782-3; VII: 245**
II.95	I.1: 129 (TT 65)
II.96	I.1: 129 (TT 65)
II.97	II: 55, 56, 57, 59

THE PLATES

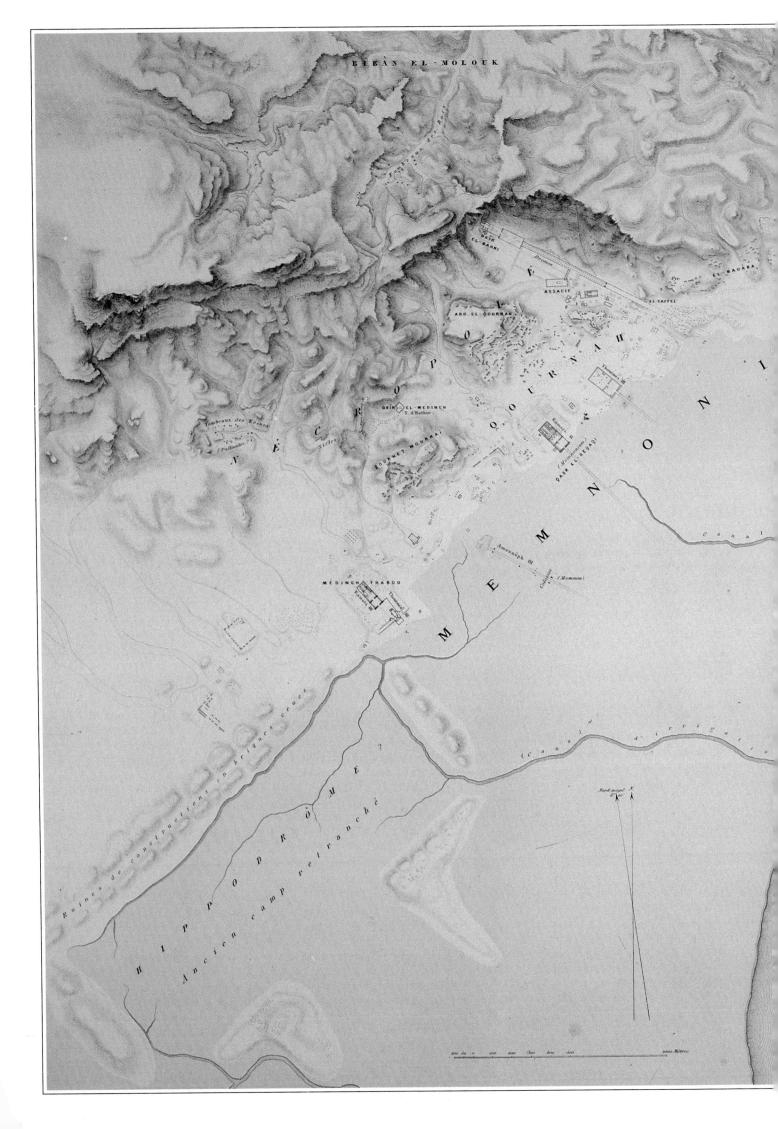

BIBÂN EL-MOLOUK

DEIR EL-BAHRI

ASSACIF

EL-BAUABA

ABD. EL-QOURNAH

EL-TAFFEL

Thoutmos. III

DEIR EL-MEDINEH
T. d'Hathor

Tombeaux des Reines

(Pallades)

Stèles

GOURNET MOURRAI

Raméss. II

QASR EL-DEQAQI
(Memnonium)

Amounoph. III

Colosses (Memnon)

Canal

MÉDINEH THABOU

(Canal d'irrigation)

Nord magnét.

Ruines de constructions en briques cruck

Ancien camp retranché

H I P P O D R Ô M E ?

NÉCROPOLE DE QOURNAH

MEMNONIA

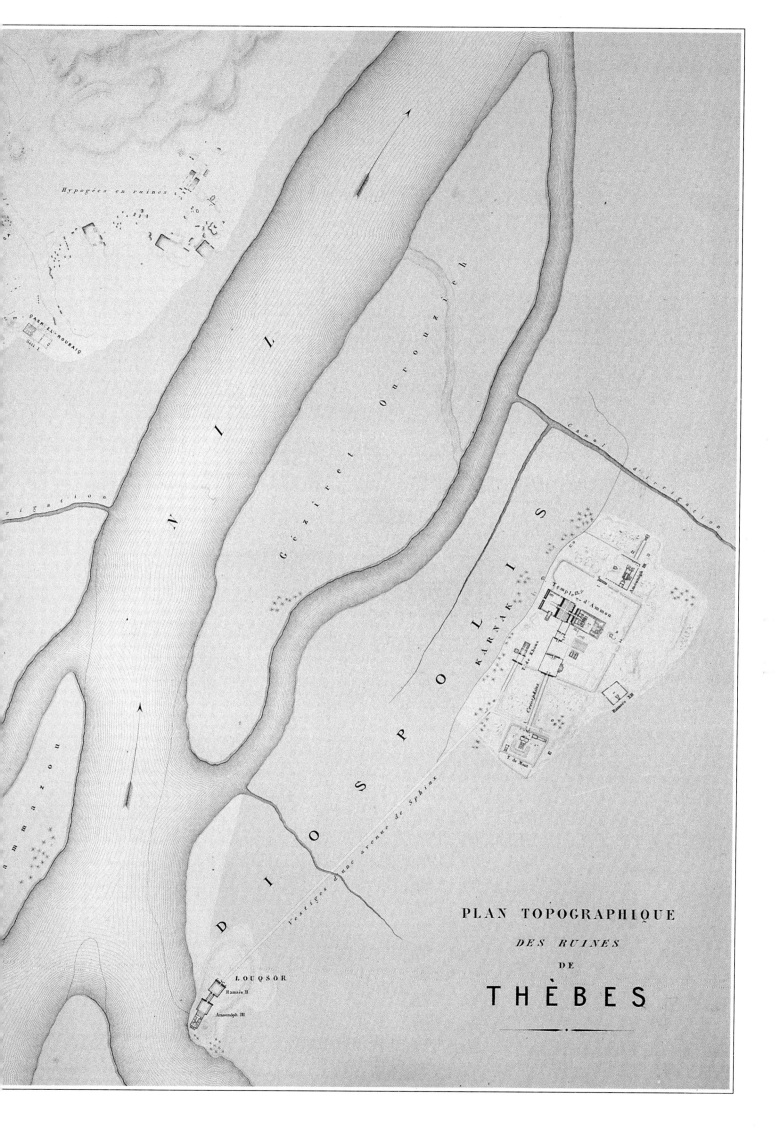

Hypogées en ruines

QASR EL-ROUBAIQ
Séti I

N I L

Gézîret Ourouzïeh

Canal d'irrigation

Canal d'irrigation

D I O S P O L I S

KARNAK

Temple d'Ammon

Amounoph III

T. de Khons

Cheops, donc

T. de Maut

vestiges d'une avenue de Sphinx

LOUQSOR
Ramsès II
Amounoph III

PLAN TOPOGRAPHIQUE

DES RUINES

DE

THÈBES

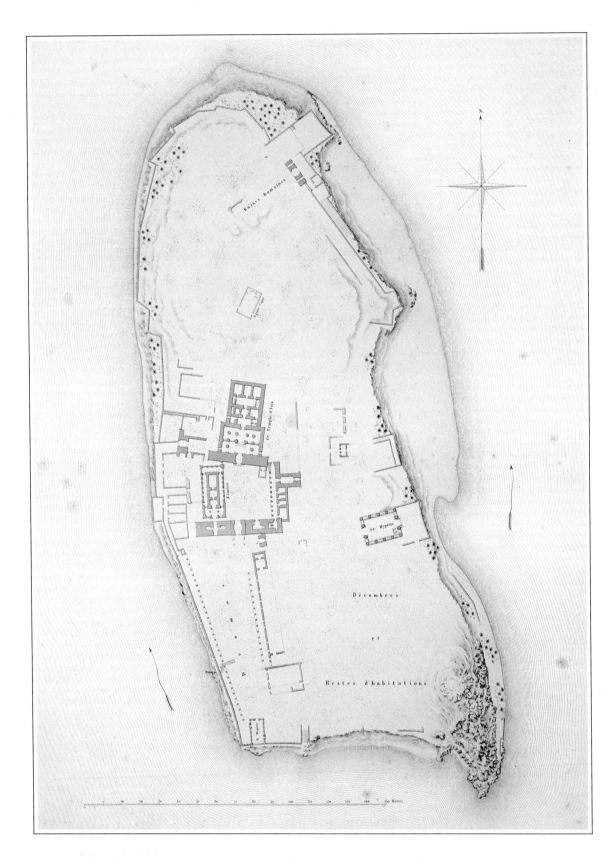

ISLAND OF PHILAE (General map of the ruins)

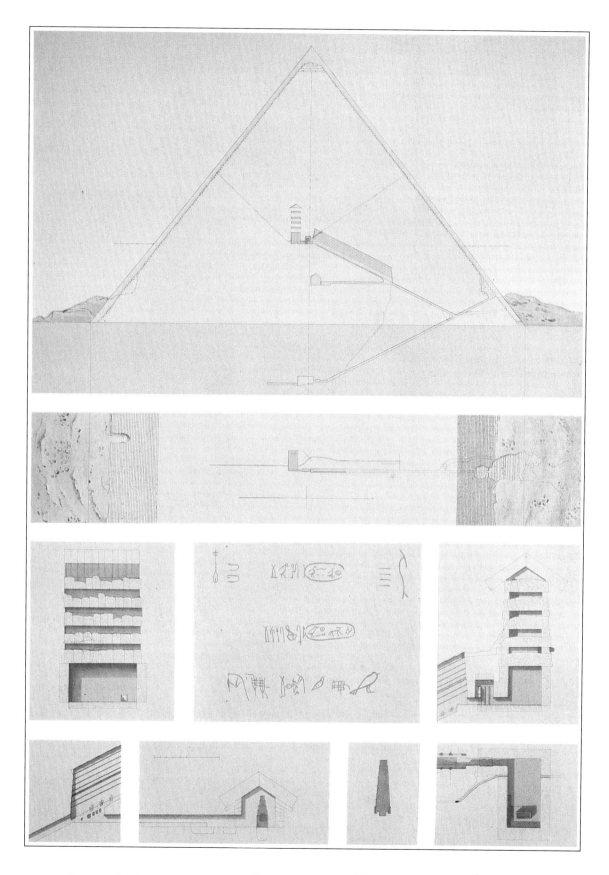

SECTION & DETAILS OF THE GREAT PYRAMID OF GIZA (Cheops or Khufu—4th Dynasty)

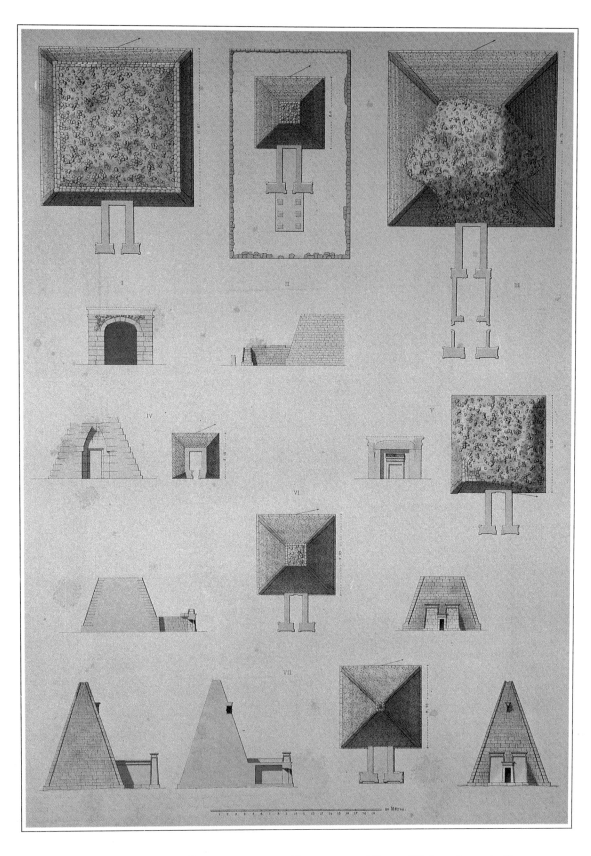

PLANS, SECTIONS & ELEVATIONS OF THE PYRAMIDS OF MEROE (Ptolemaic period)

Architecture PL.I.4

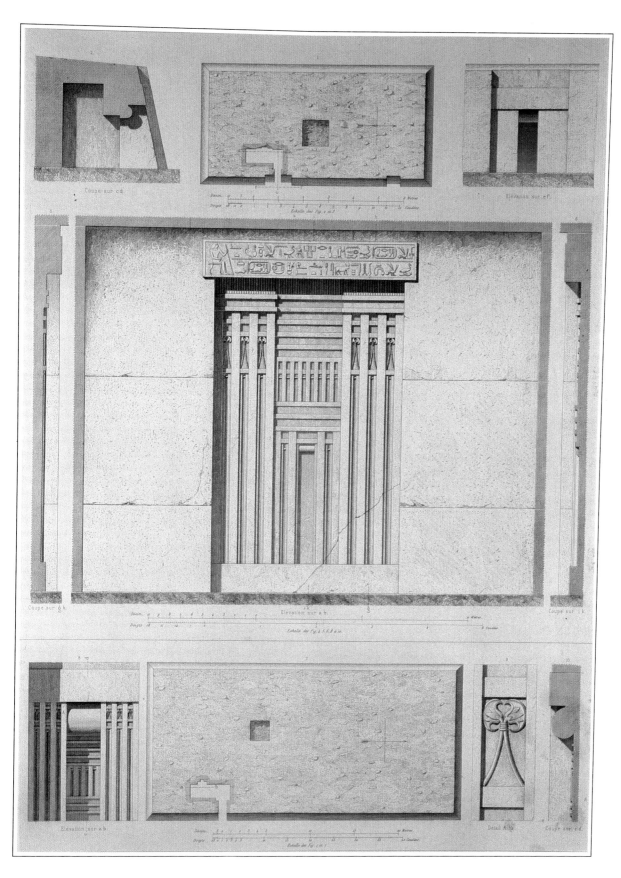

NECROPOLIS OF MEMPHIS (Tombs east of the Great Pyramid—4th Dynasty)

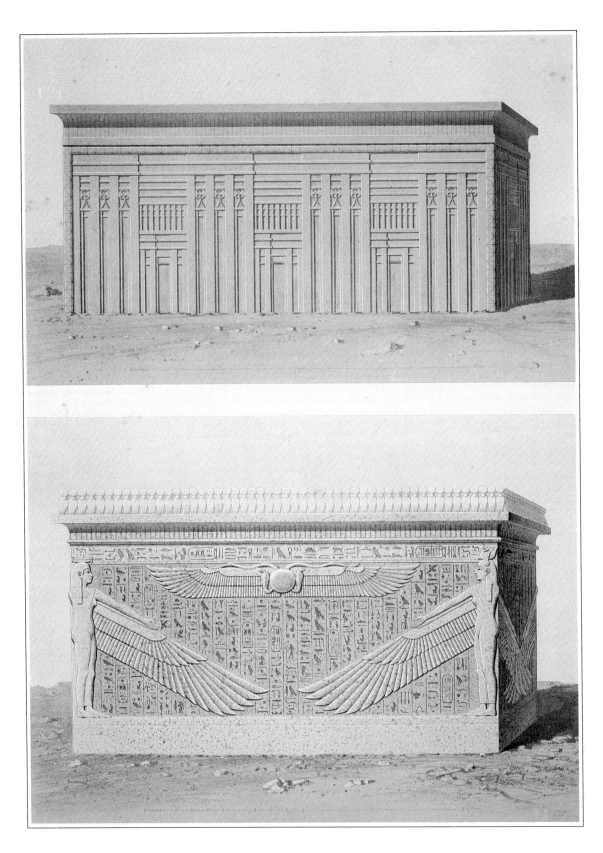

SARCOPHAGI OF MENKAURE' & OF AY (4th & 18th Dynasties)

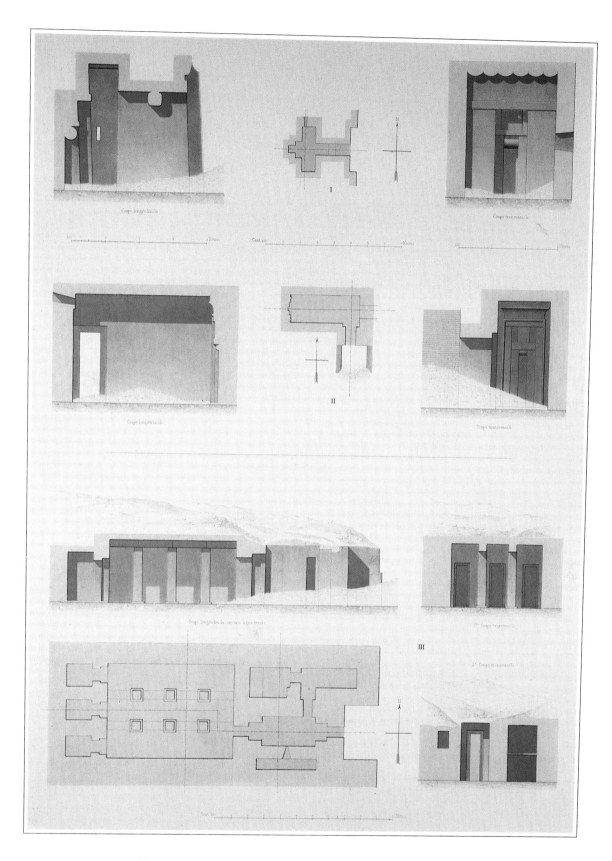

I

II

III

TOMBS OF THE NECROPOLIS OF MEMPHIS (Saqqara cemetery)

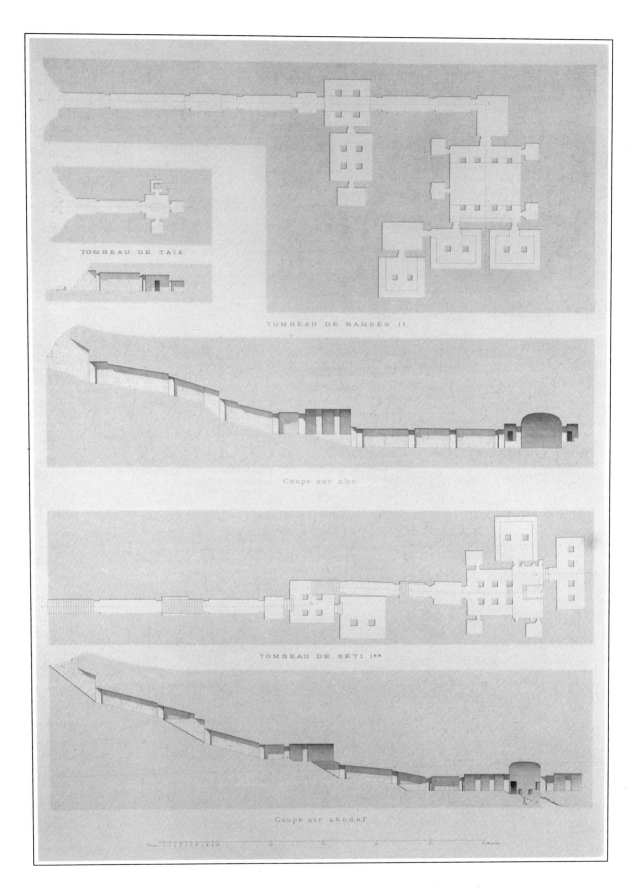

TOMBEAU DE TAIA.

TOMBEAU DE RAMSÈS II.

Coupe sur a.b.c.

TOMBEAU DE SÉTI Iᵉʳ

Coupe sur a.b.c.d.e.f.

NECROPOLIS OF THEBES; BIBAN EL-MOLOUK (Royal tombs—19th & 20th Dynasties)

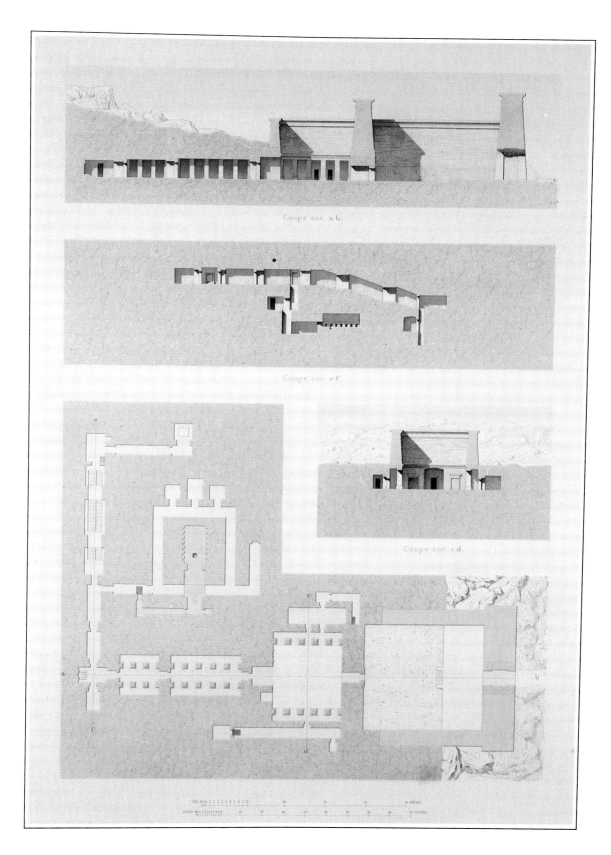

Coupe sur a b.

Coupe sur e f.

Coupe sur c d.

Necropolis of Thebes (Plan & section of the tomb of Grand Priest Petamounoph—26th Dynasty)

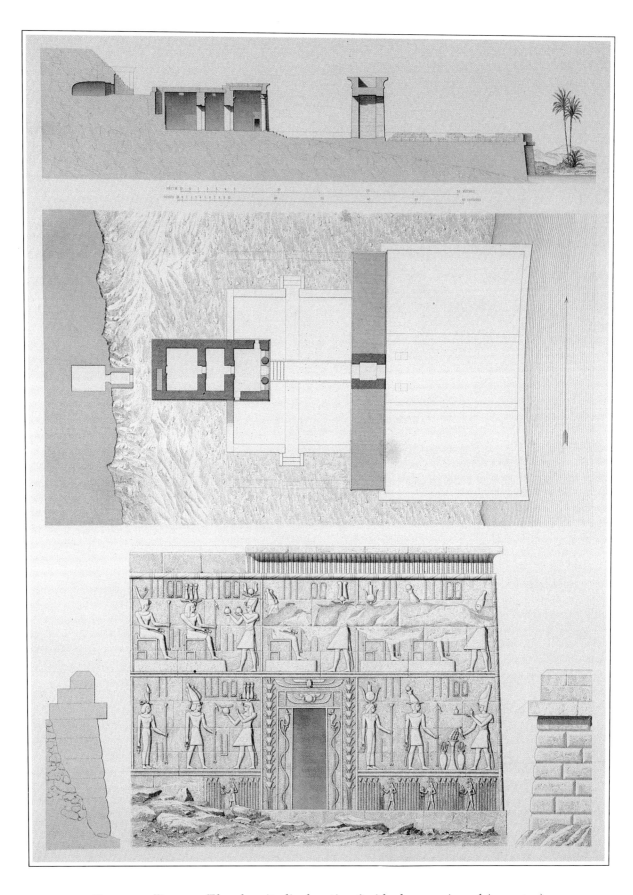

TEMPLE OF DENDUR (Plan, longitudinal section & side door—reign of Augustus)

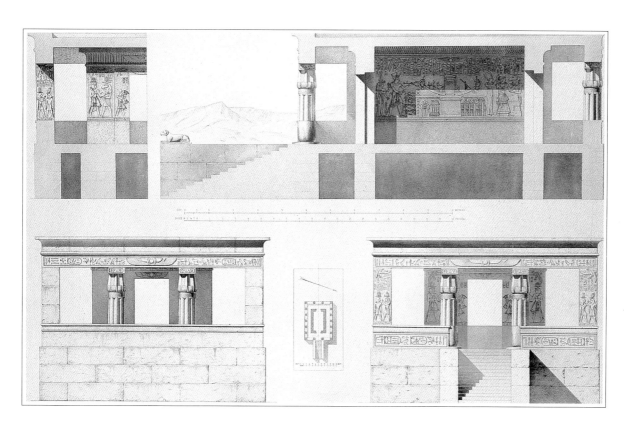

PERIPTERAL TEMPLE OF AMENOPHIS III AT ELEPHANTINE (18th Dynasty)

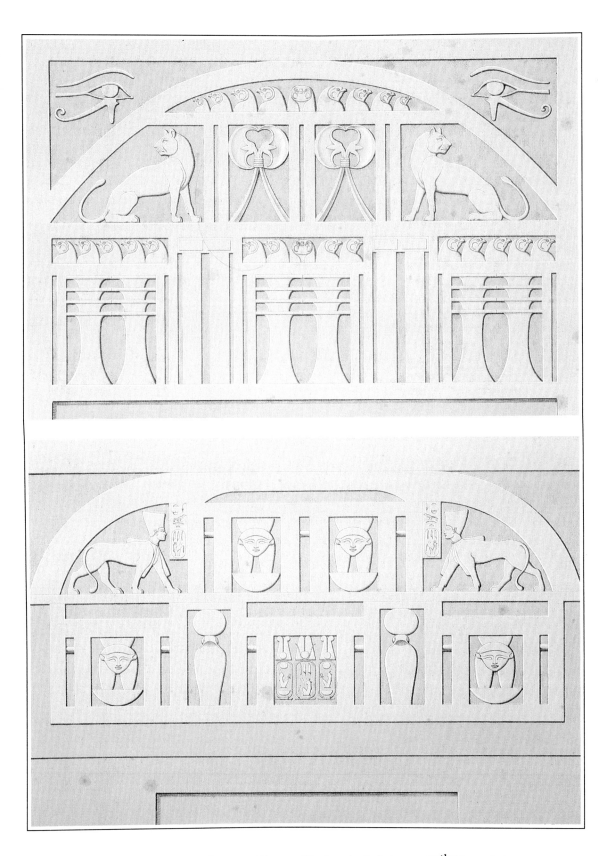

Entablatures of Interior Doors (Thebes & Sedeinga—18th Dynasty)

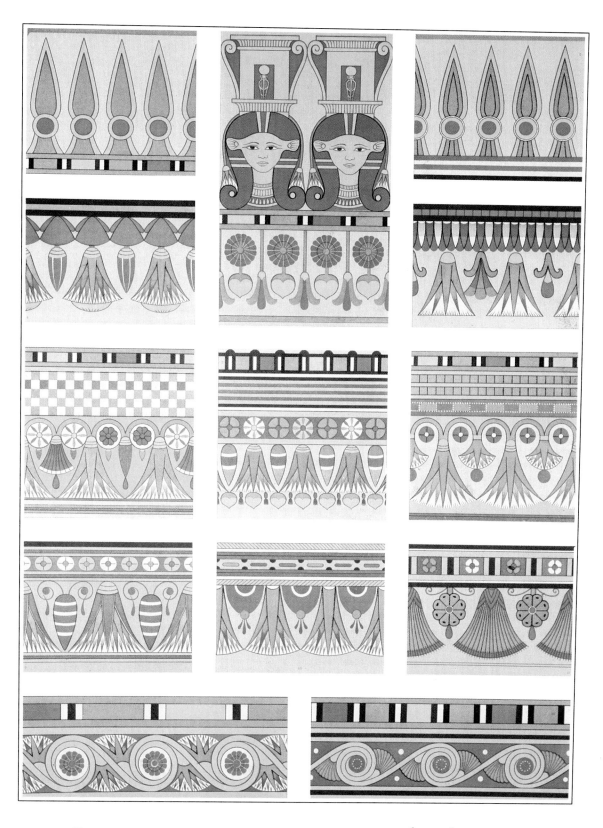

ENTABLATURES & FLORAL FRIEZES (Necropolis of Thebes—18th & 20th Dynasties)

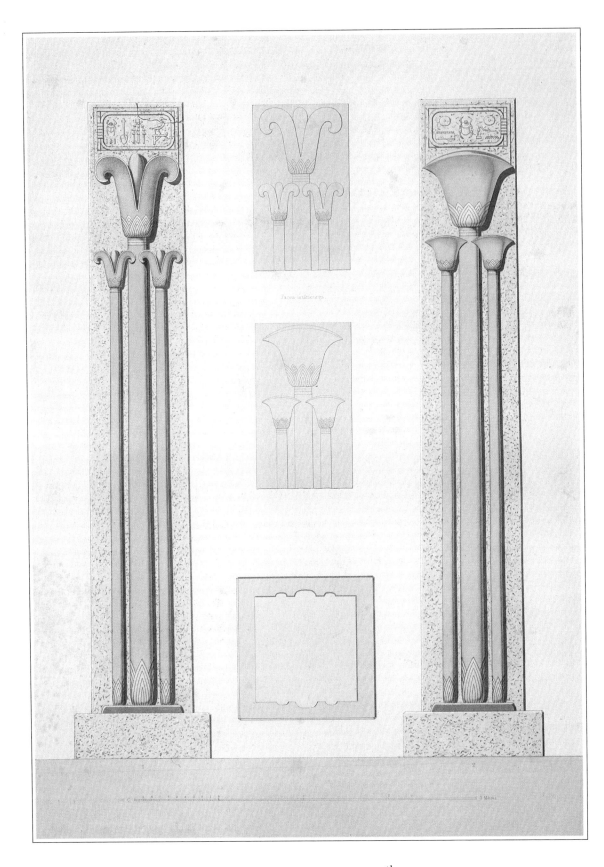

Faces intérieures.

PILLARS OF TUTHMOSIS III AT KARNAK (18th Dynasty)

Architecture PL.I.14

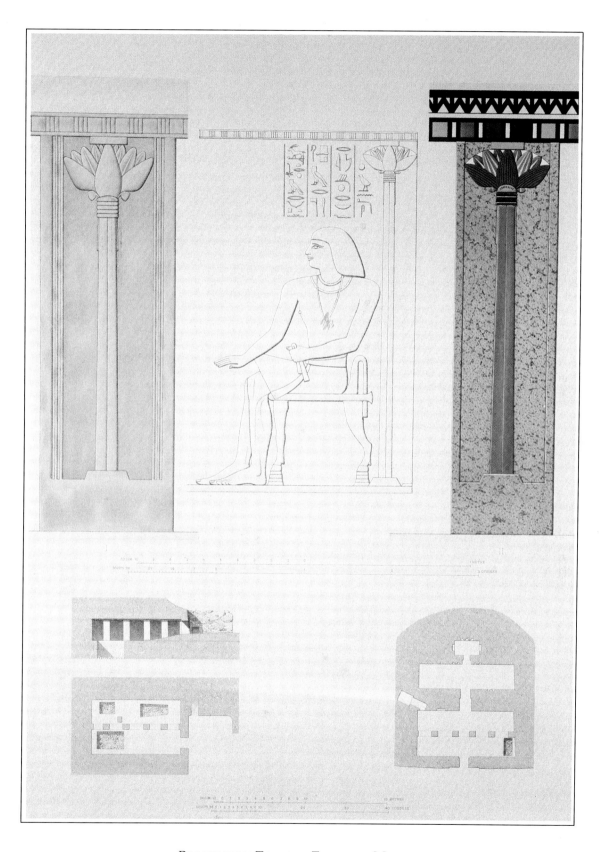

PILLARS FROM TOMBS OF ZAWYET EL-MAYITIN

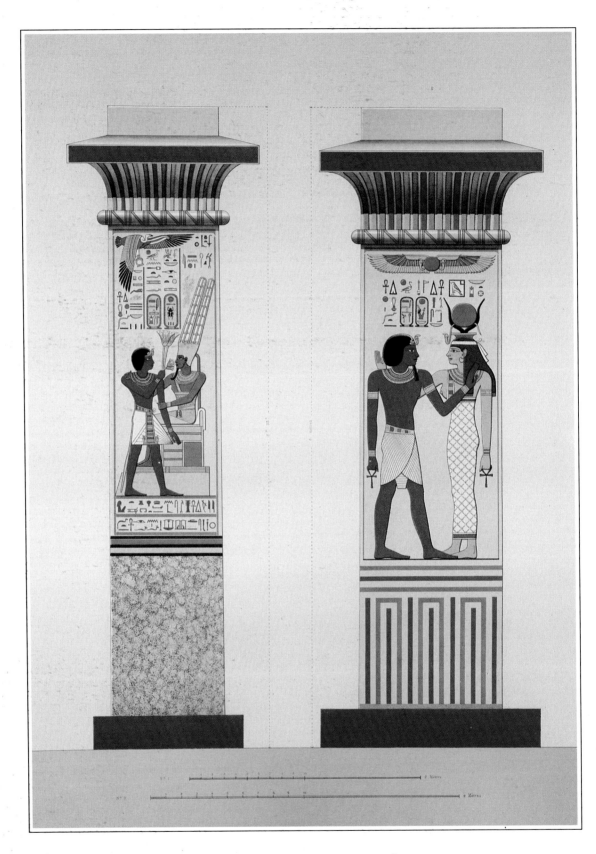

PILLARS OR SQUARE COLUMNS (Thebes—18th Dynasty)

Architecture PL.I.16

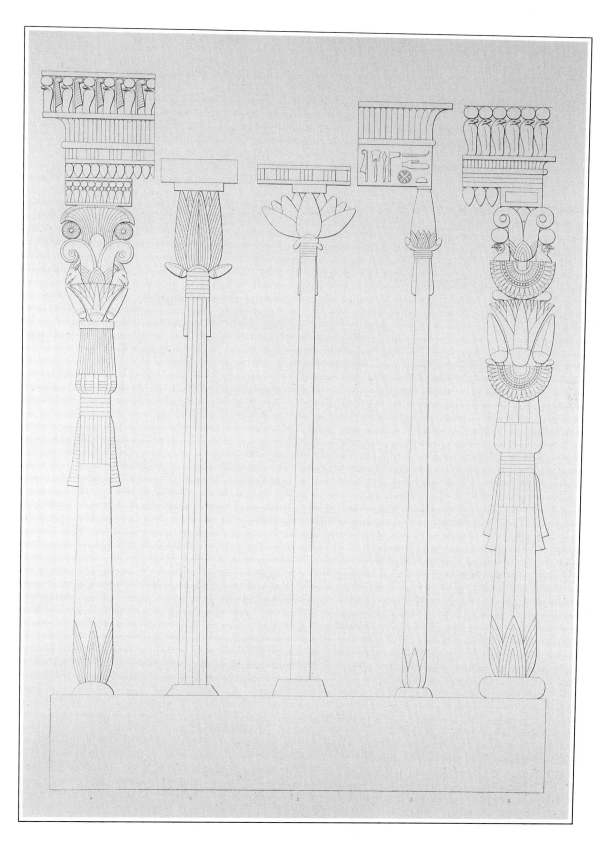

CONSTRUCTION IN WOOD, SMALL COLUMNS FROM KIOSKS (5th & 18th Dynasties)

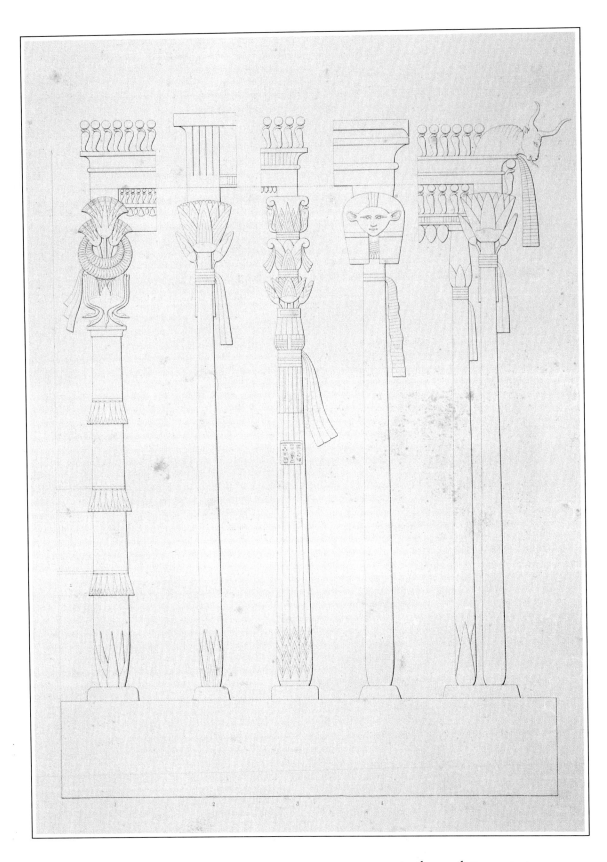

CONSTRUCTION IN WOOD, SMALL COLUMNS FROM KIOSKS (18th & 19th Dynasties)

Architecture PL.I.18

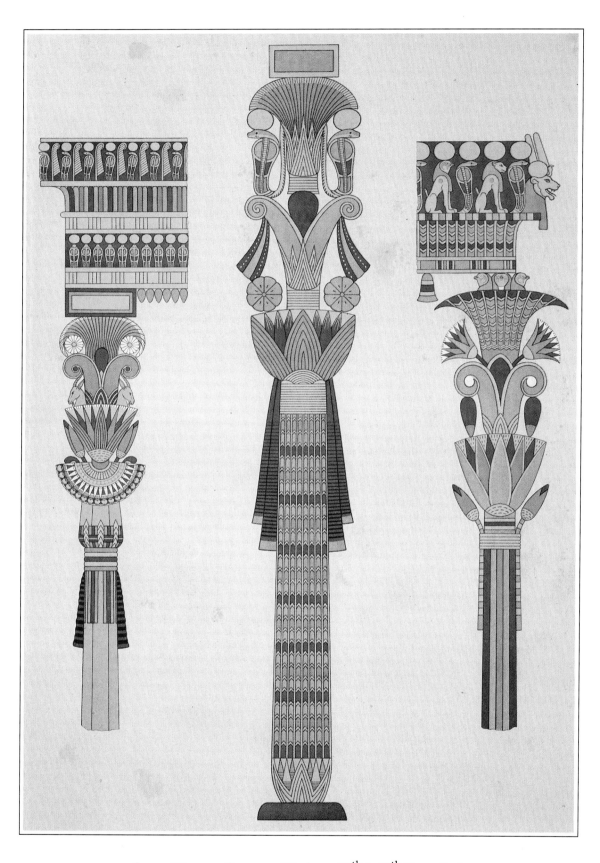

SMALL WOODEN COLUMNS (Thebes—18ᵗʰ & 20ᵗʰ Dynasties)

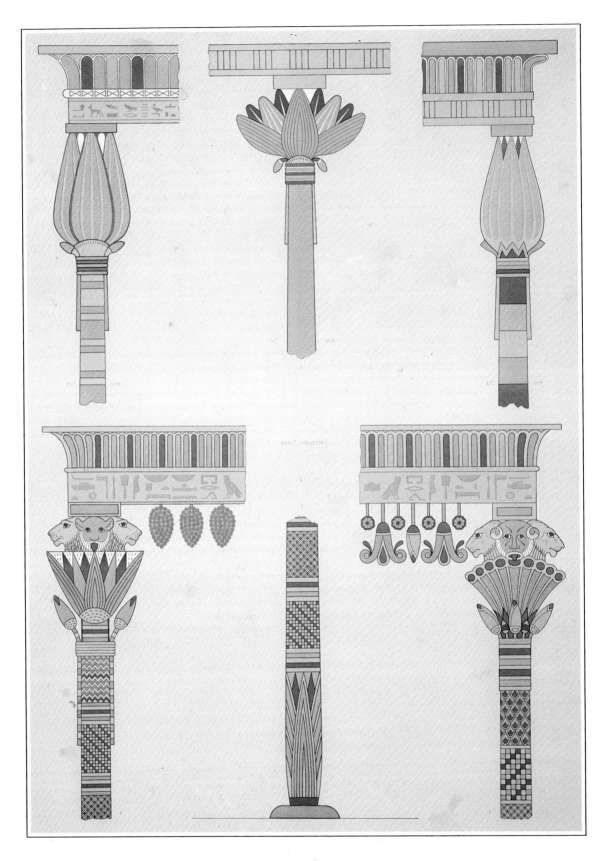

DETAILS OF SMALL WOODEN COLUMNS (From various tombs)

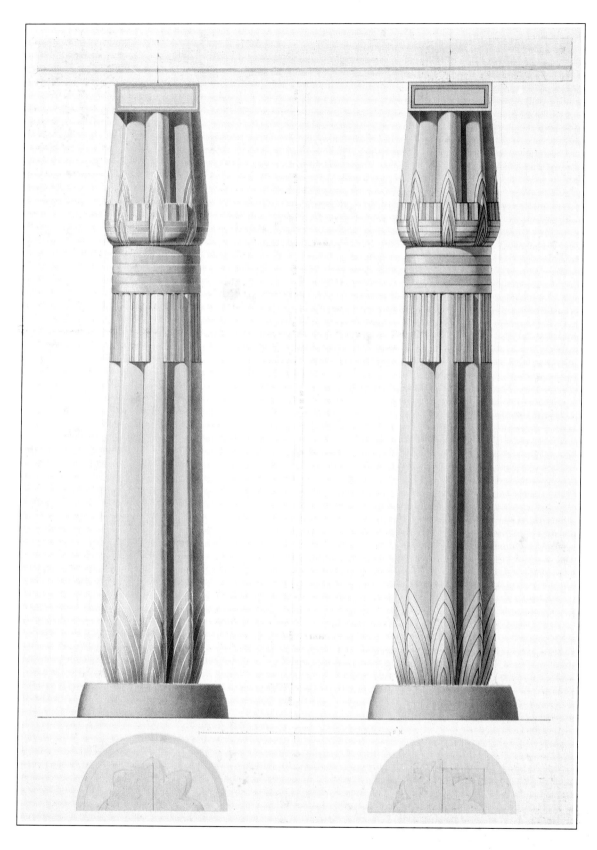

PAPYRIFORM COLUMNS OF TUTHMOSIS III, IN KARNAK (18th Dynasty)

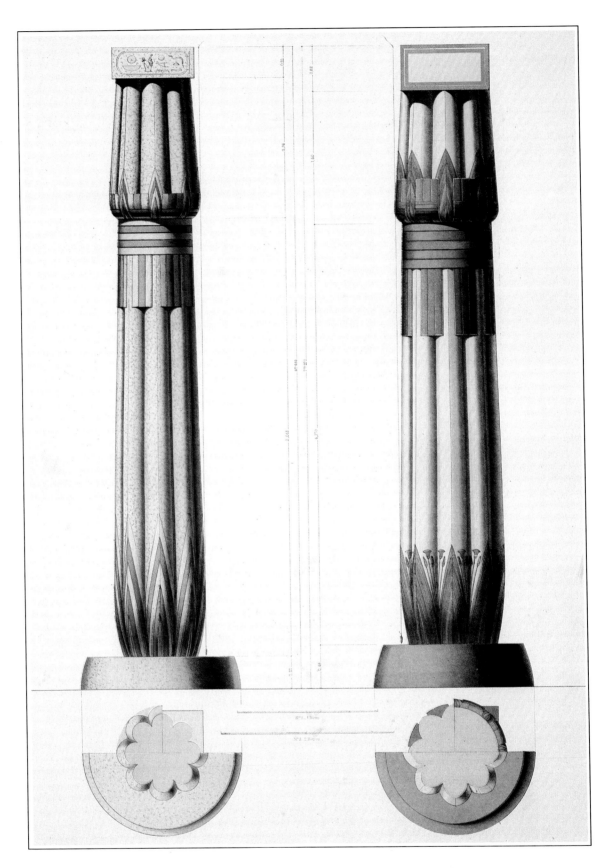

PAPYRIFORM COLUMNS OF AMENOPHIS III, IN THEBES (18th Dynasty)

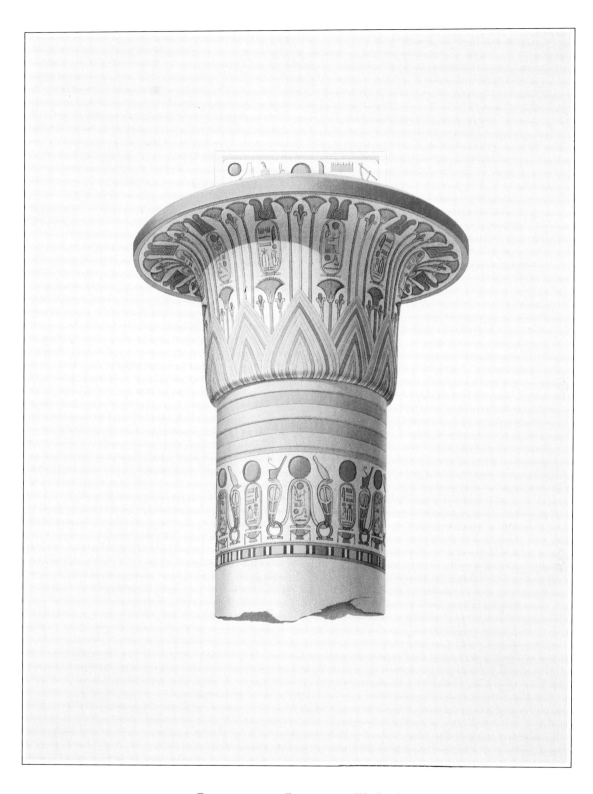

COLUMN OF THE RAMESSEUM (Thebes)

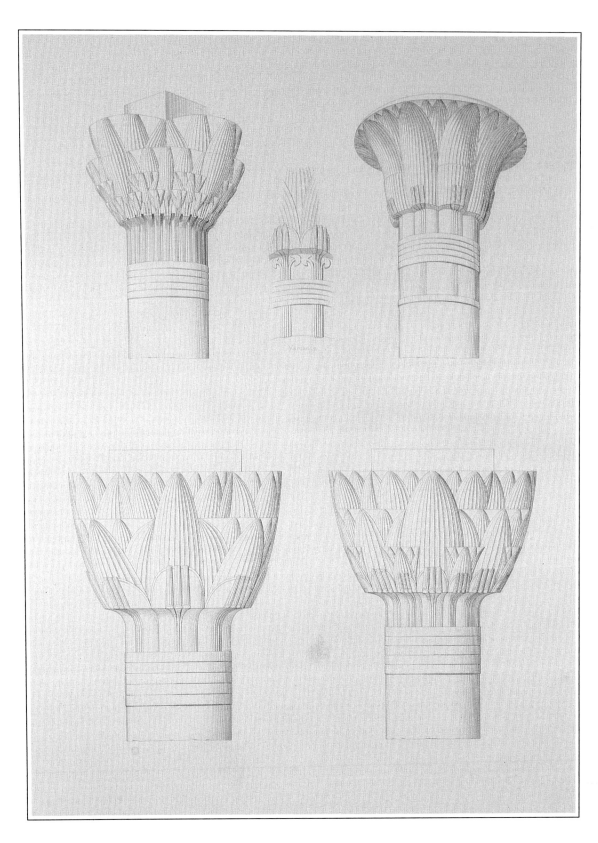

CAPITALS FROM THE TEMPLES OF EDFU AND PHILAE

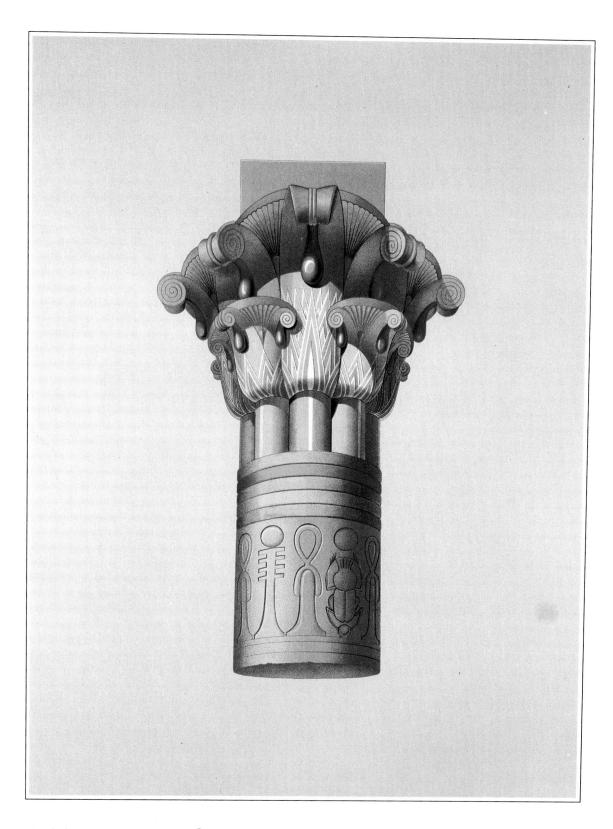

COMPOSITE CAPITALS (Temple of Philae)

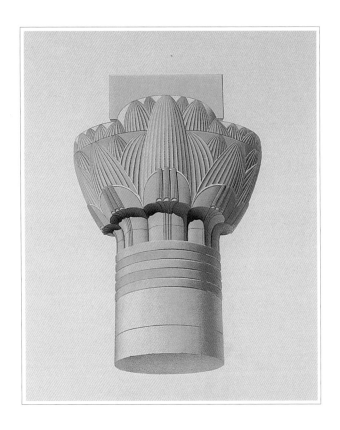

BOWL-SHAPED CAPITAL

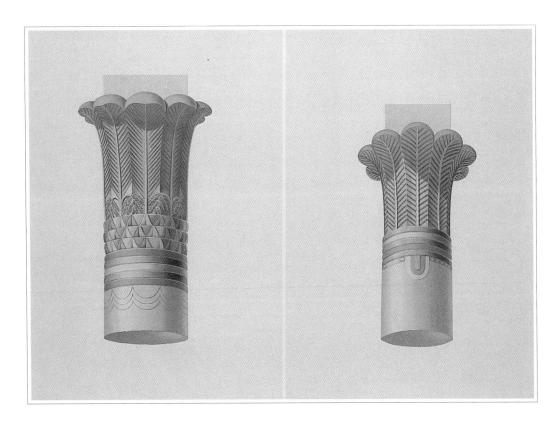

DACTYLIFORM CAPITALS (Philae)

Architecture PLs.I.26 & 27

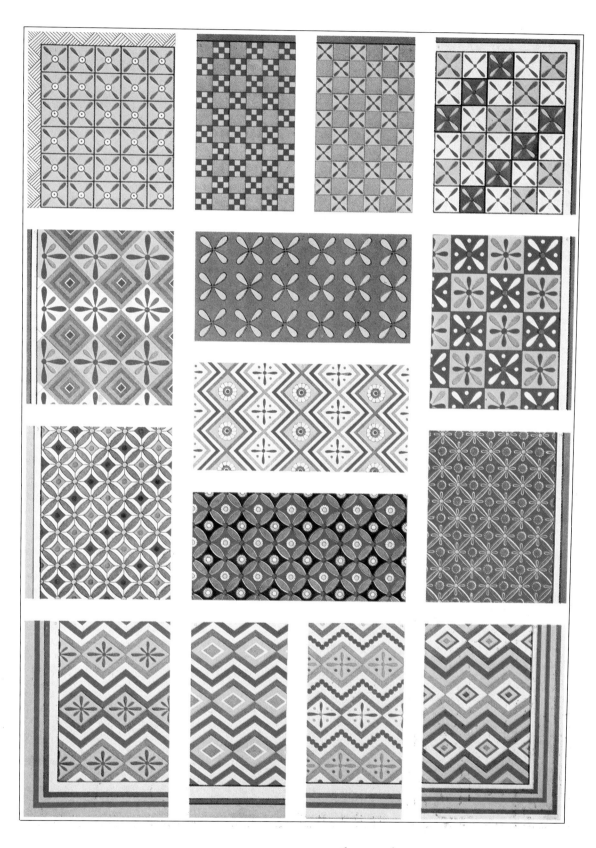

CEILING PATTERNS; SIMPLE DESIGNS (12th to 22nd Dynasties)

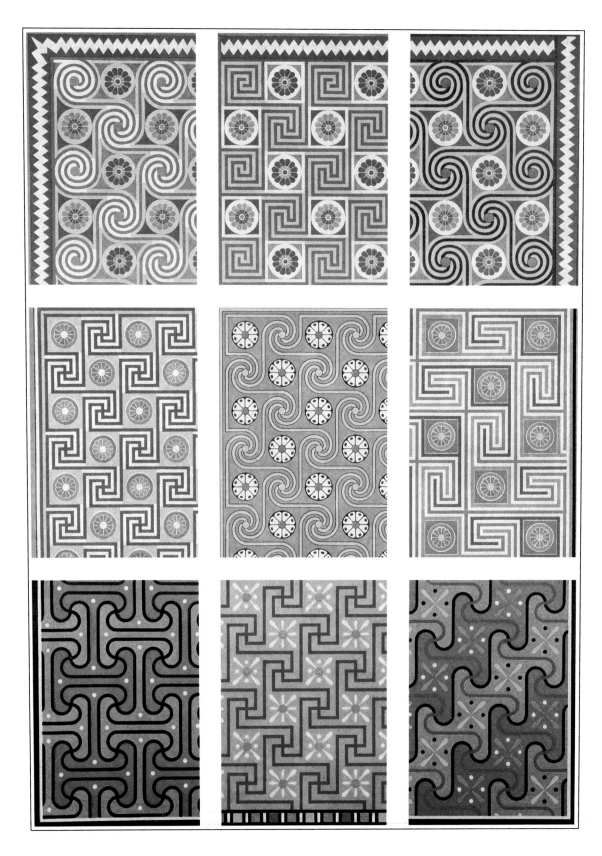

CEILING PATTERNS; SPIRALS AND MEANDERS (Necropolis of Thebes)

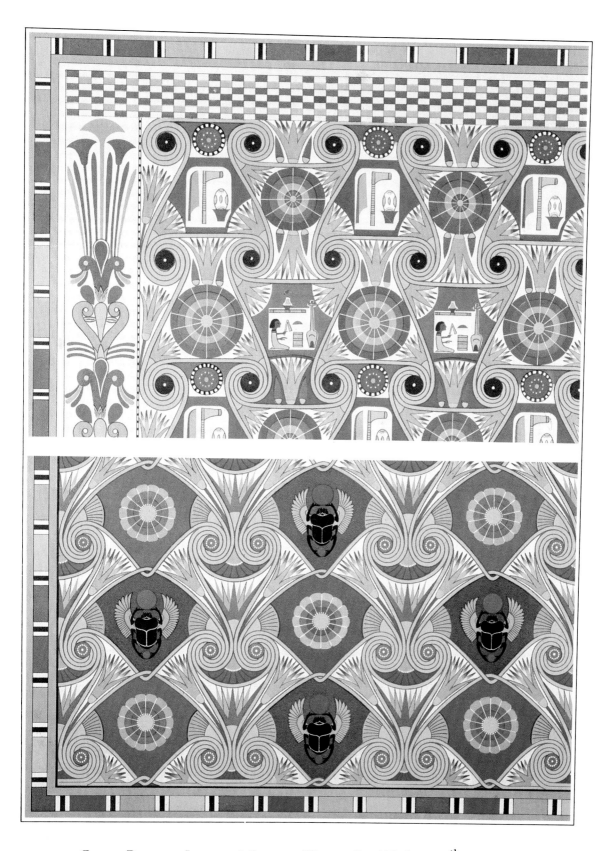

CEILING PATTERNS; LEGENDS & SYMBOLS (Necropolis of Thebes—18th Dynasty)

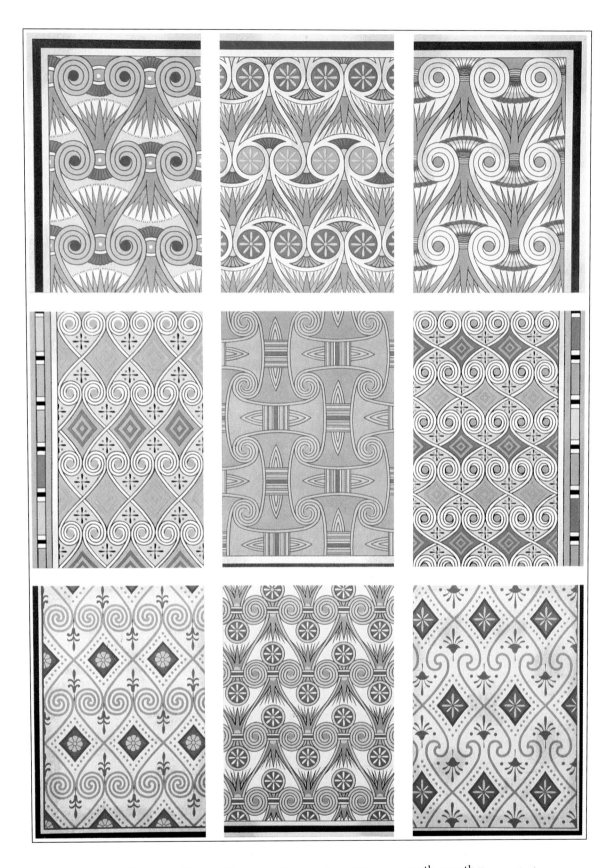

CEILING PATTERNS; FLORAL DESIGNS (Necropolis of Thebes—18th & 19th Dynasties)

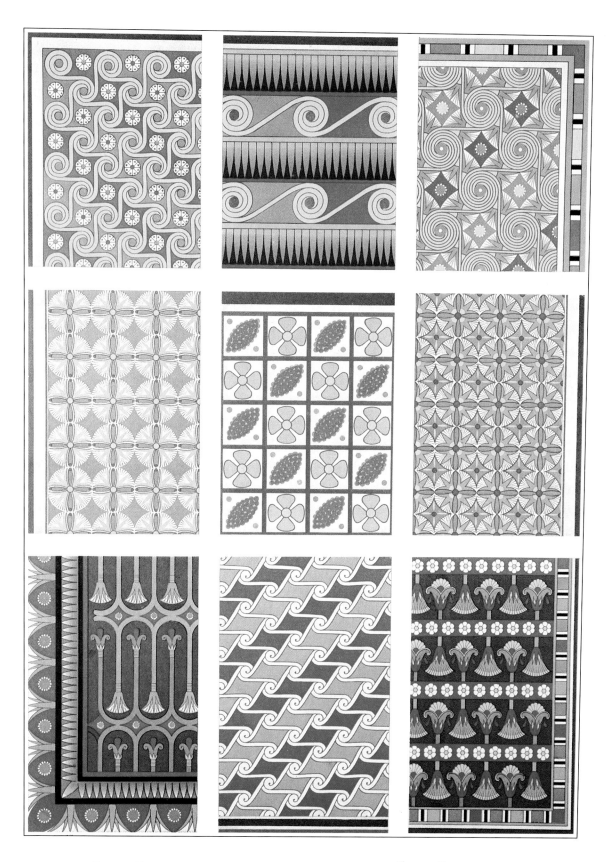

CEILING PATTERNS; FLOWERS (Necropolis of Thebes—18th to 20th Dynasties)

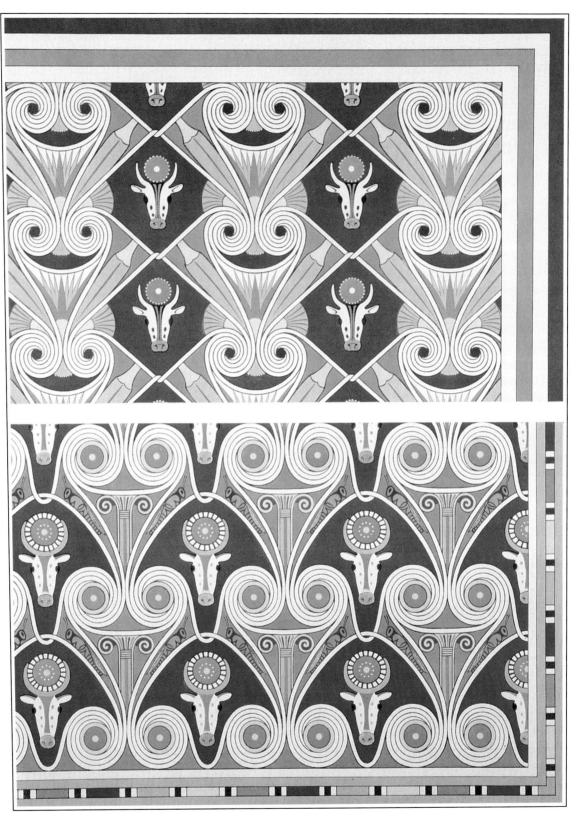

CEILING PATTERNS; BOUKRANIA (Necropolis of Thebes—18th & 20th Dynasties)

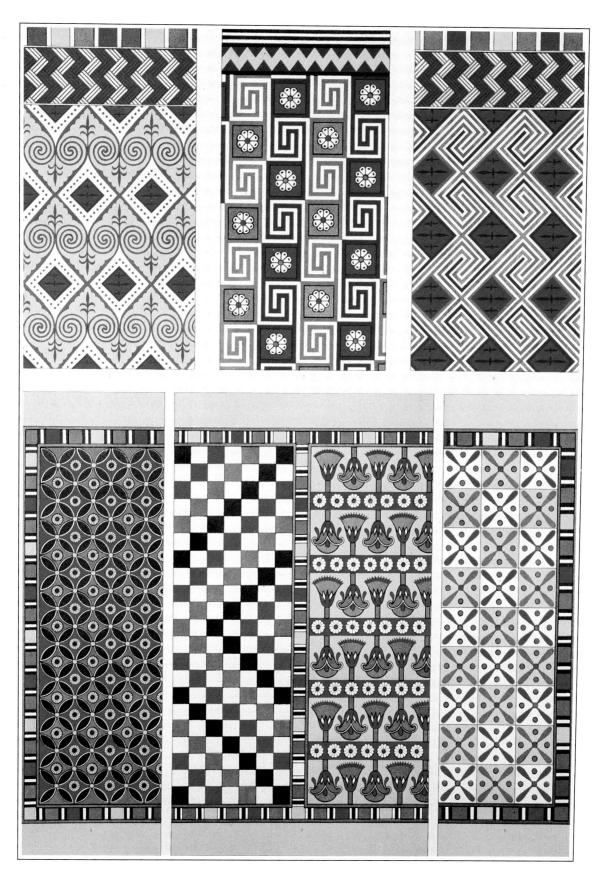

CEILING PATTERNS (Memphis & Thebes—26th Dynasty)

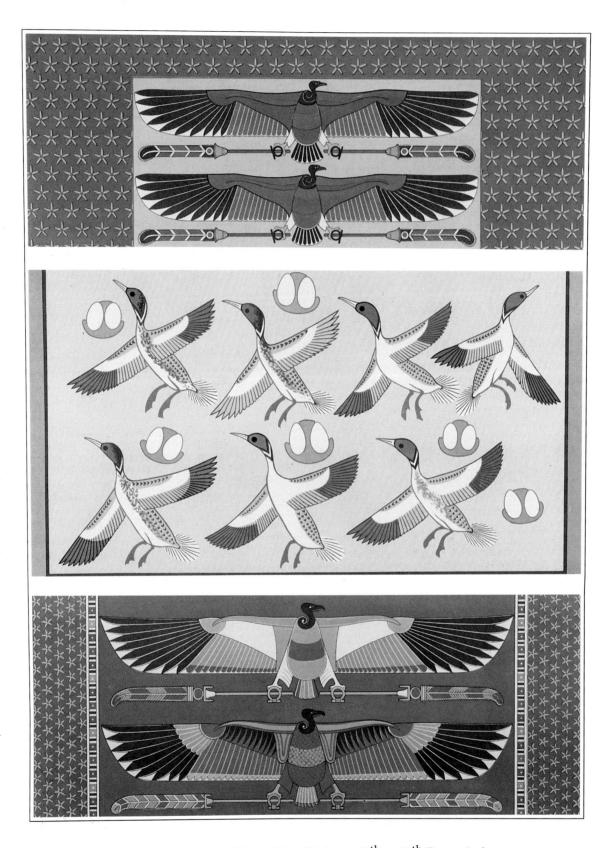

CEILING PATTERNS (Memphis & Thebes—18th to 30th Dynasties)

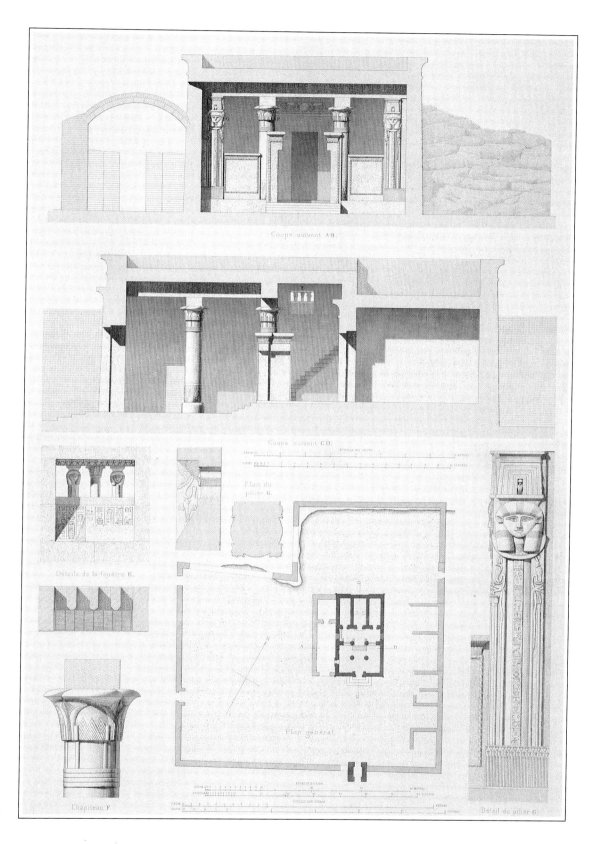

THE TEMPLE OF DEIR EL-MEDINA (Plans, sections & details)

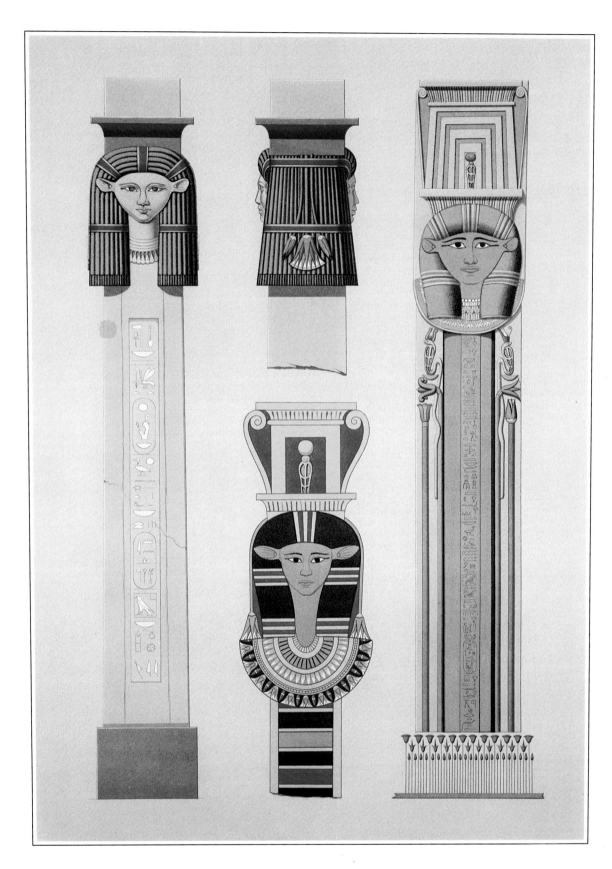

HATHOR COLUMNS

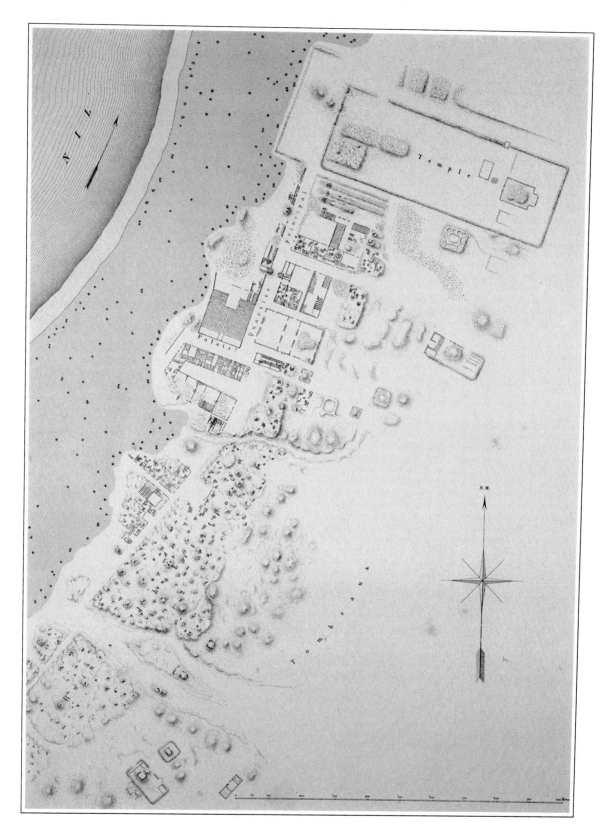

MAP OF THE RUINS OF TELL EL-AMARNA (18th Dynasty)

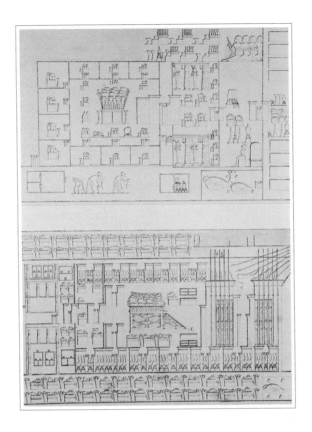

PLANS OF BUILDINGS IN TELL EL-AMARNA (Bas-reliefs from tombs—18th Dynasty)

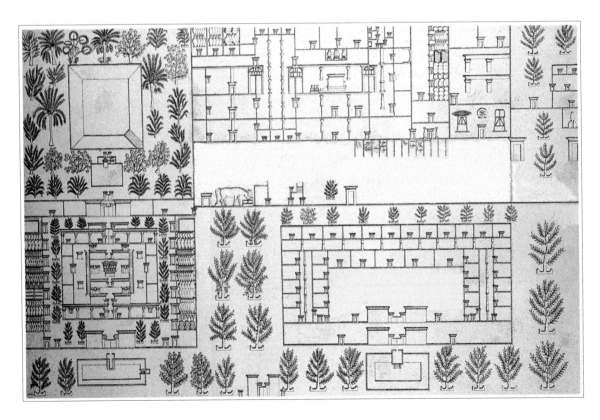

PLAN OF A ROYAL VILLA (Bas-reliefs from a tomb in Tell el-Amarna—18th Dynasty)

Architecture PLs.I.39 & 40

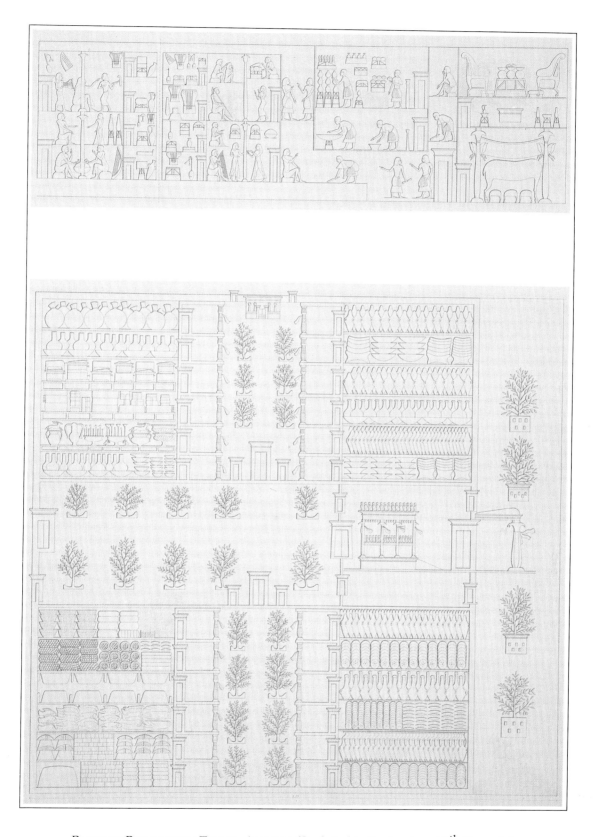

PLANS OF BUILDINGS IN TELL EL-AMARNA (Sculpted in the tombs—18th Dynasty)

Plans of Buildings in Tell el-Amarna (Sculpted in the tombs—18th Dynasty)

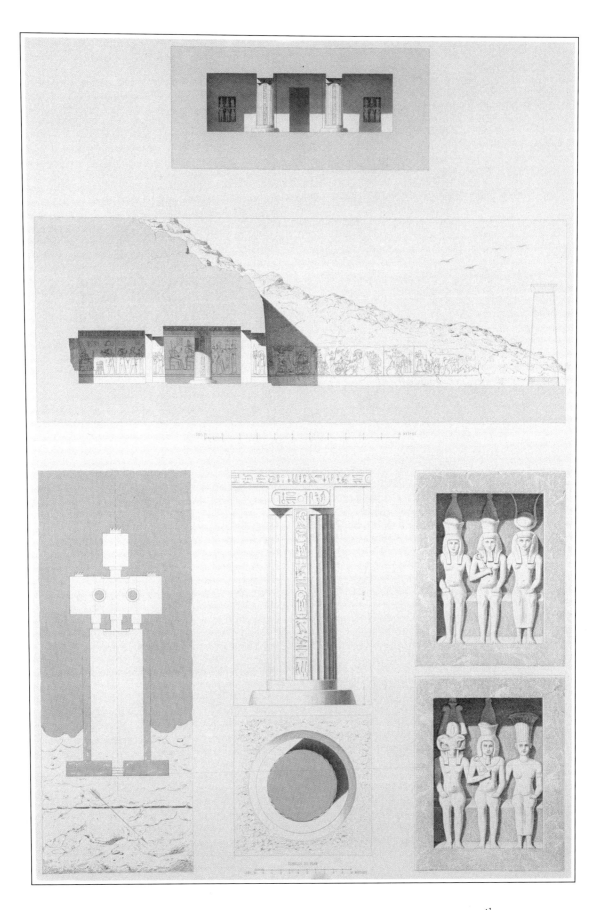

The Rock-cut Temple of Kalabsha (Plan, section & details; Ramesses II—19th Dynasty)

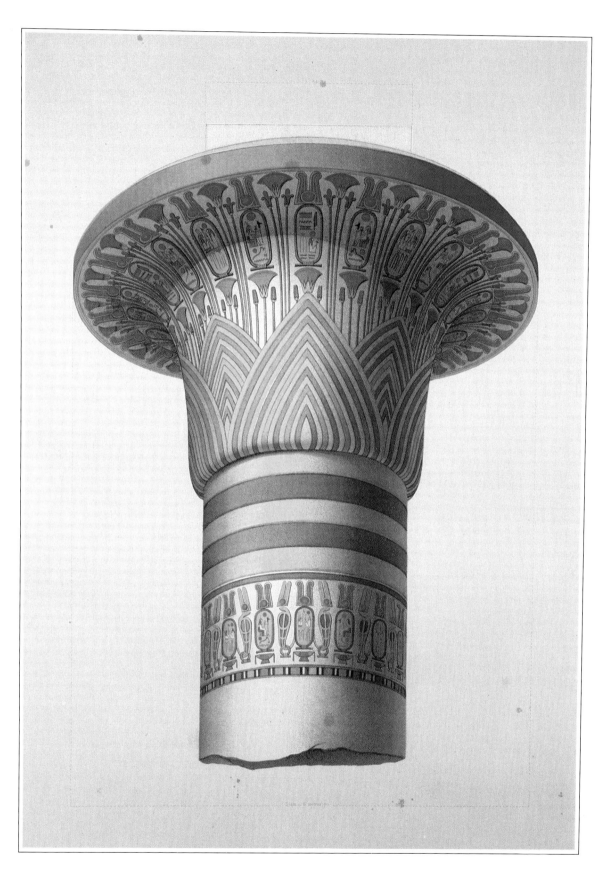

Column of the Hypostyle Hall of Karnak (Thebes—19th Dynasty)

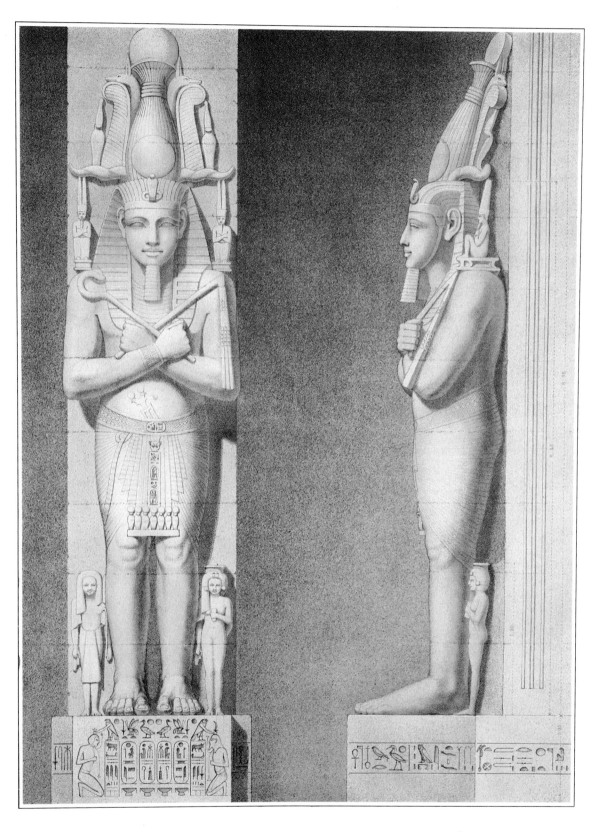

CARYATID PILLARS OF THE TEMPLE OF RAMESSES III (Medinet Habu—20th Dynasty)

INTERIOR DECORATION OF RAMESSES III'S HAREM (Medinet Habu—20th Dynasty)

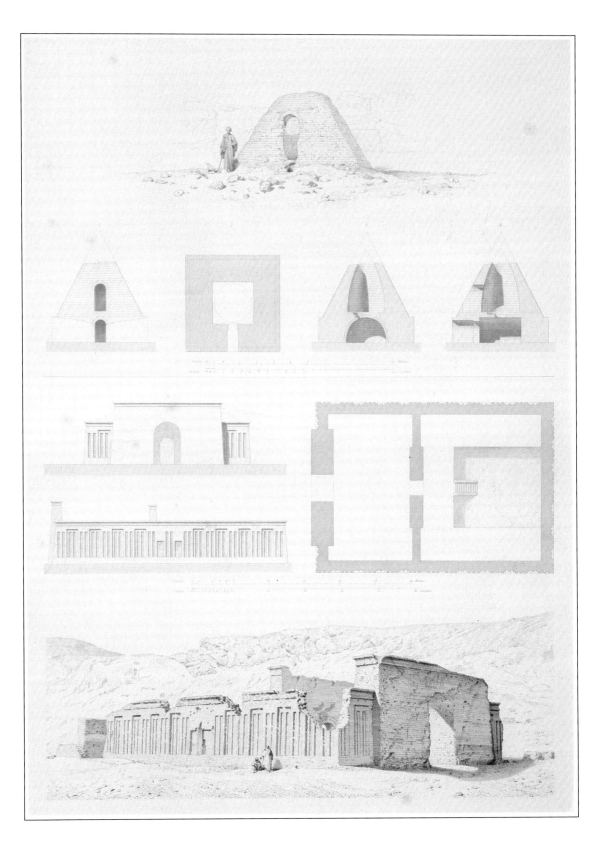

NECROPOLIS OF THEBES (Tombs from the valley of el-Asasif —26th Dynasty)

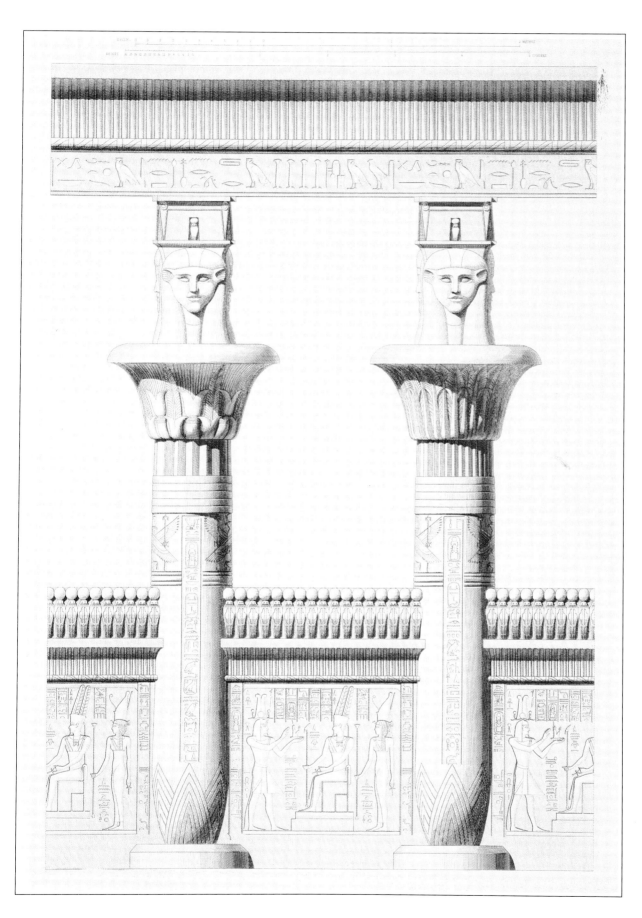

COLUMNS OF THE TEMPLE OF NECTANEBO (Philae—30th Dynasty)

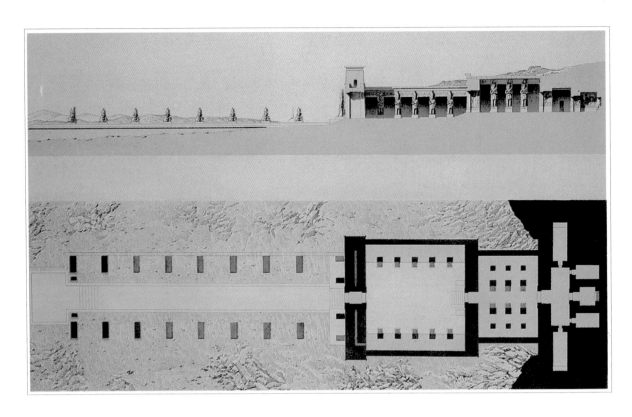

THE TEMPLE OF EL-SEBUA' (Plan & Section—Nubia)

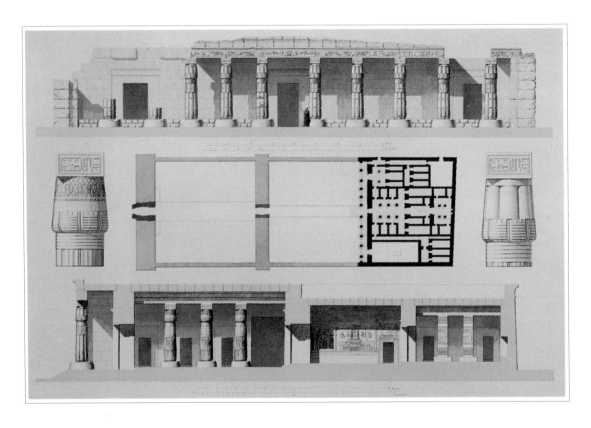

THE TEMPLE OF SETI I (Plan, section & elevation)

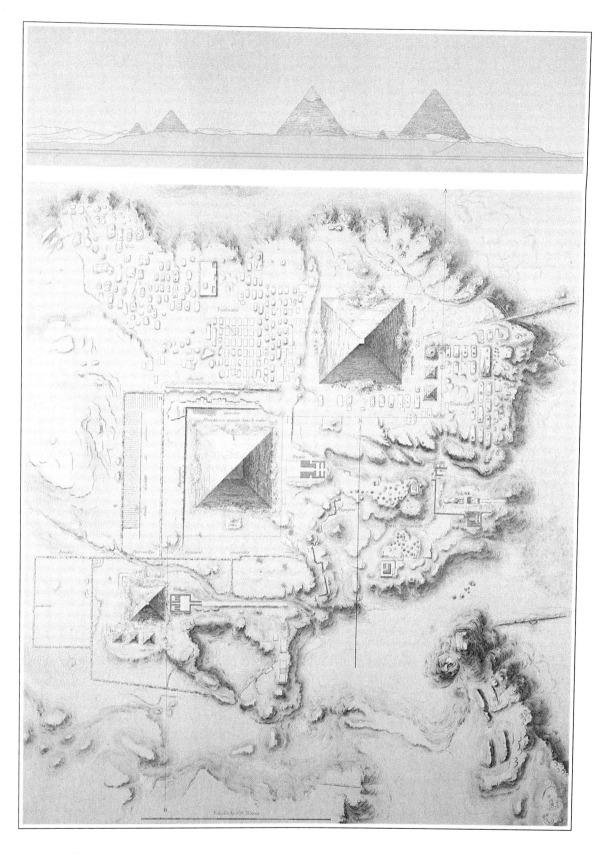

Topographical Map of Part of the Necropolis of Memphis (Pyramids of Giza)

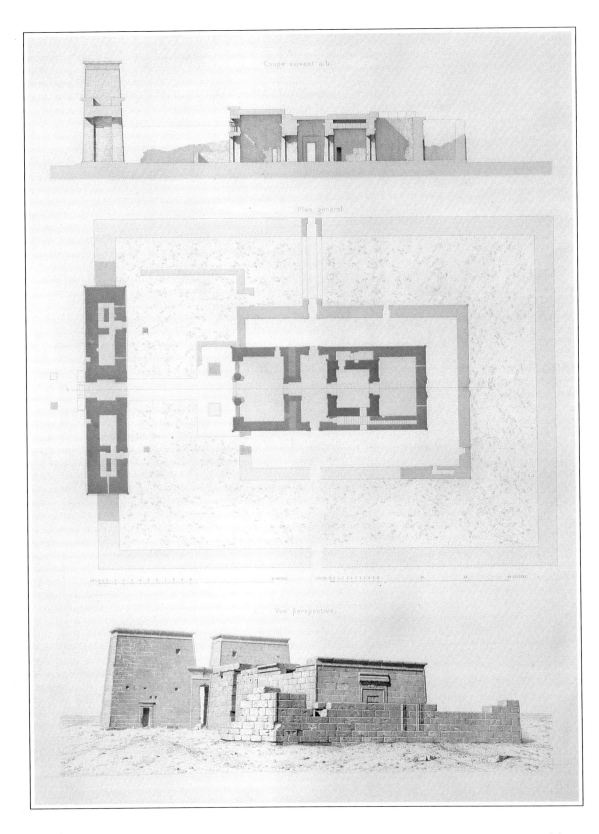

Coupe suivant a.b.

Plan général

Vue perspective.

THE TEMPLE OF DAKKA, "PSELCIS" (Plan, section & perspective—Ptolemaic & Roman periods)

Architecture PL.I.51

ELEVATION OF A PYLON & PLAN OF A HOUSE (From bas-reliefs)

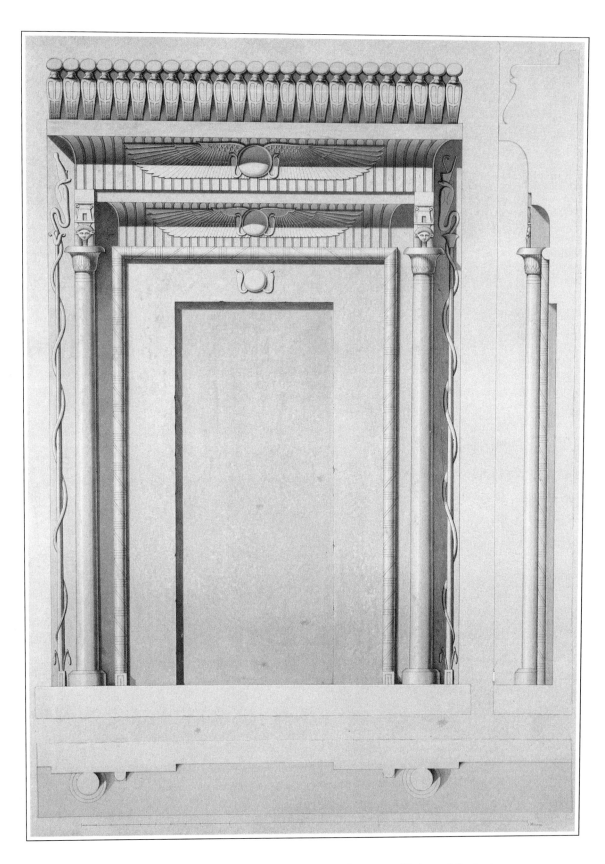

DECORATION OF THE NICHE OF MAMMISI, IN DENDERA (Reign of Trajan)

Architecture PL.I.53

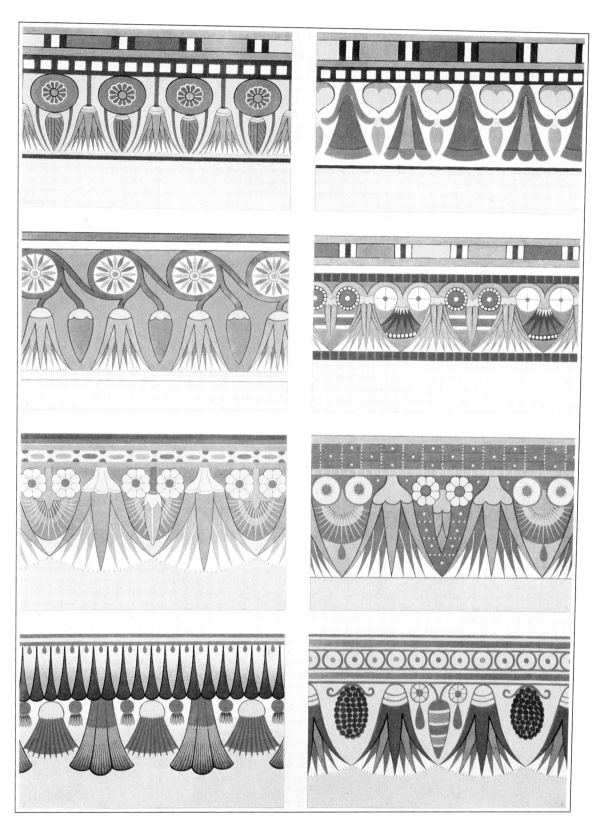

FLORAL FRIEZES (Painted in the tombs)

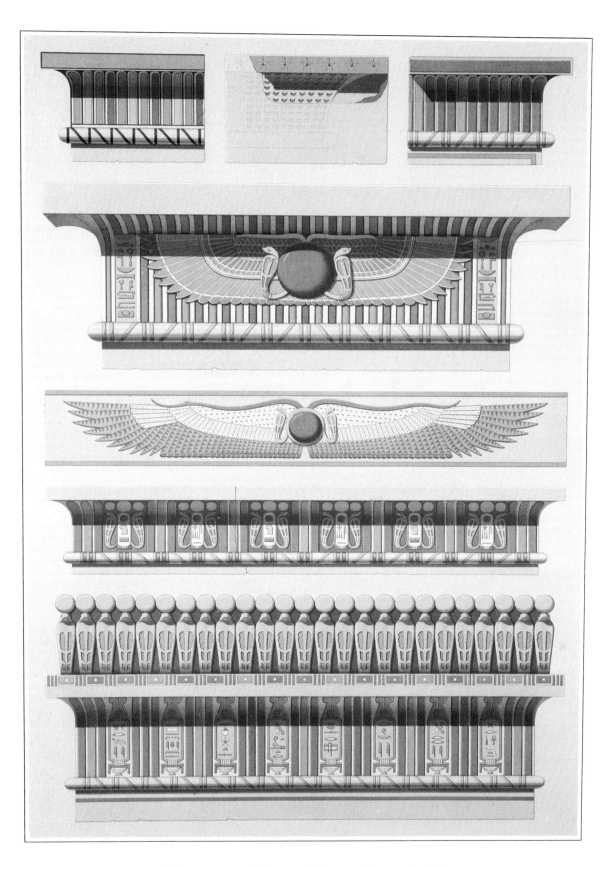

DECORATION OF CORNICES (From various periods)

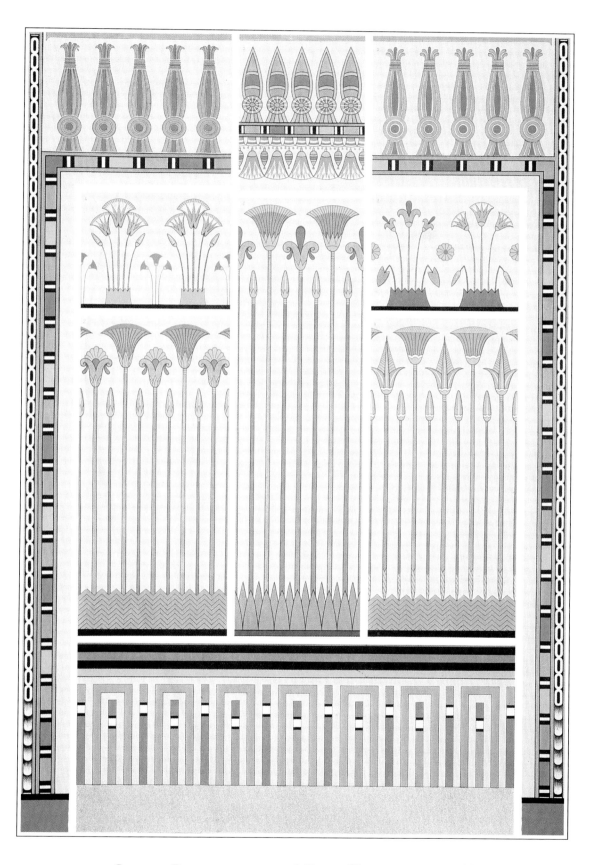

CORNICES, BORDER DECORATIONS & DADOS (From various periods)

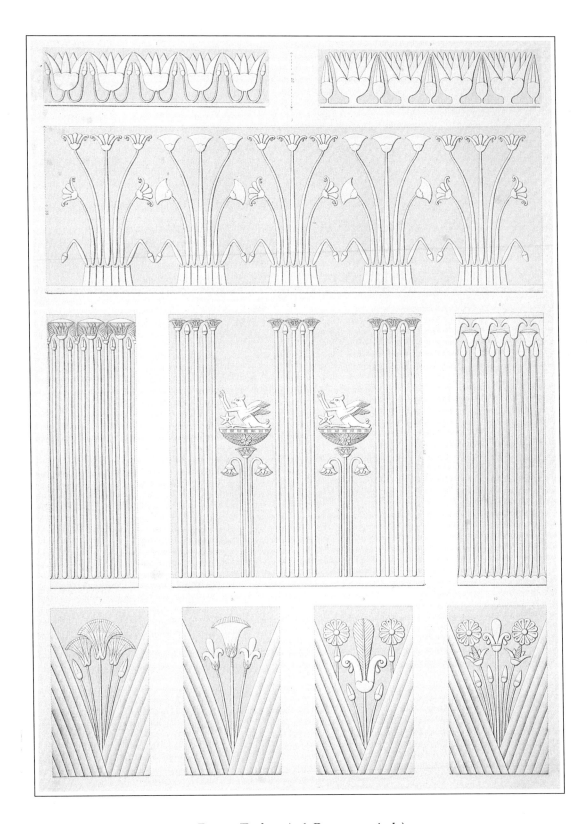

DADOS (Ptolemaic & Roman periods)

Architecture PL.I.57

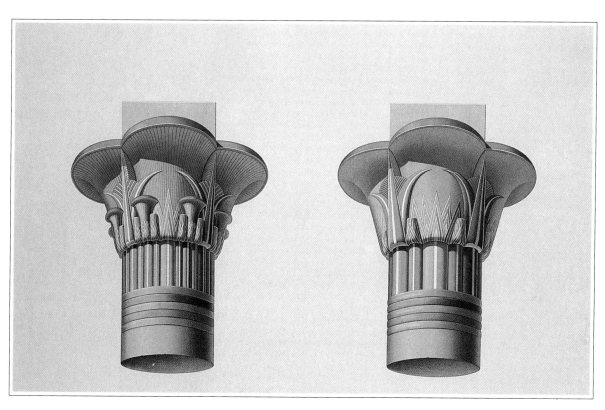

CAPITALS OF THE GREAT TEMPLE OF ISIS (At Philae—reign of Ptolemy VIII Euergetes II)

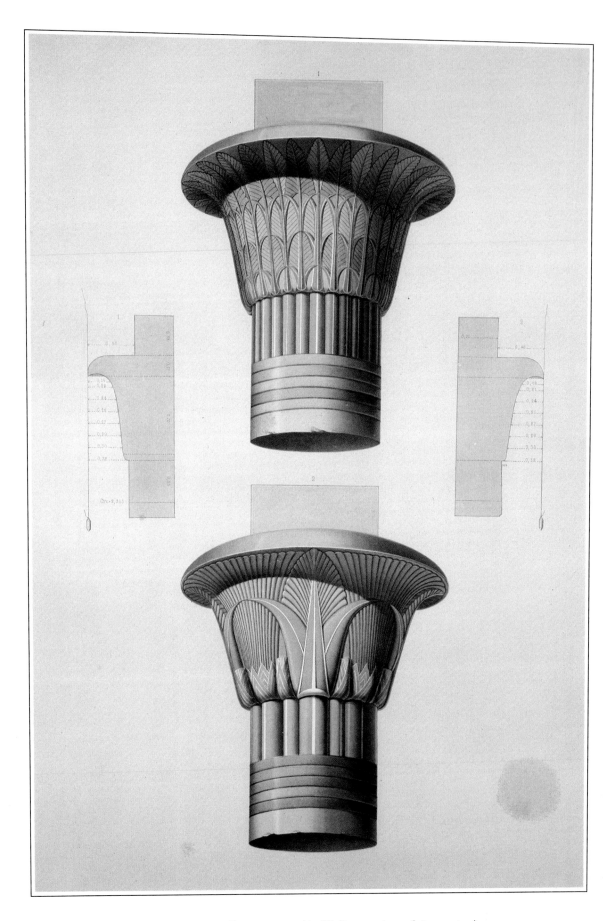

CAPITALS OF THE COLONNADE, (At Philae—reign of Augustus)

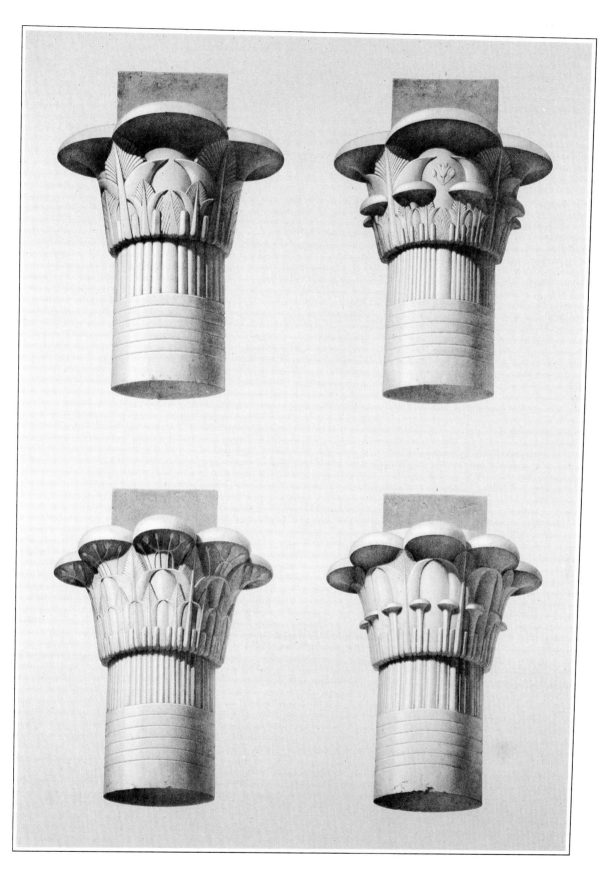

CAPITALS OF THE COLONNADE, (At Philae— reign of Augustus, Tiberius & Claudius)

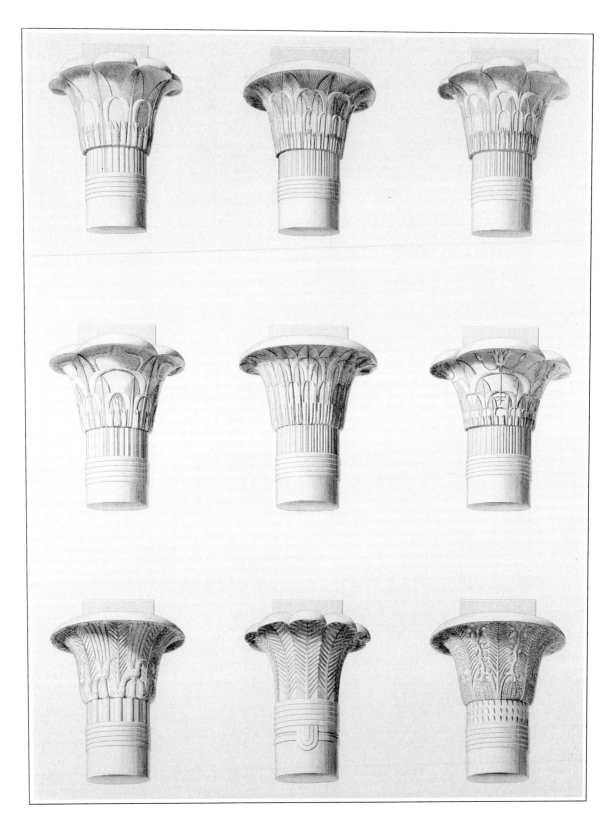

CAPITALS OF DIFFERENT SHAPES

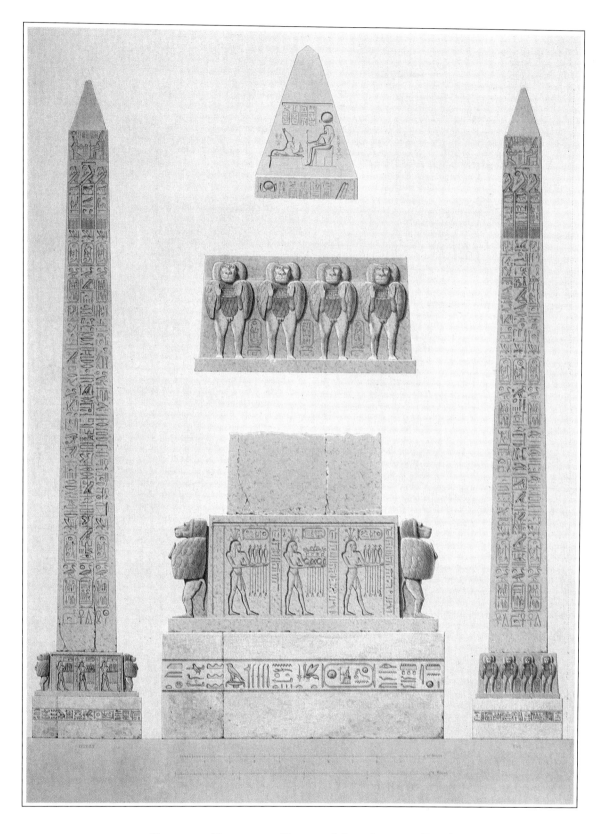

OBELISK OF RAMESSES II (Removed from Luxor to Paris)

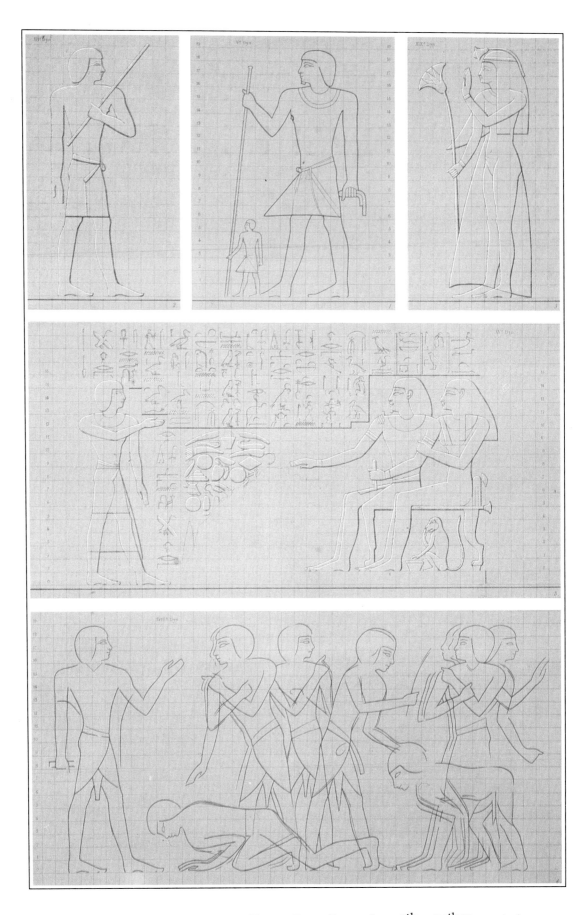

CANON OF PROPORTIONS OF THE HUMAN BODY (In use from 5th to 26th Dynasties)

Drawing PL.II.1

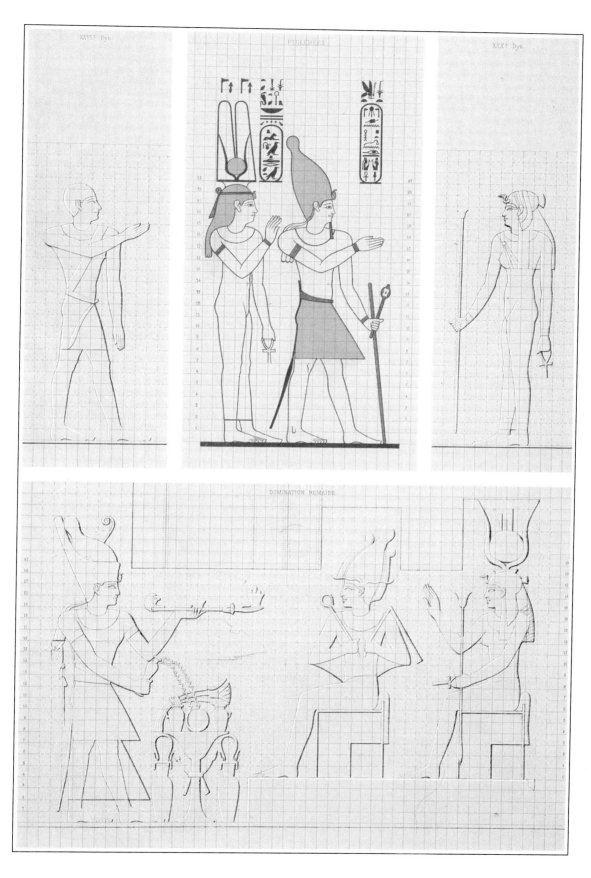

LATER CANON OF PROPORTIONS OF THE HUMAN BODY (In use from Psammetik I to Caracalla)

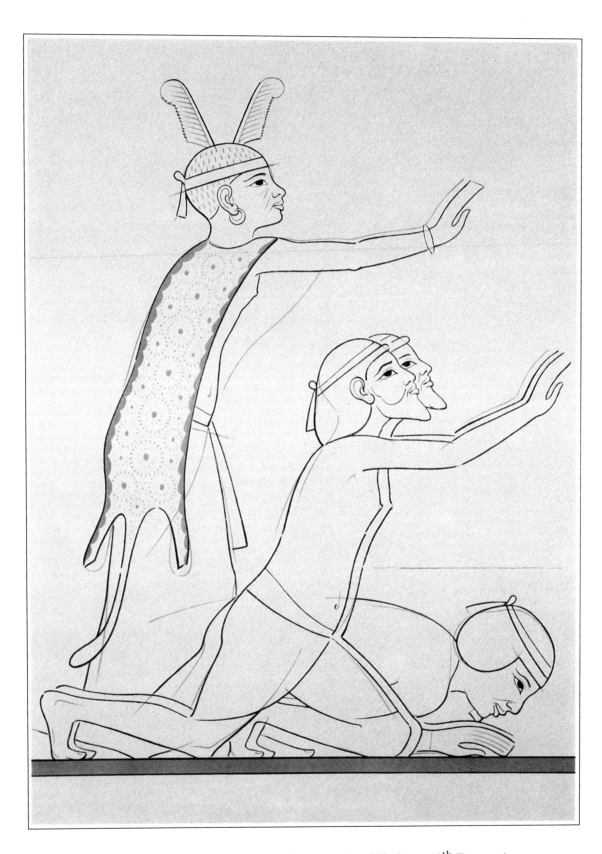

FACSIMILE OF A REWORKED SKETCH (Necropolis of Thebes—18th Dynasty)

Drawing PL.II.3

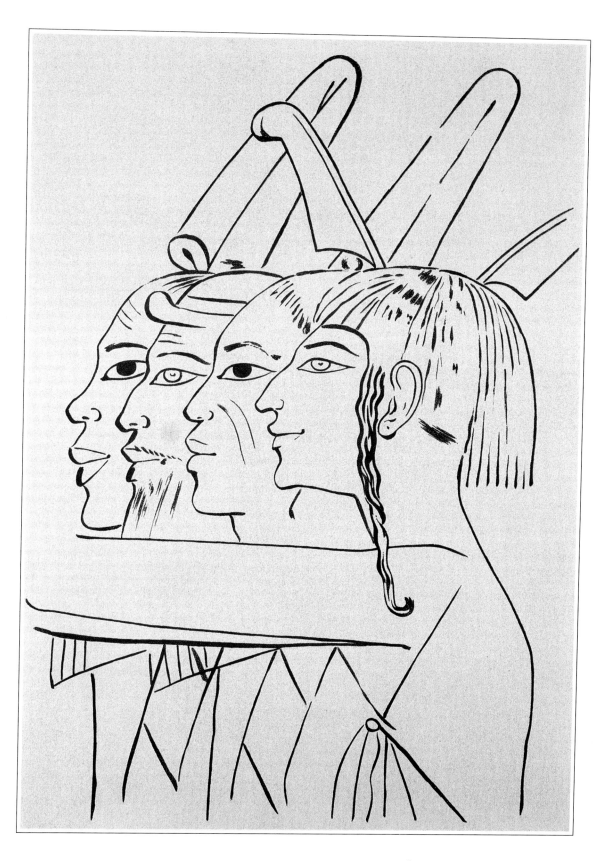

FACSIMILE OF A SKETCH (Necropolis of Thebes—18th Dynasty)

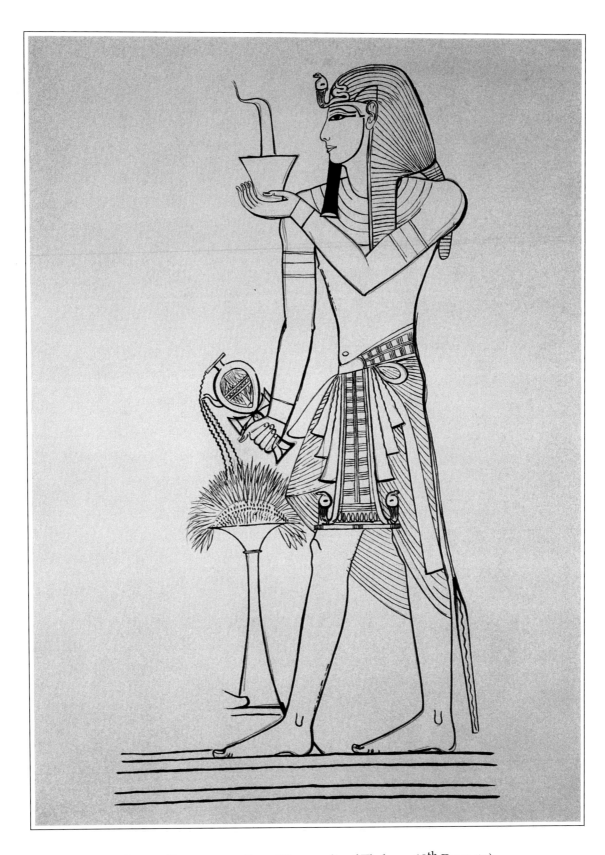

SKETCH REPRESENTING SETI I (Necropolis of Thebes—19th Dynasty)

Drawing PL.II.5

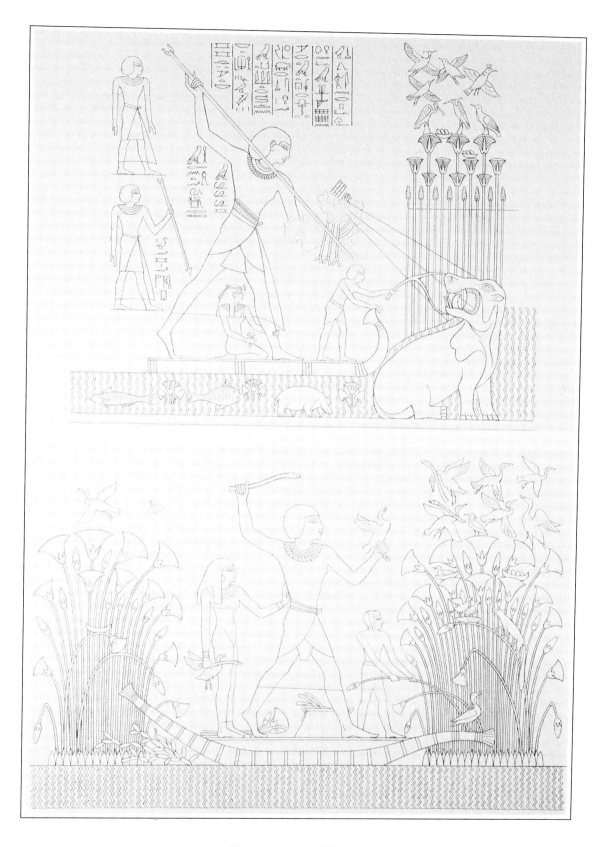

HUNTING IN THE MARSHES

Drawing PL.II.6

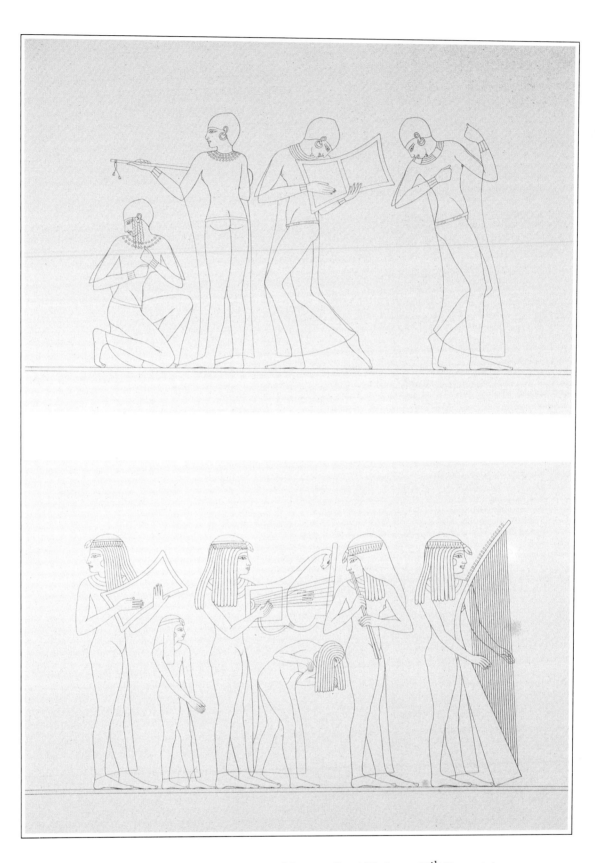

FEMALE MUSICIANS AND DANCERS (Necropolis of Thebes—18th Dynasty)

Drawing PL.II.7

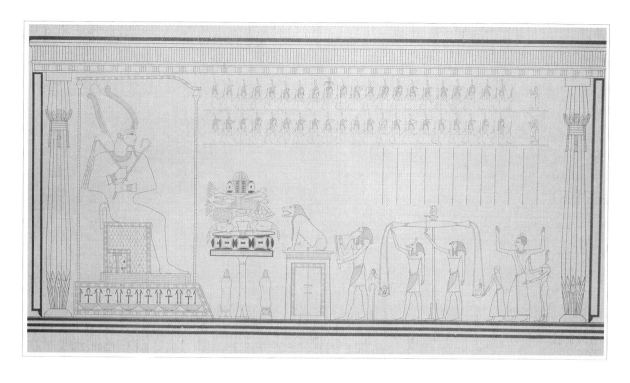

JUDGMENT OF THE DEAD IN THE COURT OF OSIRIS (Funerary ritual)

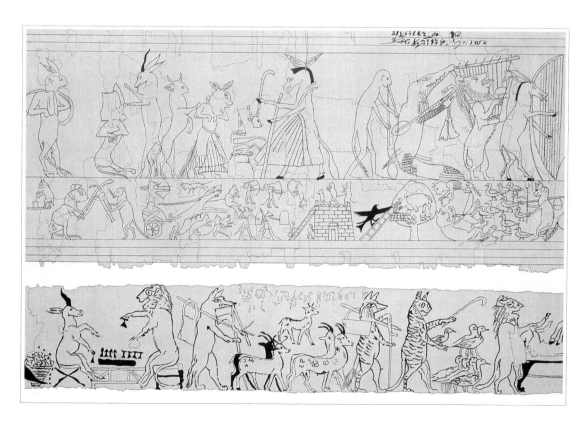

FRAGMENTS OF SATIRICAL PAPYRI (Museums of Turin & London)

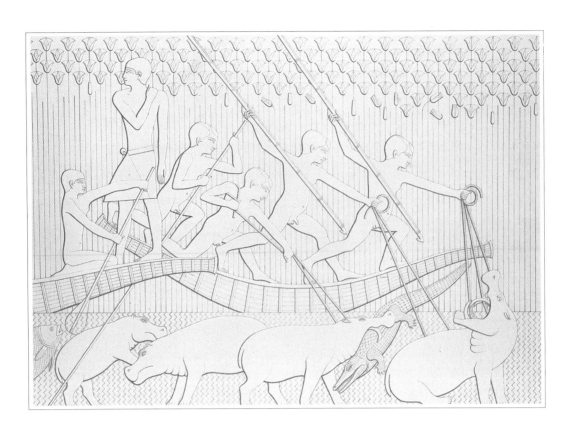

HIPPOPOTAMUS HUNT IN THE MARSHES (Memphis)

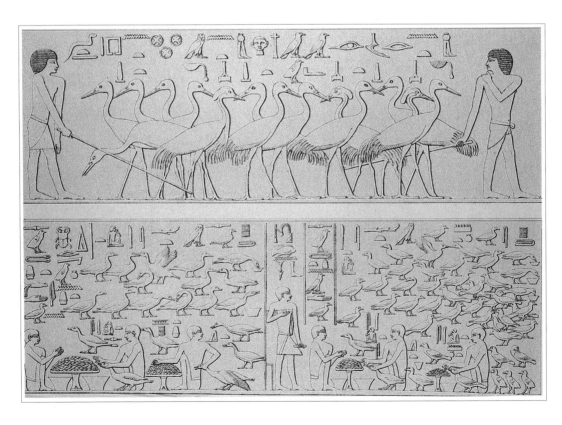

CRANES & THE POULTRY YARD OF TI (Necropolis of Memphis—5th Dynasty)

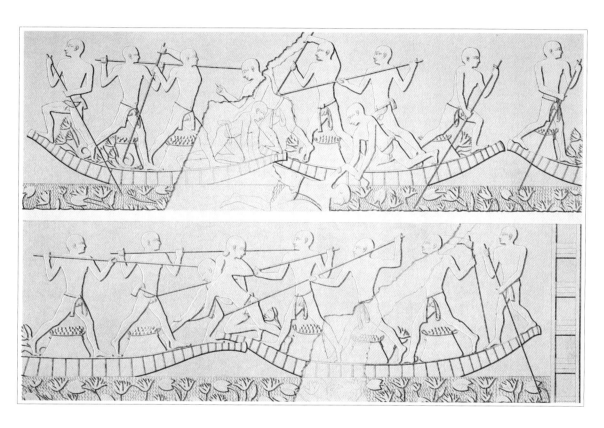

BOATMEN IN A TILTING MATCH (Kom el-Ahmar—6th Dynasty)

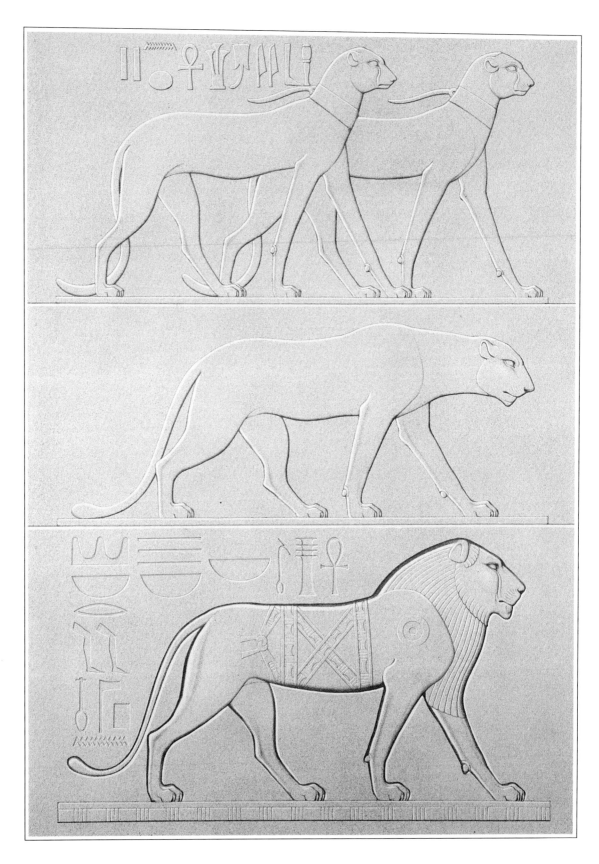

ANIMALS; FELINE SPECIES (Thebes)

Sculpture PL.II.13

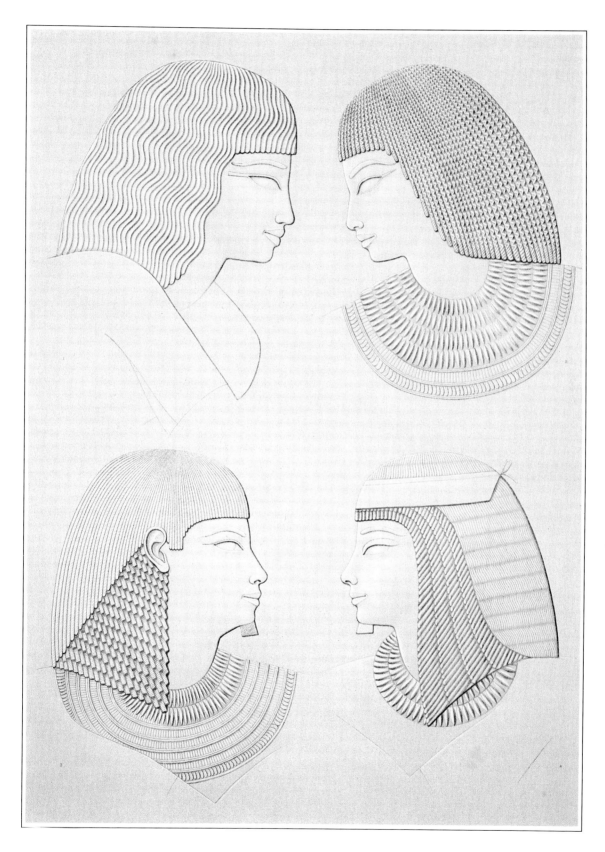

TYPES & PORTRAITS (Necropolis of Thebes—18th Dynasty)

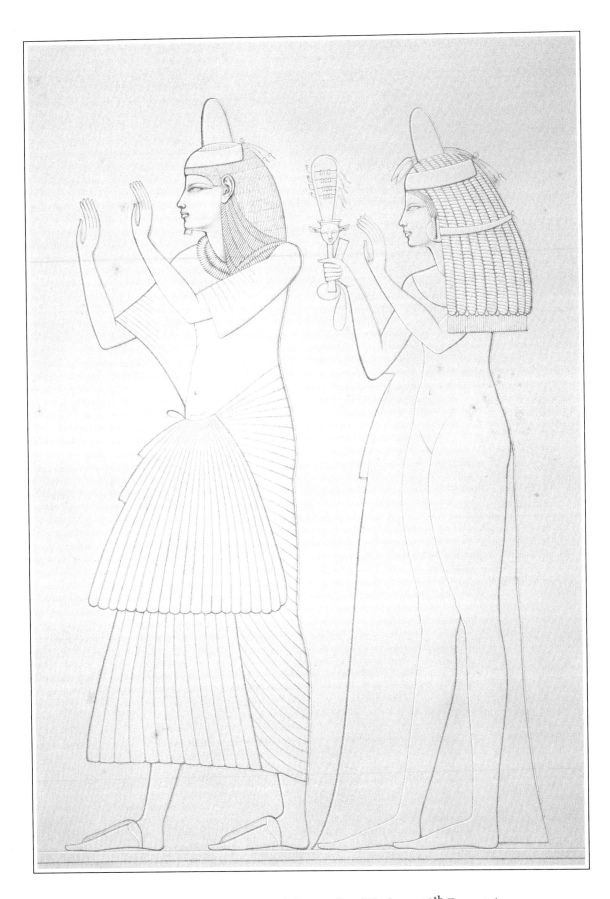

SCRIBE & PRIESTESS OF AMUN (Necropolis of Thebes—18th Dynasty)

Sculpture PL.II.15

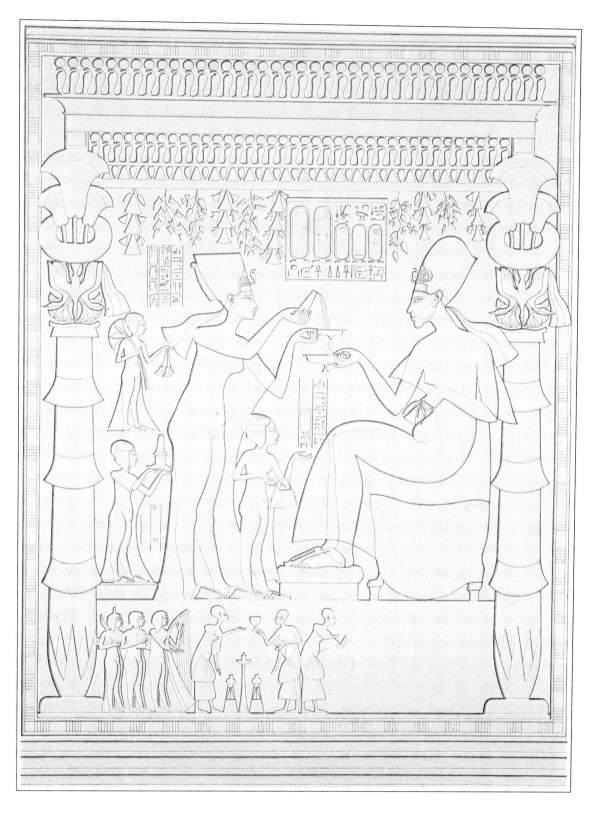

KING AKHENATEN SERVED BY THE QUEEN (Tell el-Amarna—18th Dynasty)

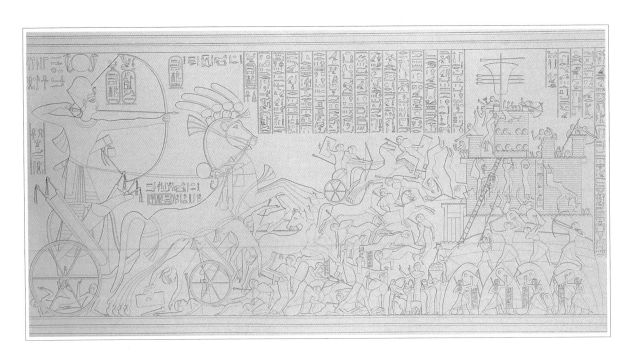

CAPTURE OF A FORTRESS BY RAMESSES II (Thebes, Ramesseum)

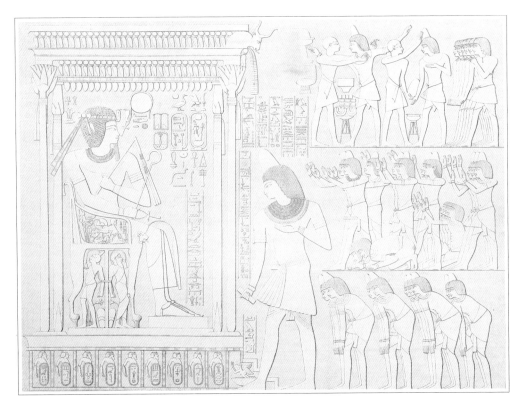

HOMAGE TO AMENOPHIS III (Tomb of Kha'emhet, intendant of the domains—18th Dynasty)

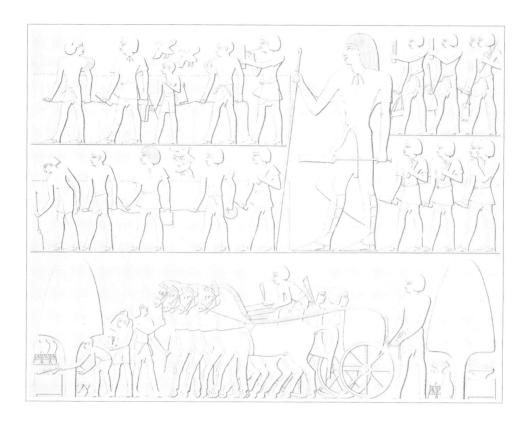

MEASURING THE FIELDS (Overseen by Kha'emhet, intendant of the domains—18th Dynasty)

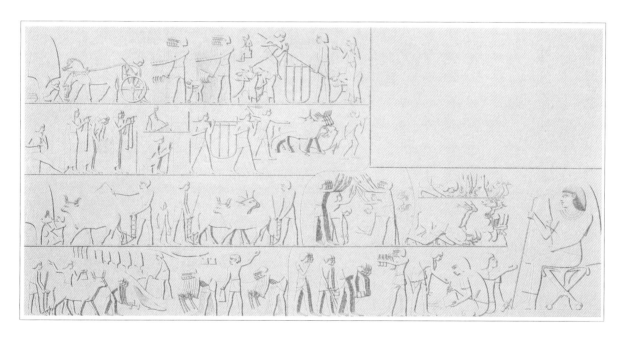

AGRICULTURAL SCENES (Tomb of Kha'emhet, intendant of the domains—18th Dynasty)

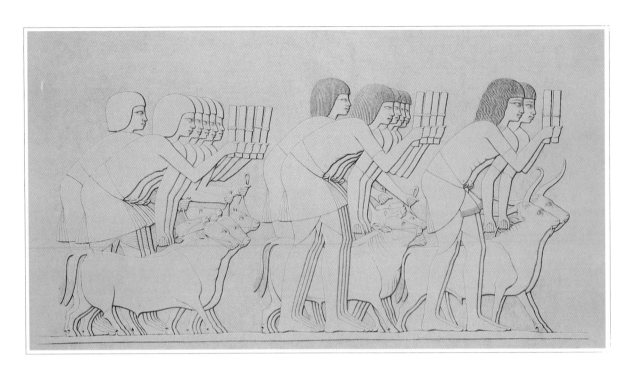

COUNTING THE OXEN (Tomb of Kha'emhet, intendant of the domains—18th Dynasty)

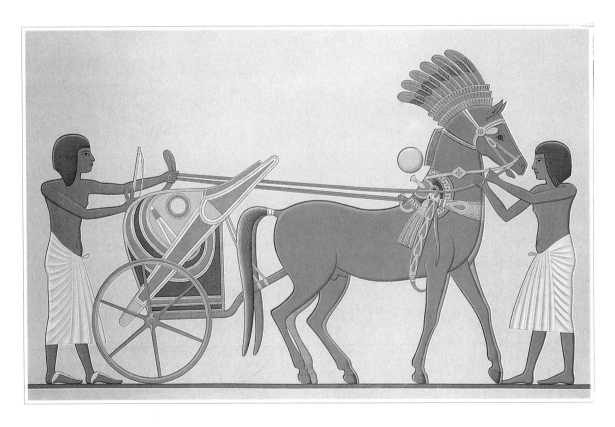

PRINCELY CHARIOT (Tell el-Amarna—18th Dynasty)

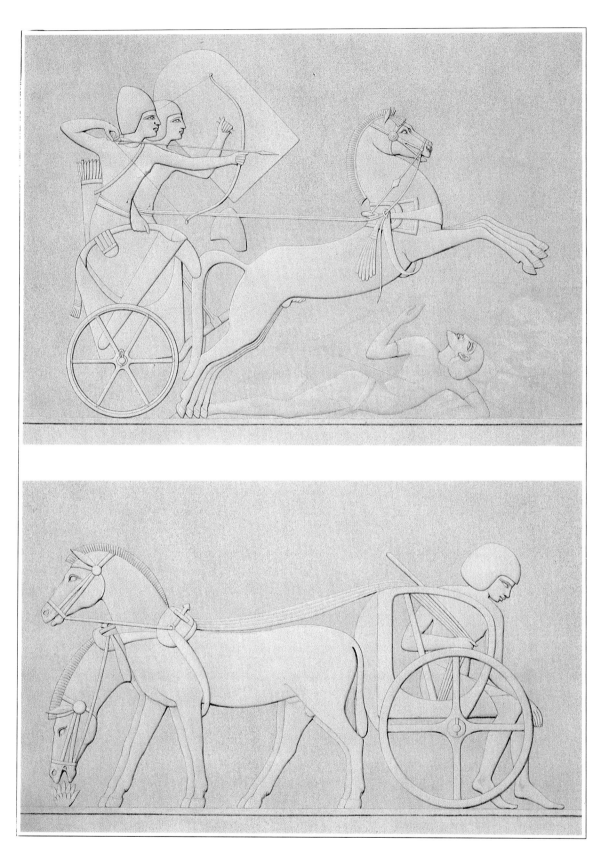

FRAGMENTS OF BAS-RELIEFS; TEAMS OF HORSES (Thebes—18th Dynasty)

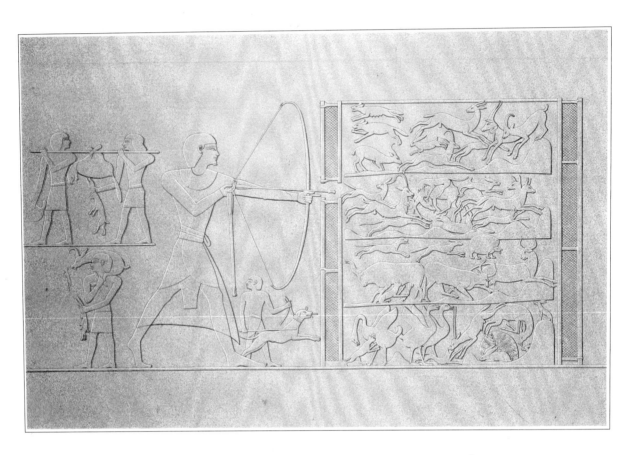

HUNTING WITH BOW & RUNNING DOGS (Necropolis of Thebes—18th Dynasty)

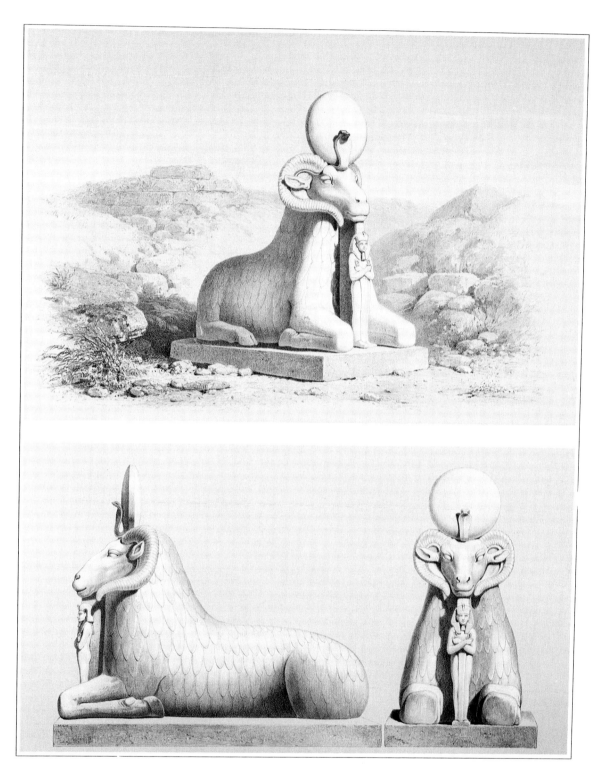

Statues of a Ram (Temple of Mut & Chonsu—18th Dynasty)

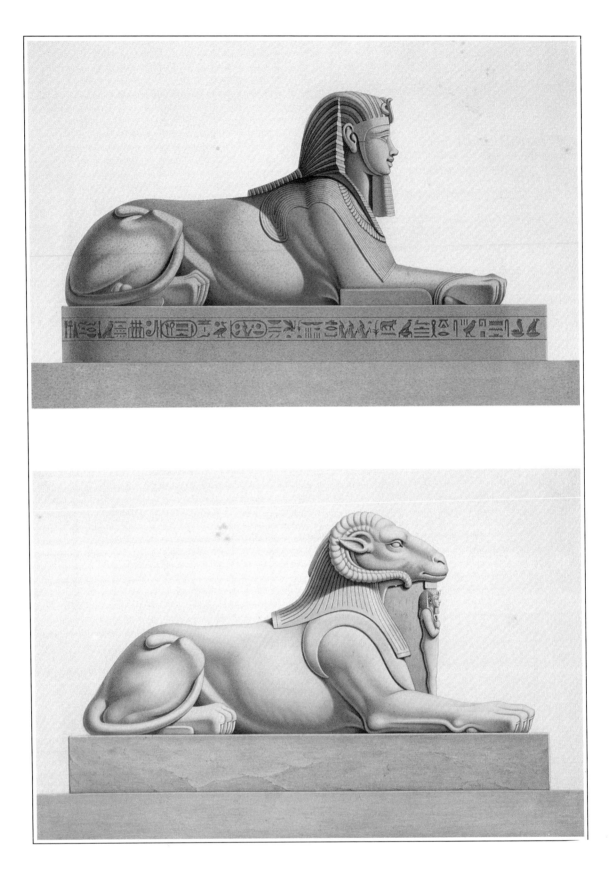

ANDROSPHINX & CRIOSPHINX

Sculpture PL.II.26

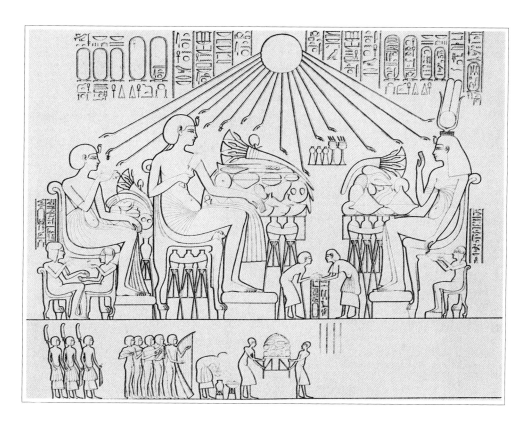

Offerings to the Sun (Tombs of Tell el-Amarna—18th Dynasty)

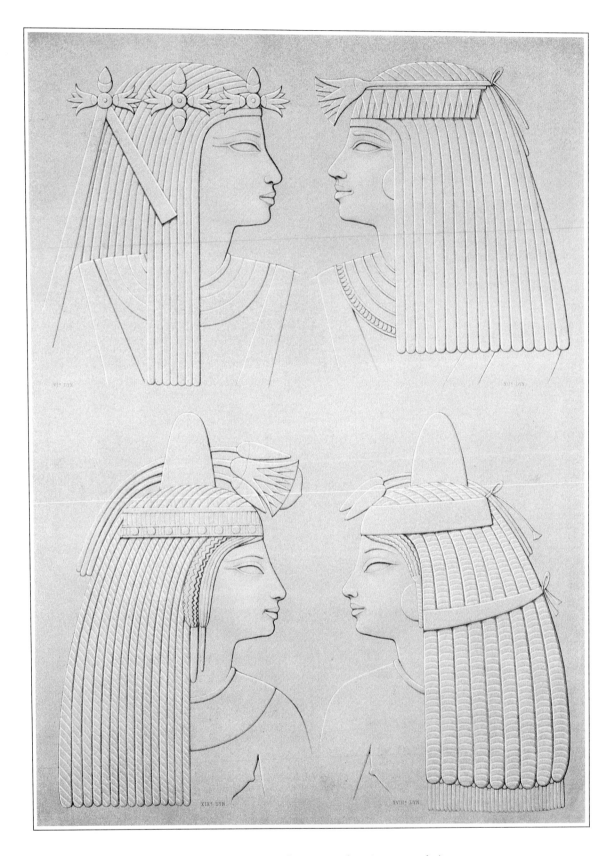

TYPES & PORTRAITS (Women of various epochs)

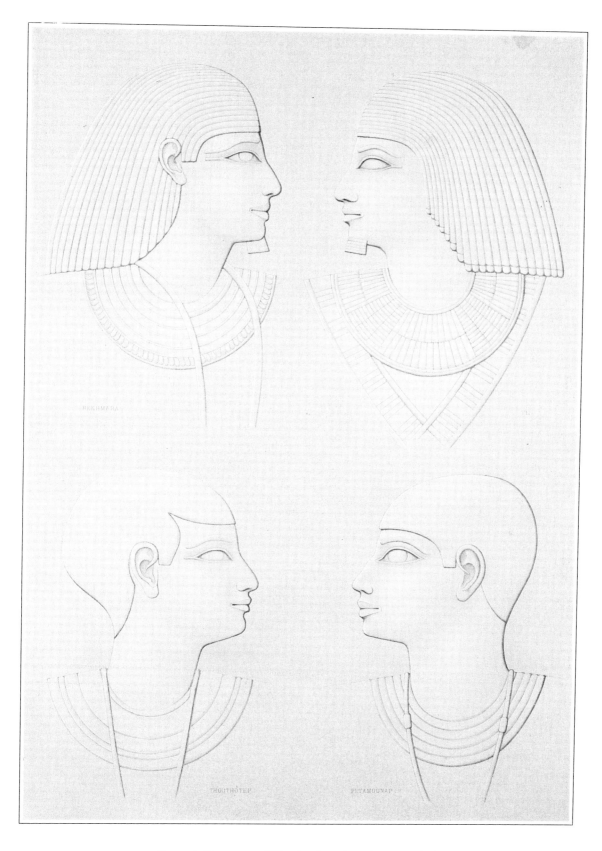

TYPES & PORTRAITS (Dignitaries of various epochs)

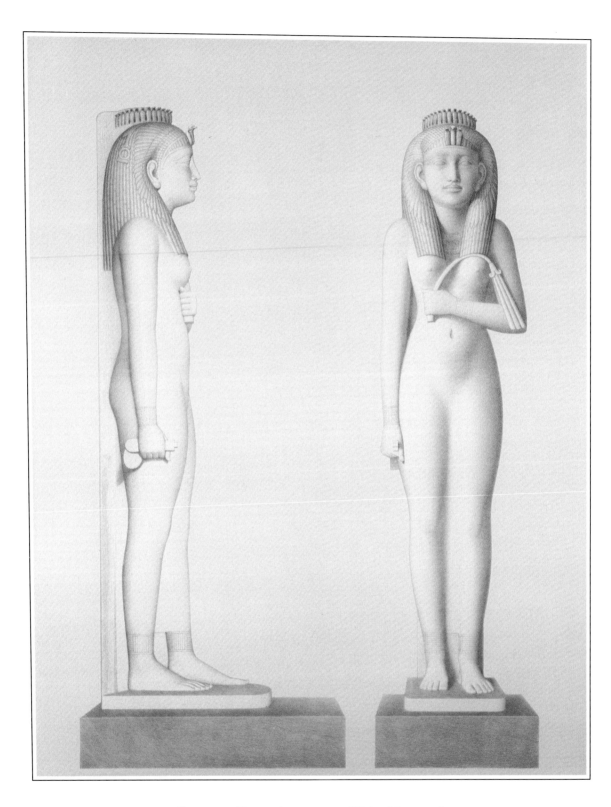

STATUE OF QUEEN AMENARDAIS (Cairo Museum)

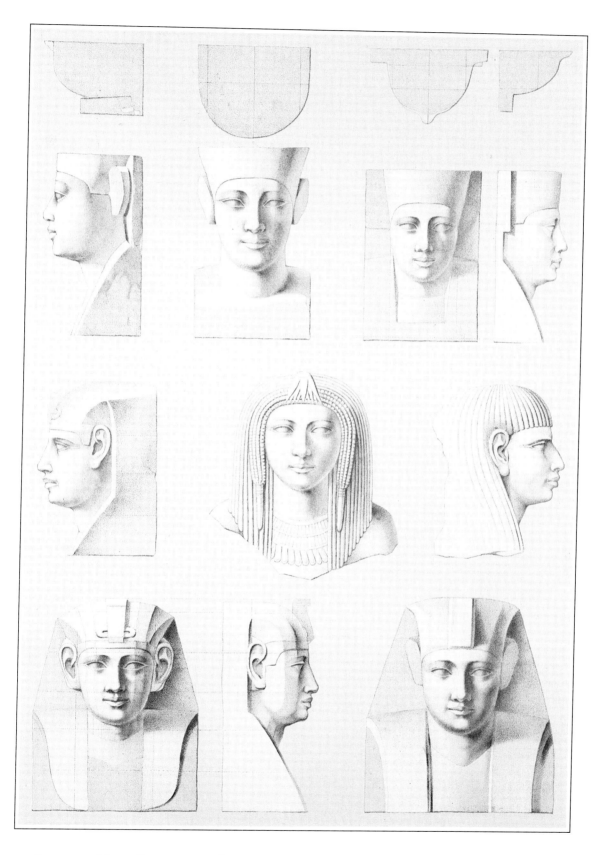

STUDIES OF HEADS BASED ON THE CANON OF PROPORTION (Workshops of Memphis & Thebes)

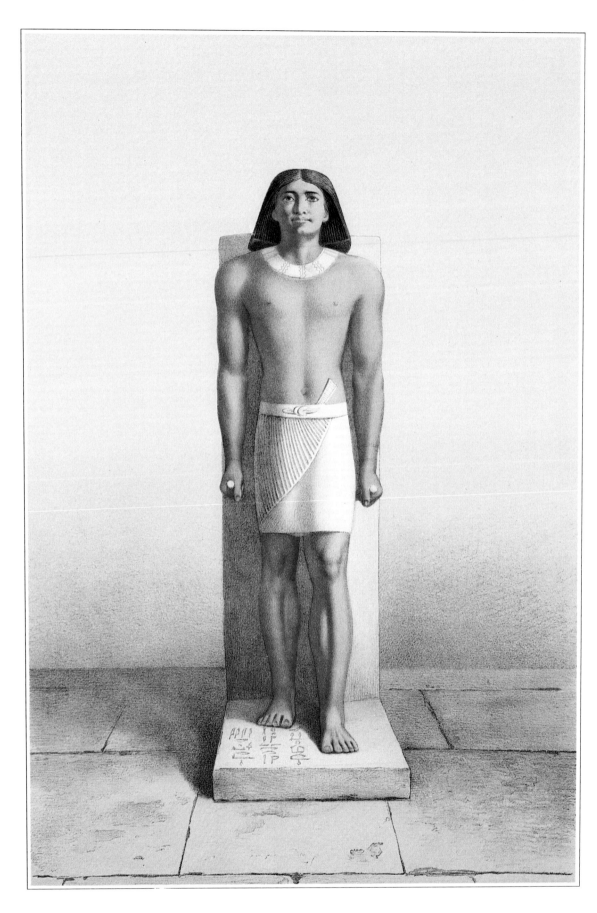

STATUE OF RANOFER (Limestone painted red)

FRAGMENTS OF STATUES (From different epochs)

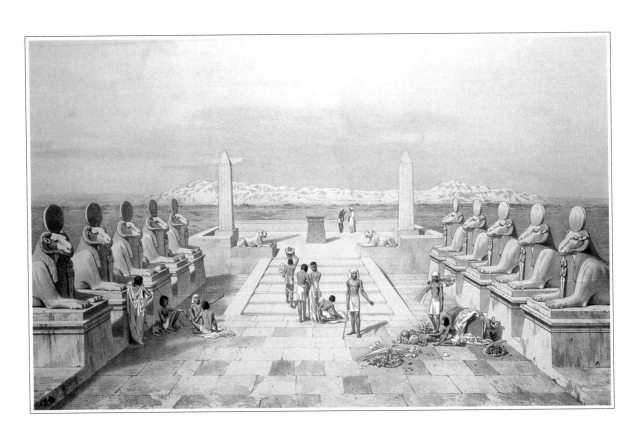

Dromos of the Great Temple at Karnak

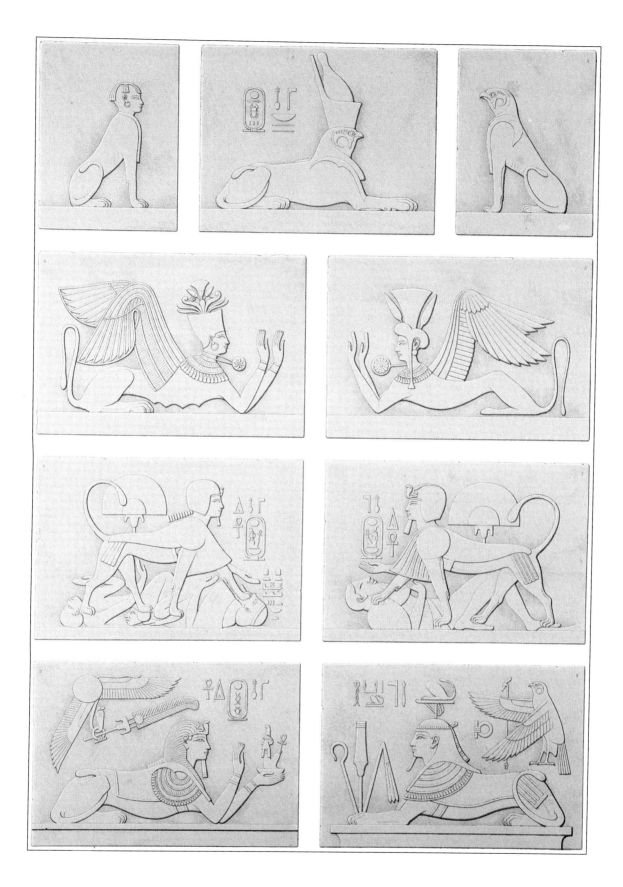

TYPES OF SPHINXES (From various monuments)

ANIMALS; OVINE & BOVINE SPECIES (Cairo Museum)

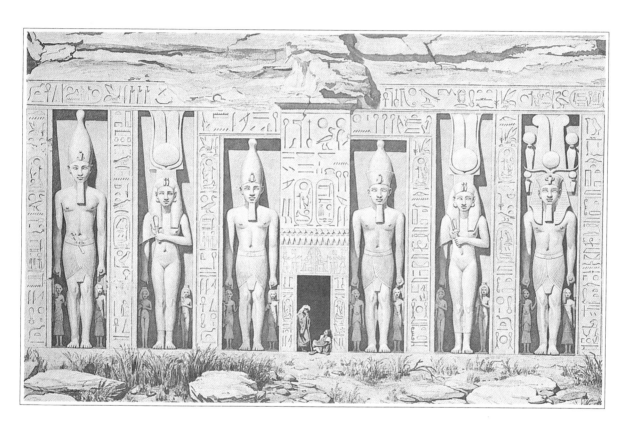

GREAT TEMPLE OF ABESHEK [sic] (Nubia)

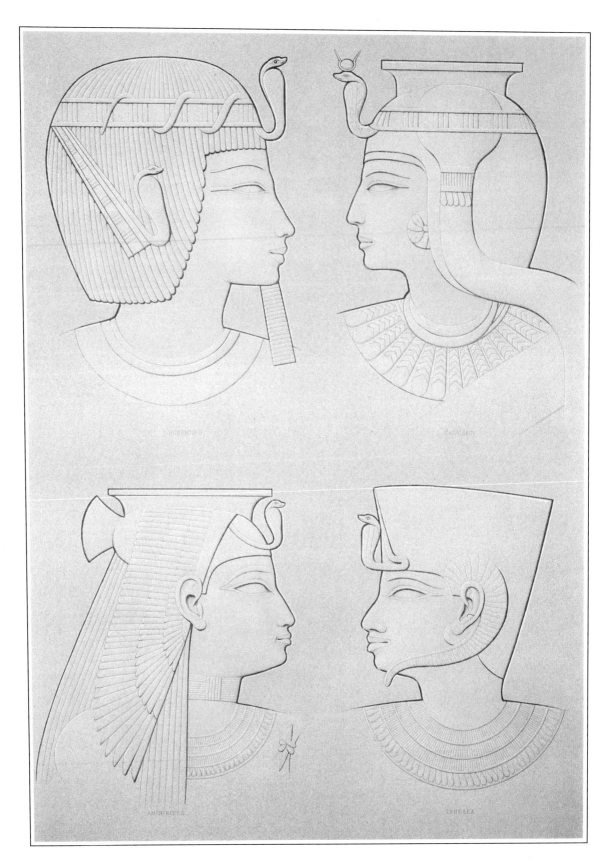

Royal Portraits (Thebes—18th, 19th & 25th Dynasties)

THE CAMP OF RAMESSES II IN HIS CAMPAIGN AGAINST THE HITTITES (Thebes, Ramesseum—19th Dynasty)

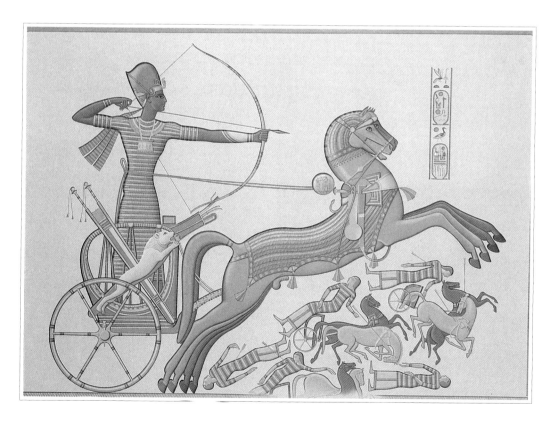

RAMESSES II'S BATTLE AGAINST THE HITTITES ON THE BANKS OF THE ORONTES (Thebes, Ramesseum—19th Dynasty)

Sculpture PLs.II.39 & 40

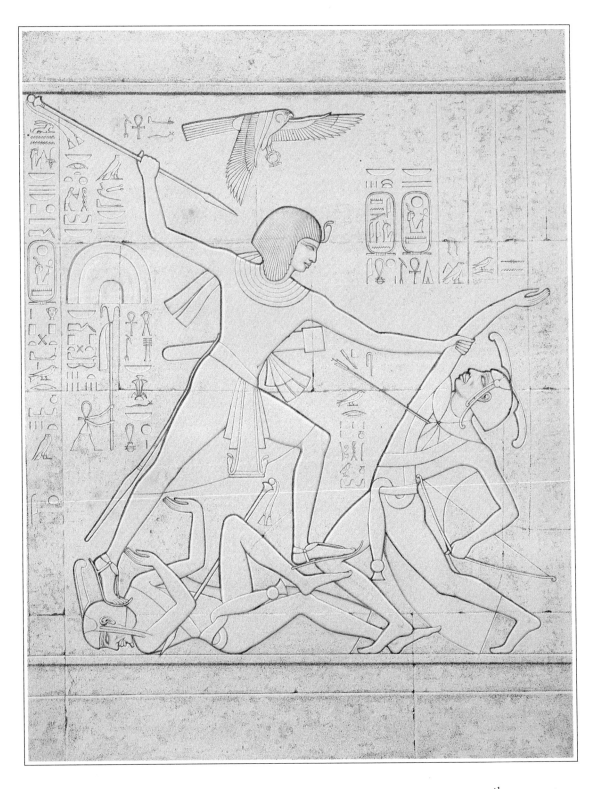

THE COMBAT OF SETI I AGAINST THE CHIEFS OF THE THEHENU (Thebes, Karnak—19th Dynasty)

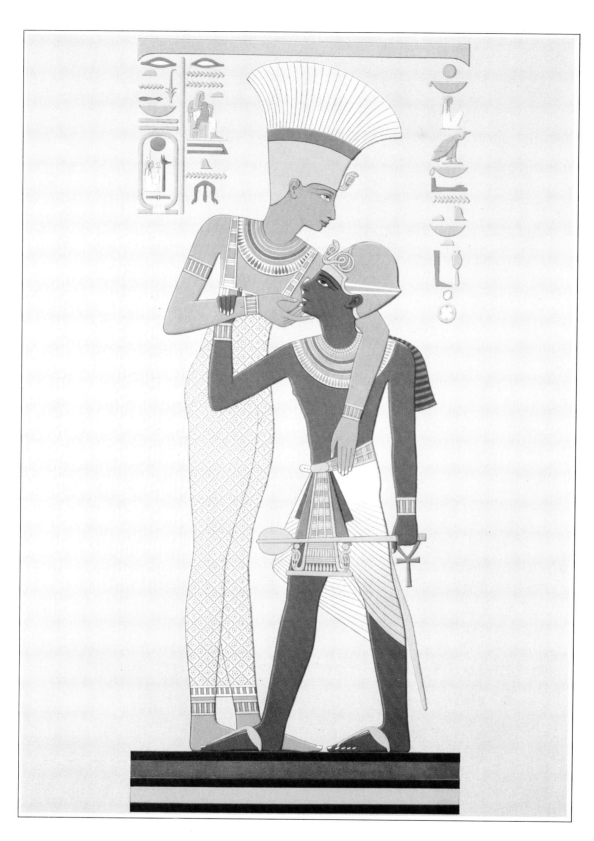

THE GODDESS ANUKIS & RAMESSES II (Talmis—19th Dynasty)

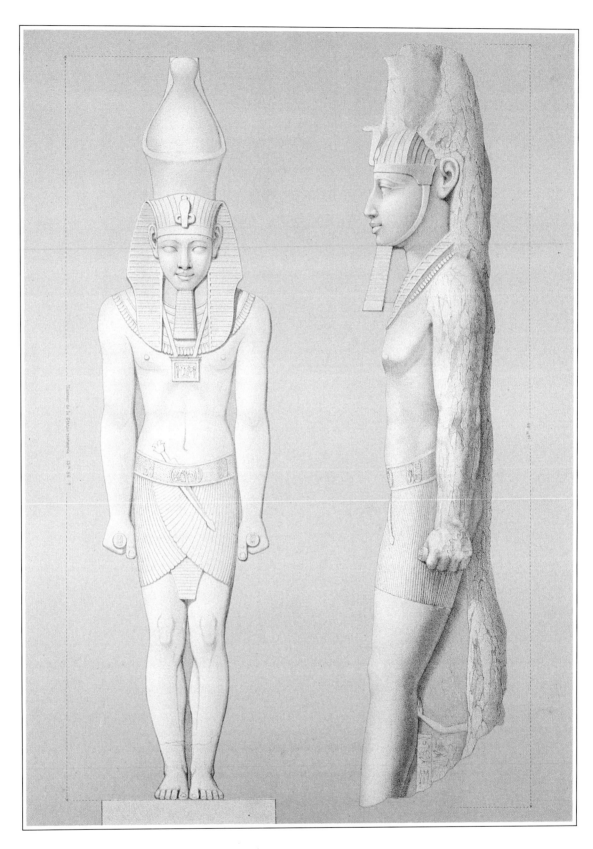

Colossus of Ramesses II (Memphis—19th Dynasty)

Sculpture PL.II.43

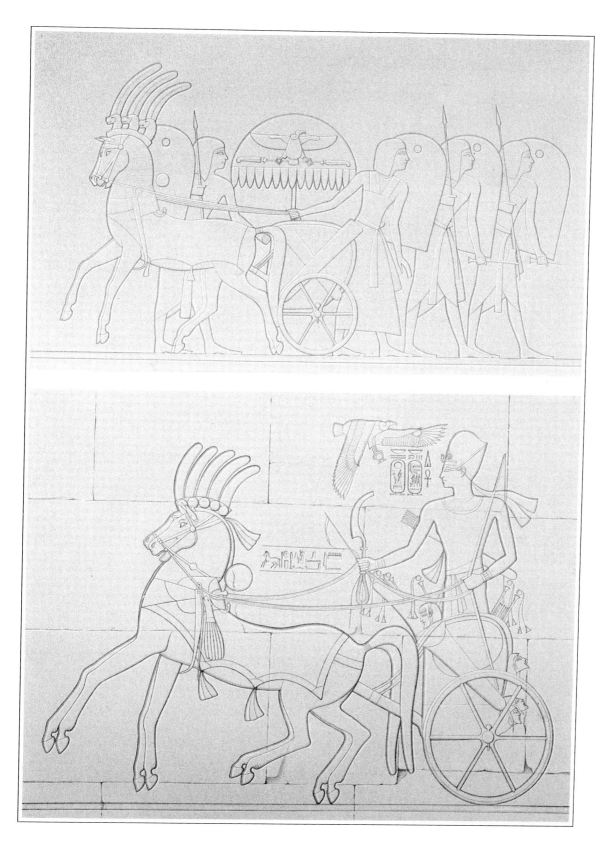

FRAGMENTS OF MILITARY SCENES (Abeshek & Thebes—19th Dynasty)

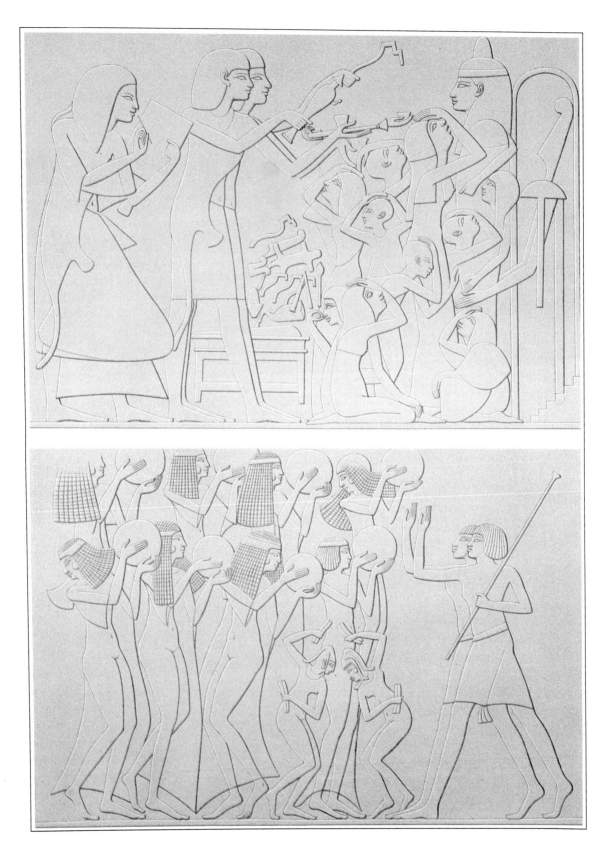

Fragments of Funerary Bas-reliefs

Sculpture PL.II.45

PORTRAIT OF TI AND HIS WIFE (Necropolis of Memphis—5th Dynasty)

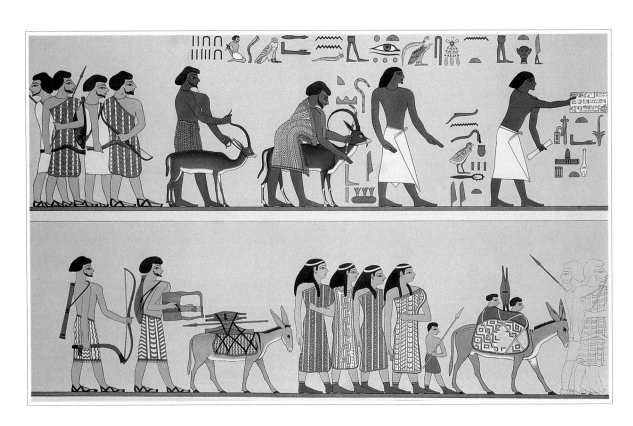

ARRIVAL OF AN ASIATIC FAMILY IN EGYPT (Beni Hasan—12th Dynasty)

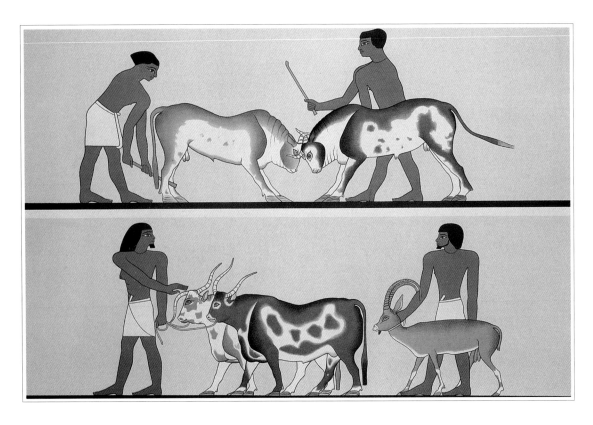

SCENES OF RURAL LIFE (Tombs of Beni Hasan—12th Dynasty)

Painting PLs.II.47 & 48

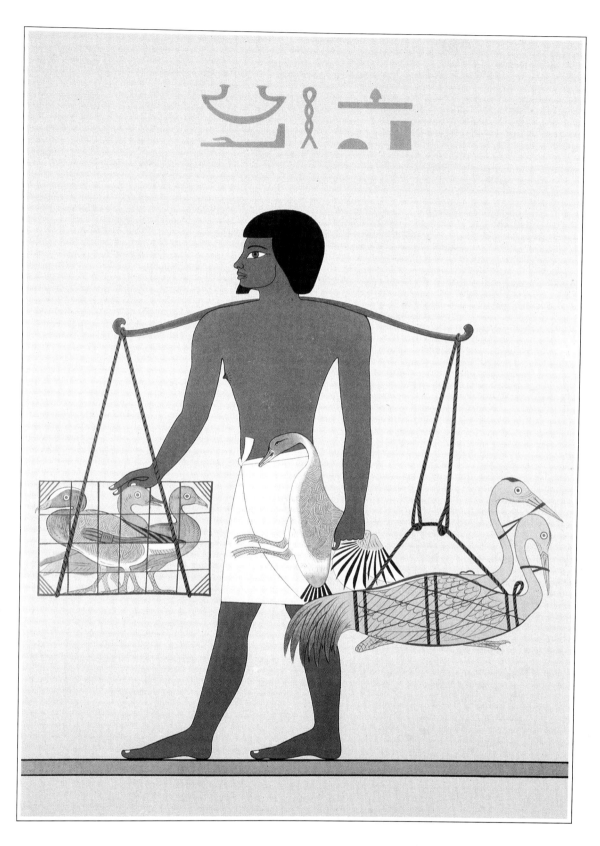

RETURN OF A HUNTER ON A BARQUE (Beni Hasan—12th Dynasty)

NATIVE OF THE LAND OF PUNT (Thebes; 'Asasif)

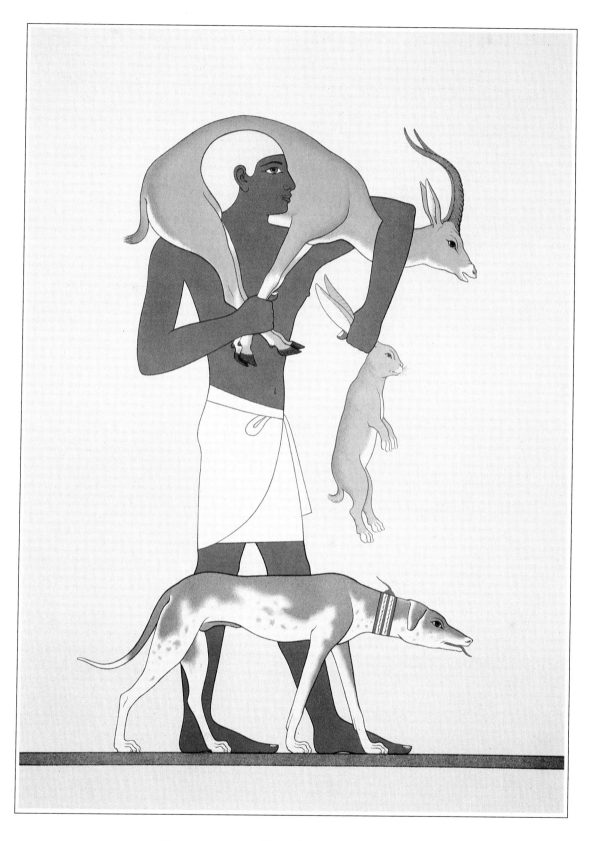

RETURN FROM THE HUNT (Necropolis of Thebes)

PORTRAIT OF QUEEN TYTI

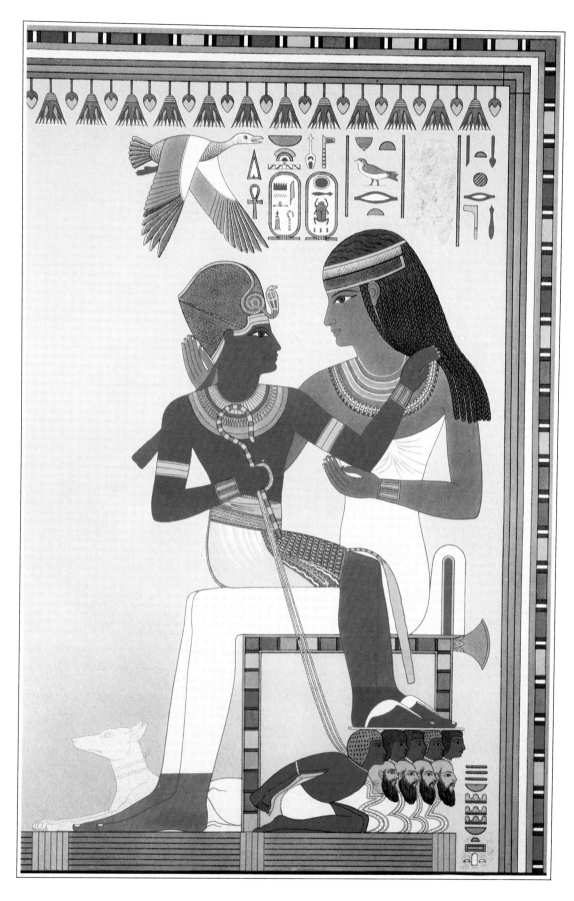

AMENOPHIS II & HIS WET-NURSE (Necropolis of Thebes—18th Dynasty)

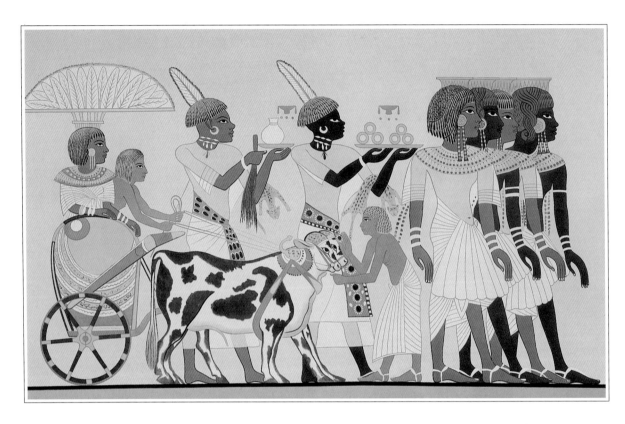

ARRIVAL OF AN ETHIOPIAN PRINCESS IN THEBES (During the reign of Tutankhamun—18th Dynasty)

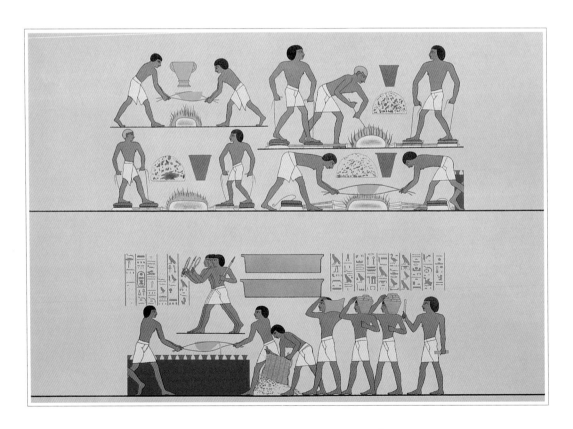

GOLDSMITHS' WORKSHOP OF THE RETJENU (18th Dynasty)

Painting PLs.II.54 & 55

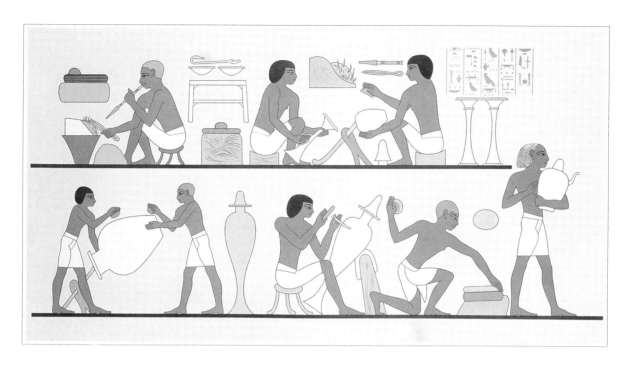

MANUFACTURING GOLD AND SILVER VASES (Necropolis of Thebes—18th Dynasty)

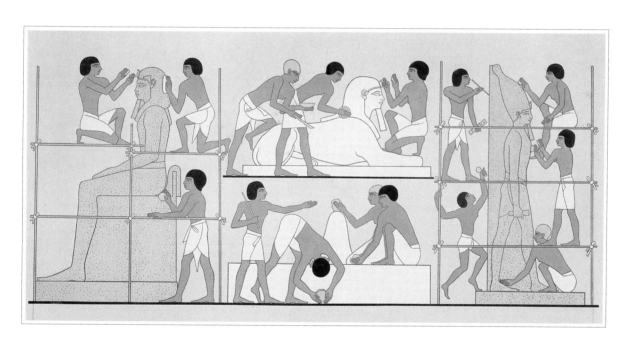

SCULPTORS' WORKSHOP (18th Dynasty)

Painting PLs.II.56 & 57

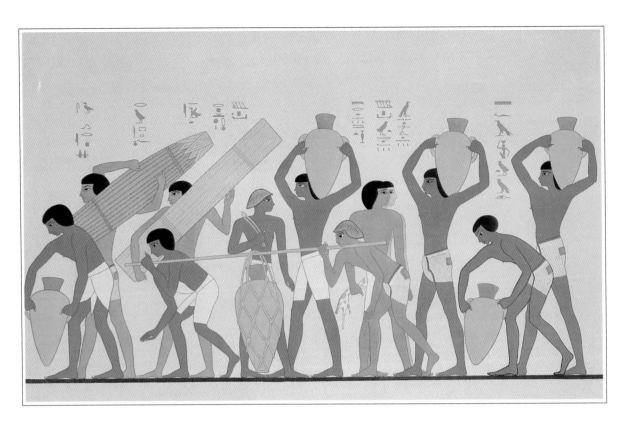

TRANSPORT OF UTENSILS & PROVISIONS (Necropolis of Thebes—18th Dynasty)

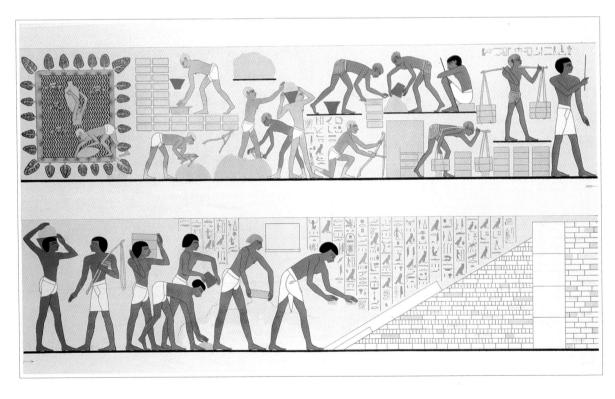

CAPTIVES CONSTRUCTING A TEMPLE OF AMUN (Thebes—18th Dynasty)

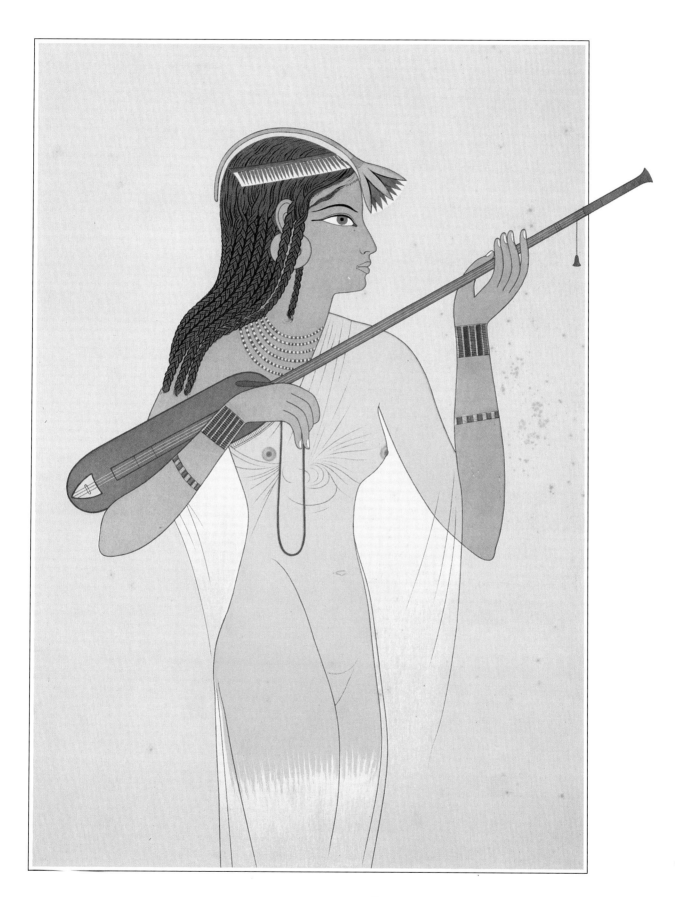

LUTIST (Necropolis of Thebes—18th Dynasty)

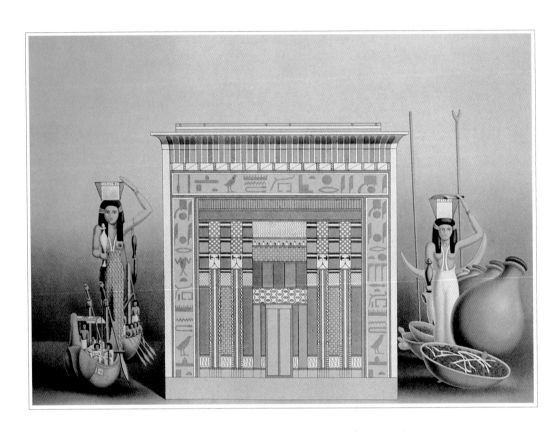

TOMB DISCOVERED IN THE VALLEY OF 'ASASIF (Thebes)

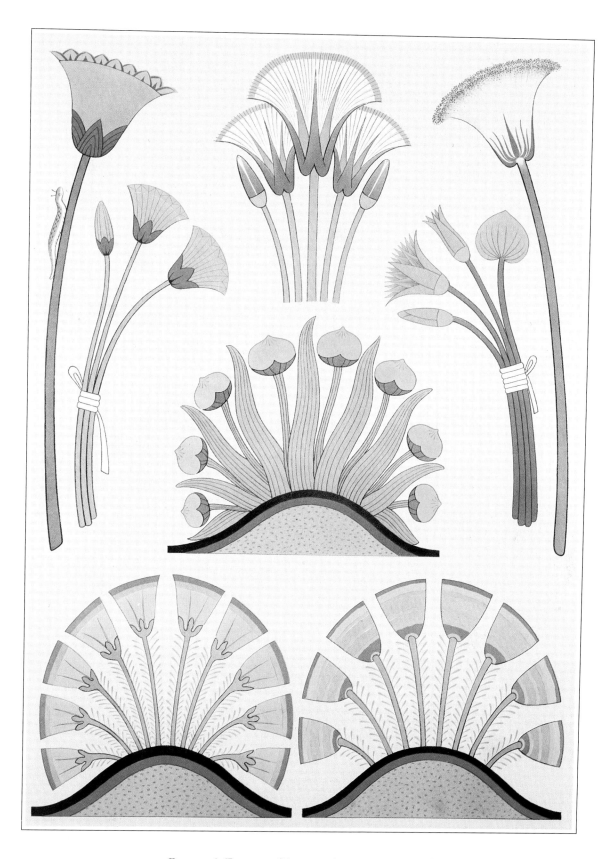

PLANTS & FLOWERS (From various monuments)

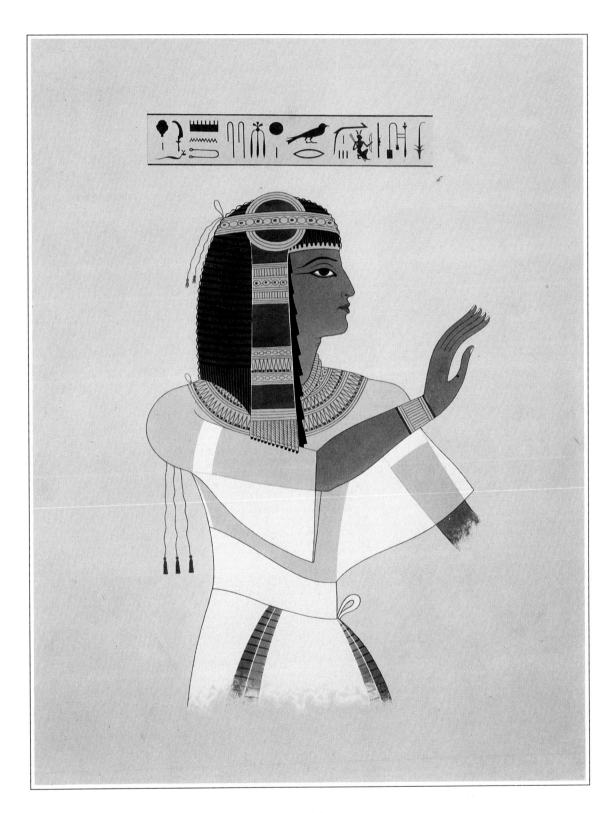

PORTRAIT OF PRINCE MONTUHERKHEPSHEF

Painting PL.II.63

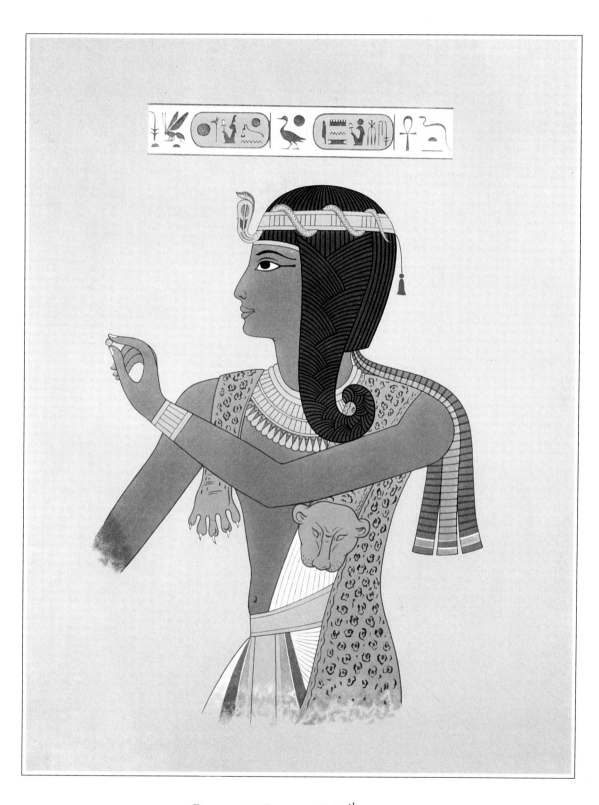

PORTRAIT OF RAMESSES II (19th Dynasty)

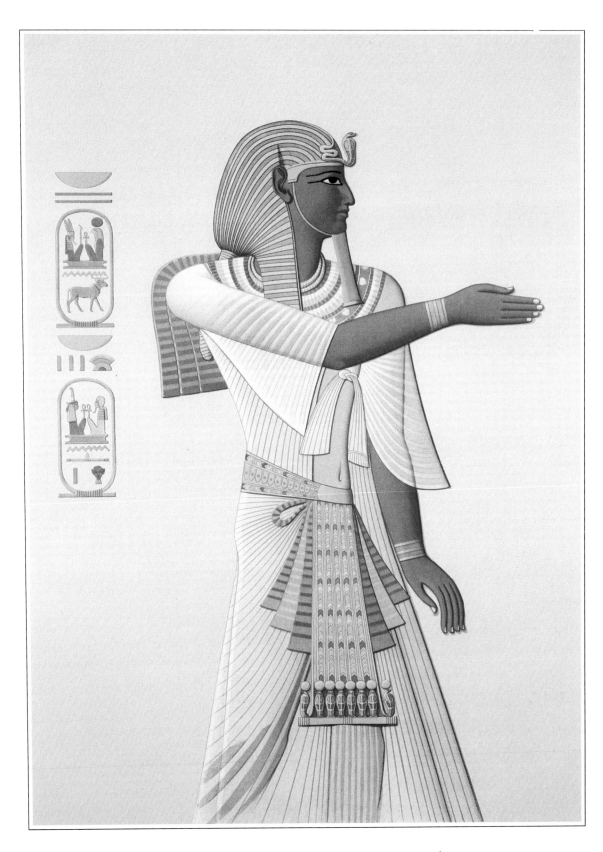

PORTRAIT OF KING MERNEPTAH (Necropolis of Thebes—19th Dynasty)

Painting PL.II.65

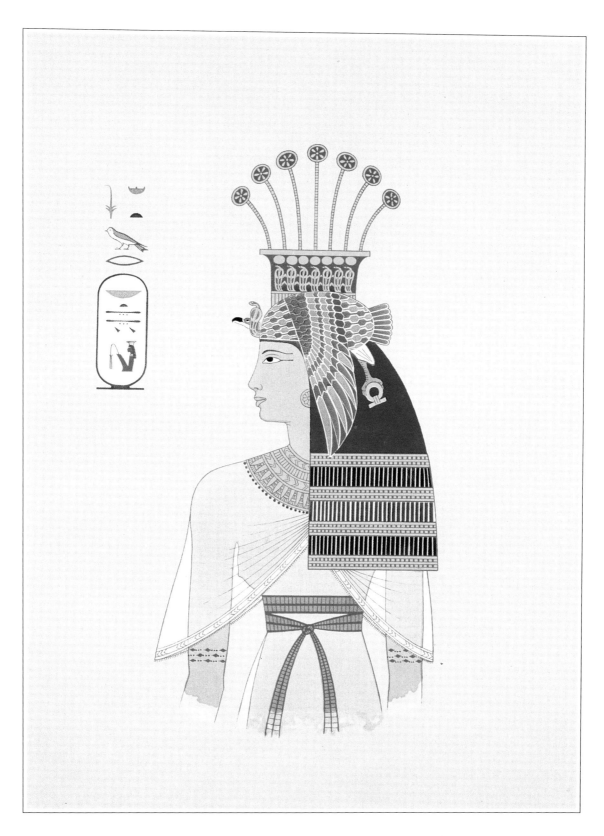

PORTRAIT OF QUEEN NEBTAWY (Daughter of Ramesses II—19th Dynasty)

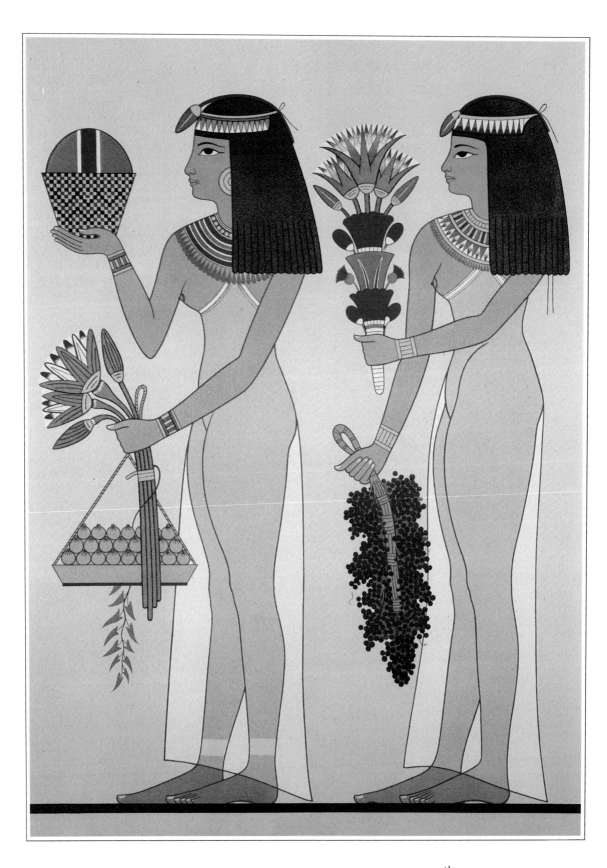

OFFERING OF FLOWERS AND FRUITS (Necropolis of Thebes—19th Dynasty)

Painting PL.II.67

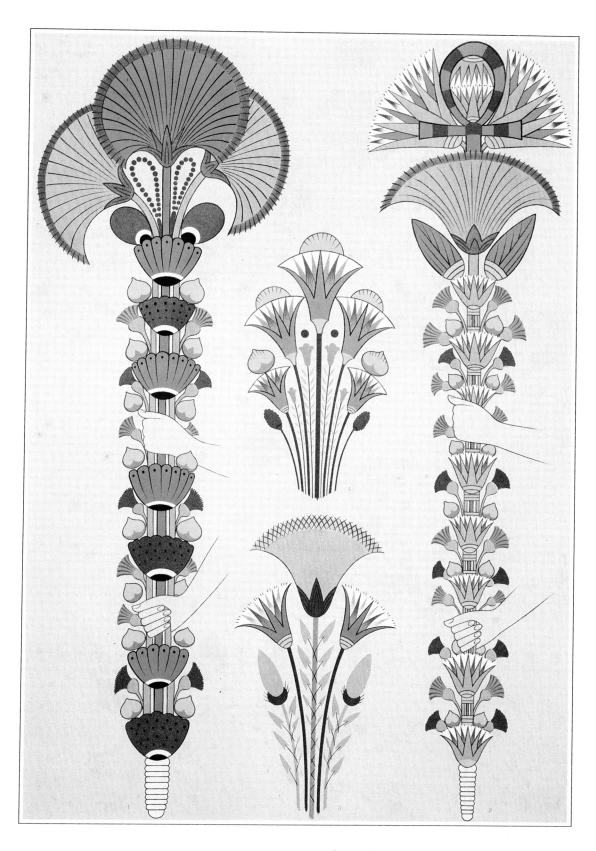

BOUQUETS PAINTED IN TOMBS (19th & 20th Dynasties)

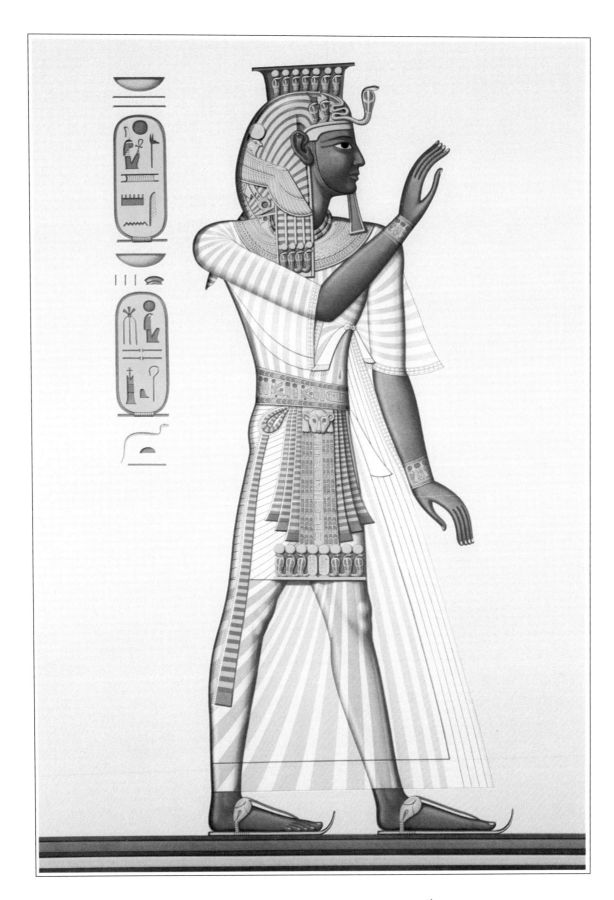

PORTRAIT OF RAMESSES III (Necropolis of Thebes—20th Dynasty)

Painting PL.II.69

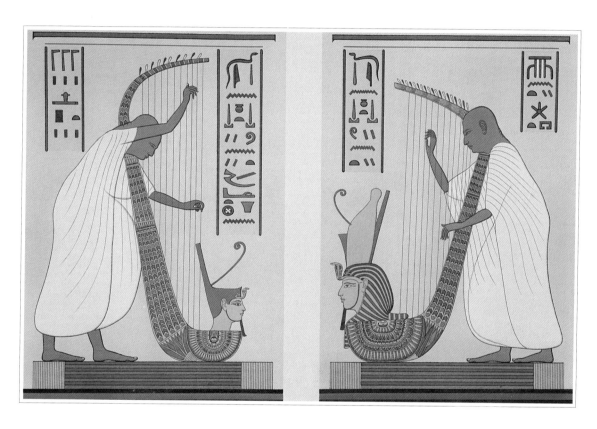

HARPERS OF RAMESSES III (Thebes—20th Dynasty)

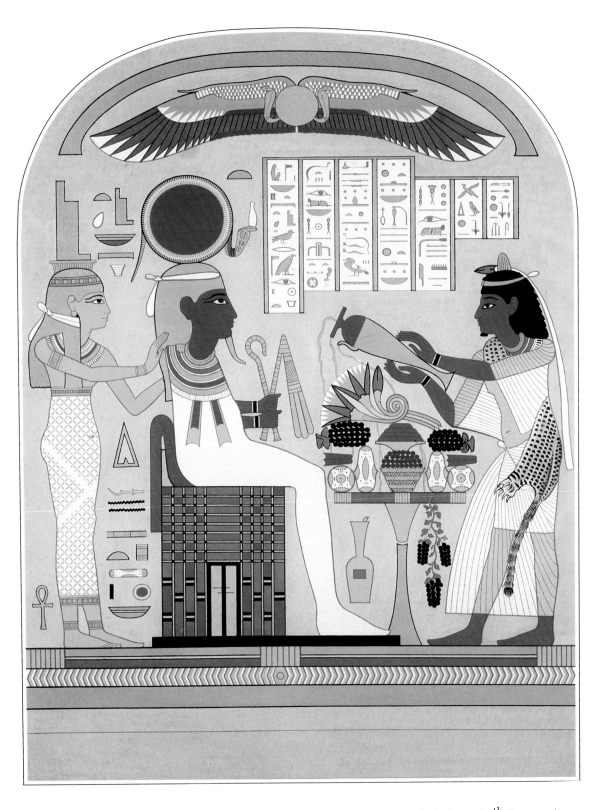

OFFERING TO OSIRIS (Stela painted on a sarcophagus; Necropolis of Thebes—20th Dynasty)

Painting PL.II.71

SELECTION OF VASES CONTEMPORARY WITH THE PYRAMIDS (Necropolis of Memphis)

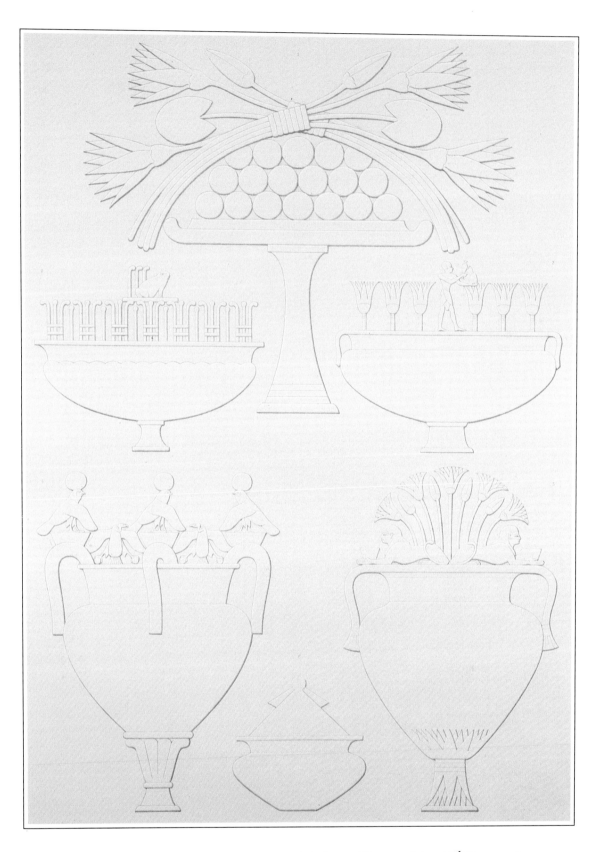

Vases from the Reign of Tuthmosis III (Thebes & Hermonthis—18th Dynasty)

VASES FROM THE REIGN OF TUTHMOSIS III (Thebes—18th Dynasty)

VASES FROM THE LAND OF KEFTIU, TRIBUTARY OF TUTHMOSIS III (Necropolis of Thebes, 18th Dynasty)

VASES FROM THE TRIBUTARIES OF THE KEFTIU (Necropolis of Thebes—18ᵗʰ Dynasty)

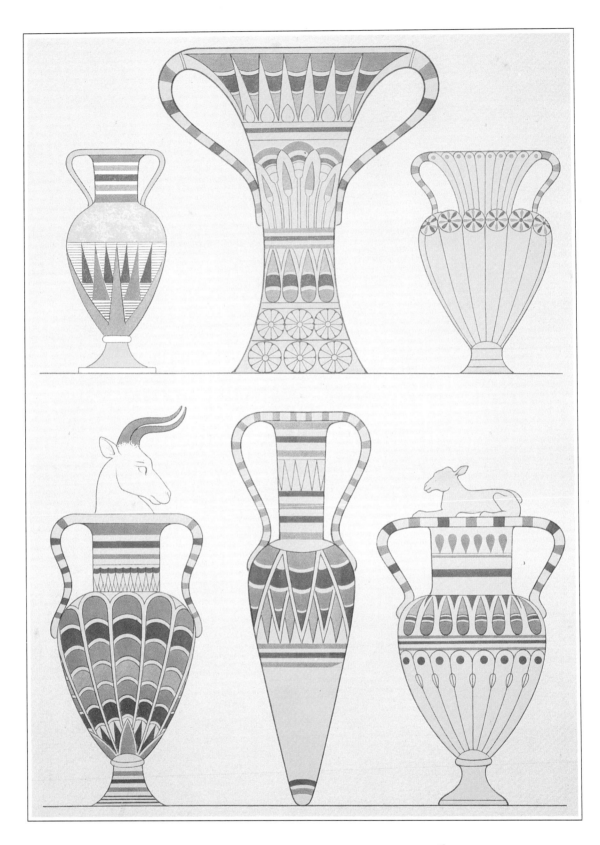

VASES FROM ASIATIC TRIBUTARIES (Necropolis of Thebes—18th Dynasty)

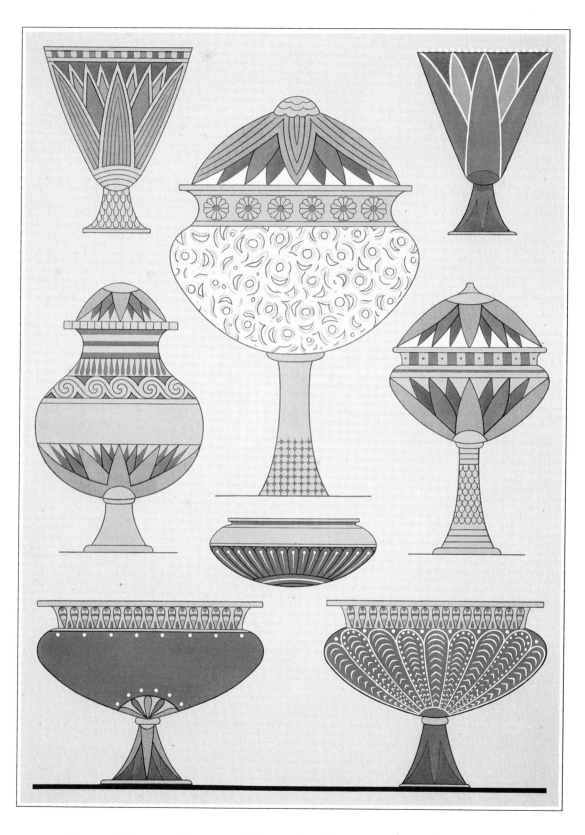

Vases of Different Materials (Necropolis of Thebes—18th & 20th Dynasties)

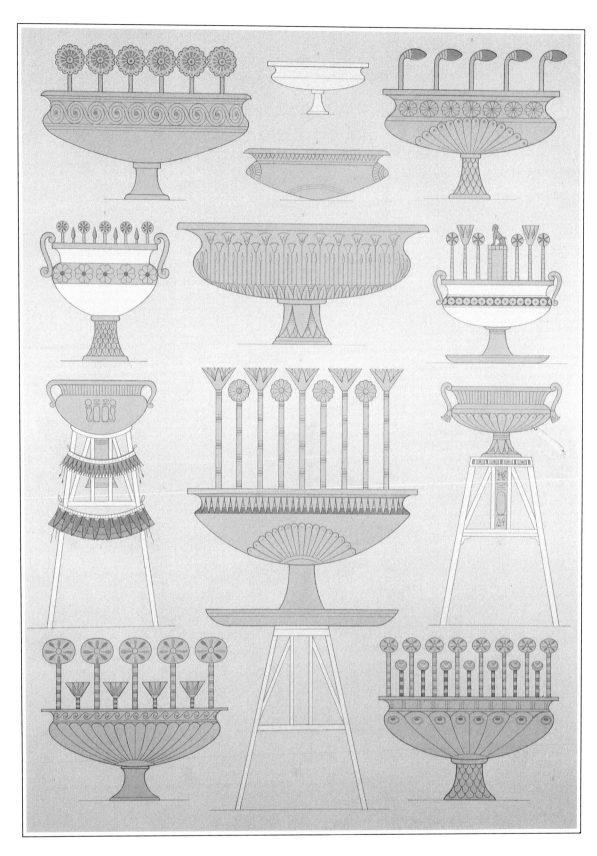

BOWL-SHAPED VASES (Necropolis of Thebes—18th & 20th Dynasties)

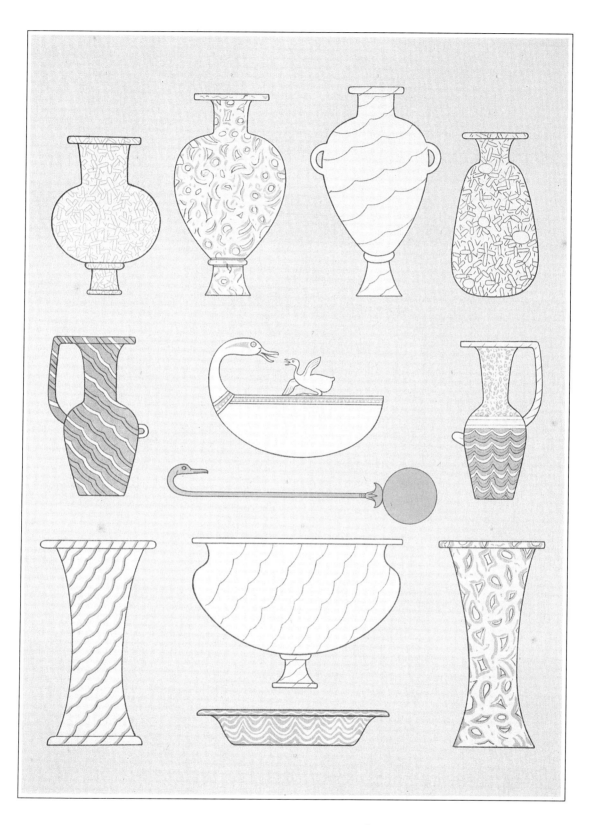

Vases in Opaque Glass (Thebes—18th Dynasty)

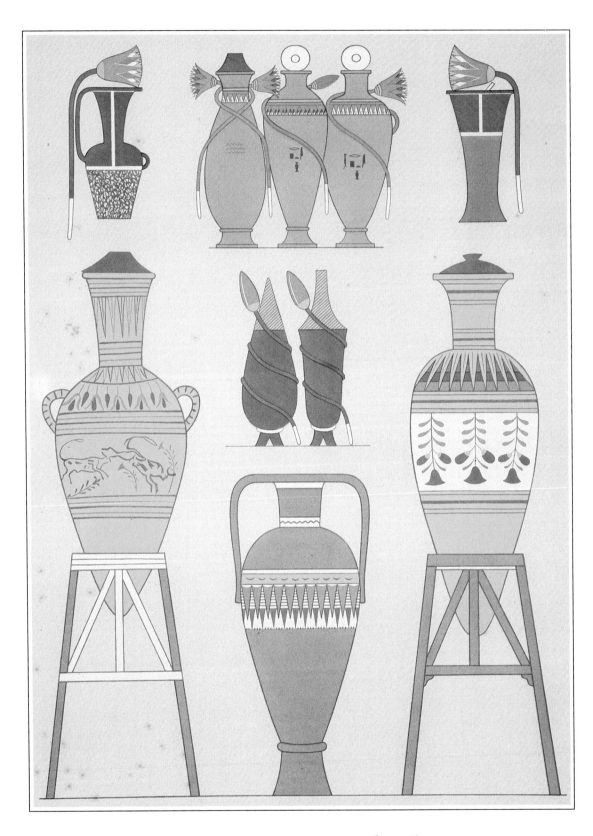

AMPHORAS, JARS & OTHER VASES (Thebes—18th & 19th Dynasties)

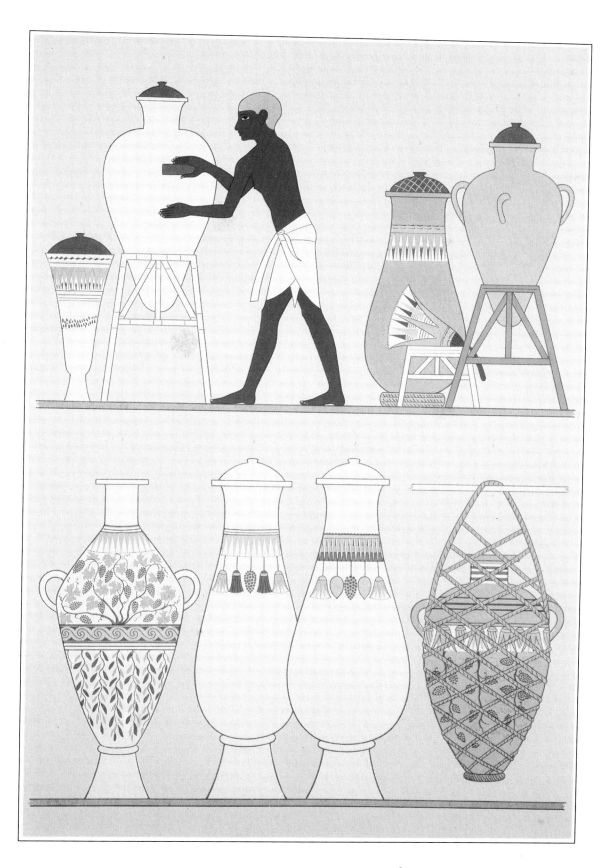

JARS & AMPHORAS (Necropolis of Thebes—18th Dynasty)

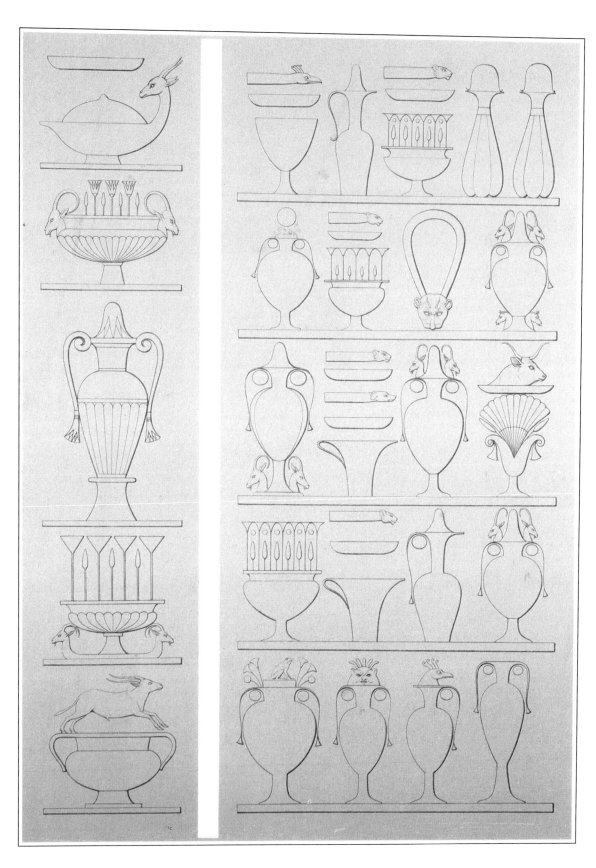

V ASES FROM THE R EIGN OF R AMESSES III (Karnak and Medinet Habu—20th Dynasty)

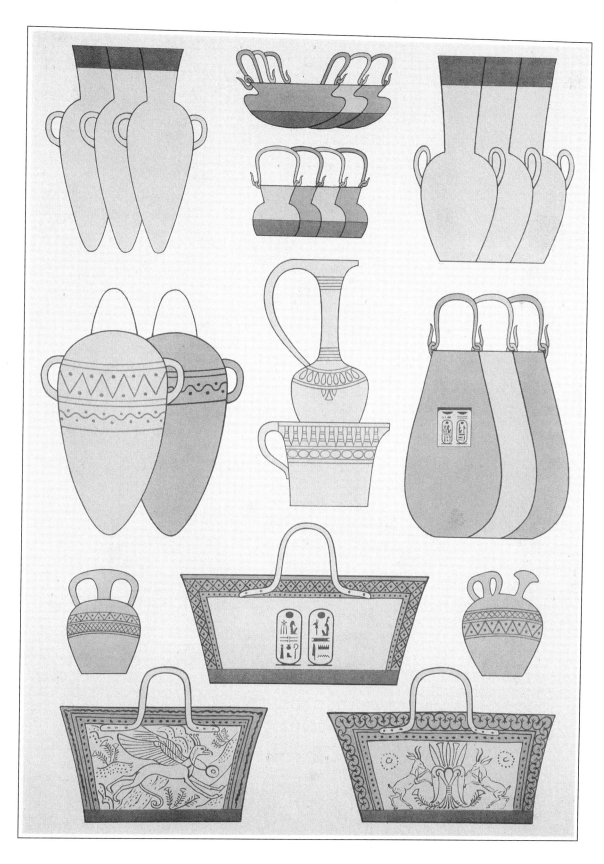

VASES FROM THE TOMB OF RAMESSES III (Thebes—20th Dynasty)

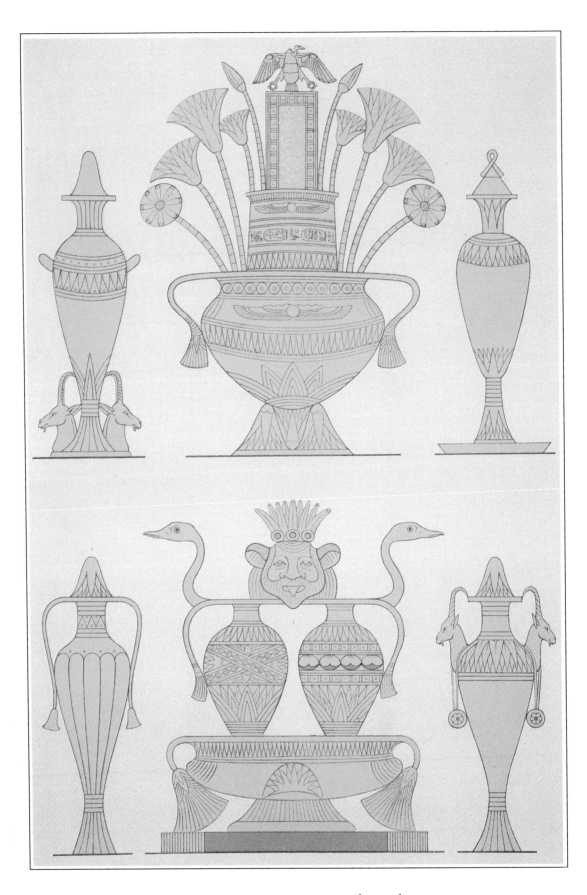

SIX ENAMELED OR INLAID GOLD VASES (19th & 20th Dynasties)

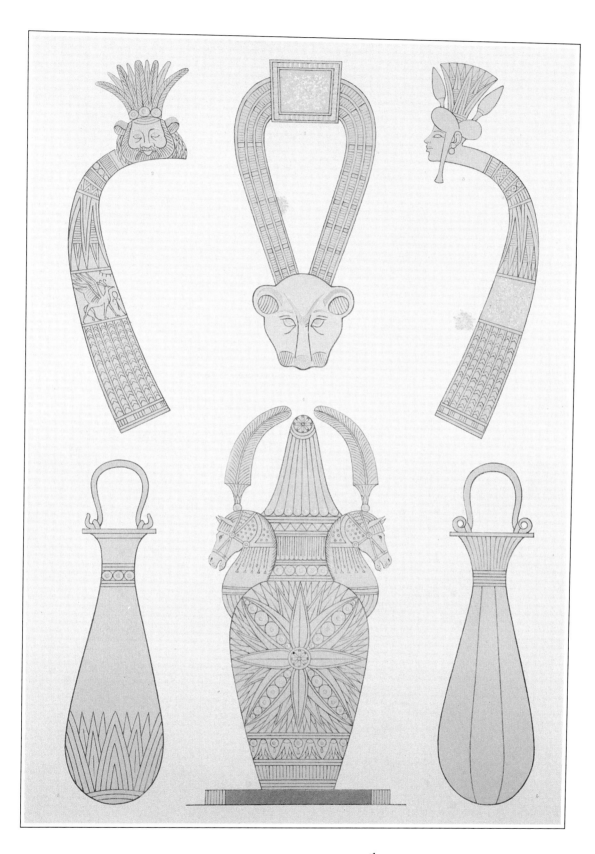

RHYTONS & OTHER VASES (Thebes—20th Dynasty)

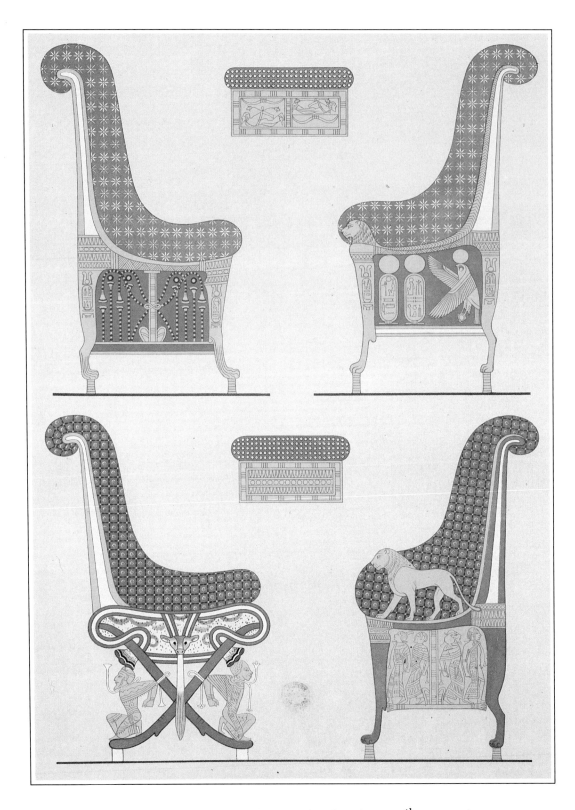

THRONES OF RAMESSES III (Necropolis of Thebes—20th Dynasty)

P<small>ALANQUINS</small> (Necropolis of Thebes—20th Dynasty)

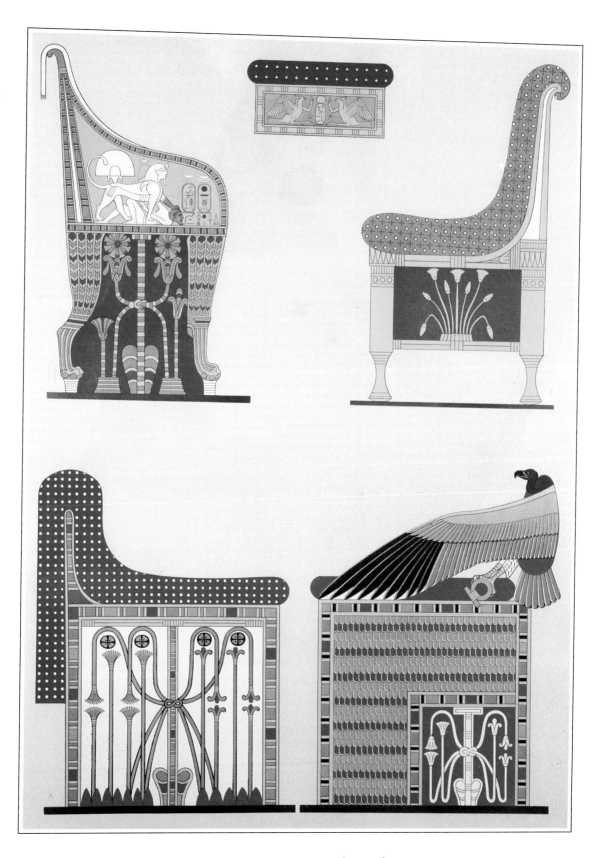

THRONES (Necropolis of Thebes—18th & 20th Dynasties)

TEXTILES & EMBROIDERIES

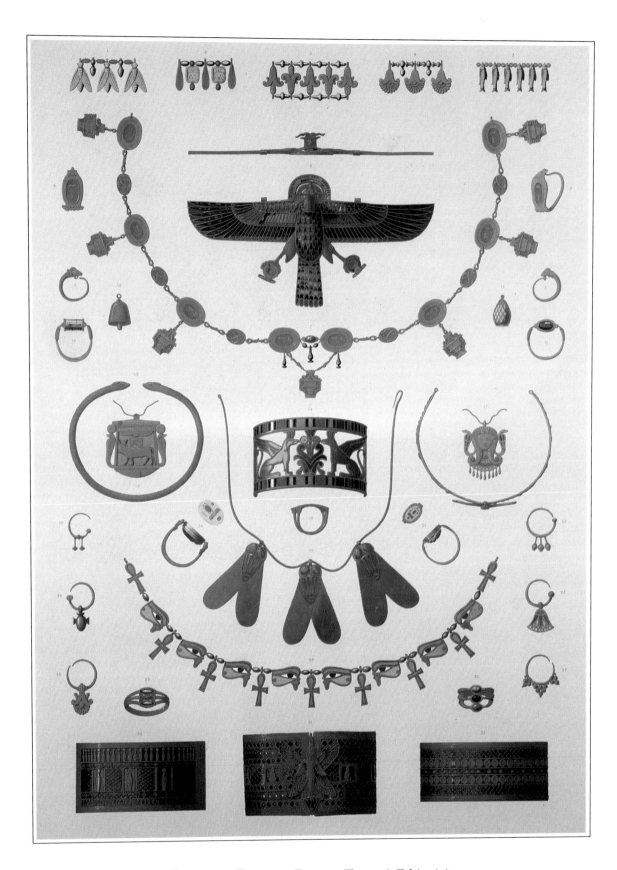

JEWELRY OF DIFFERENT PERIODS (Egypt & Ethiopia)

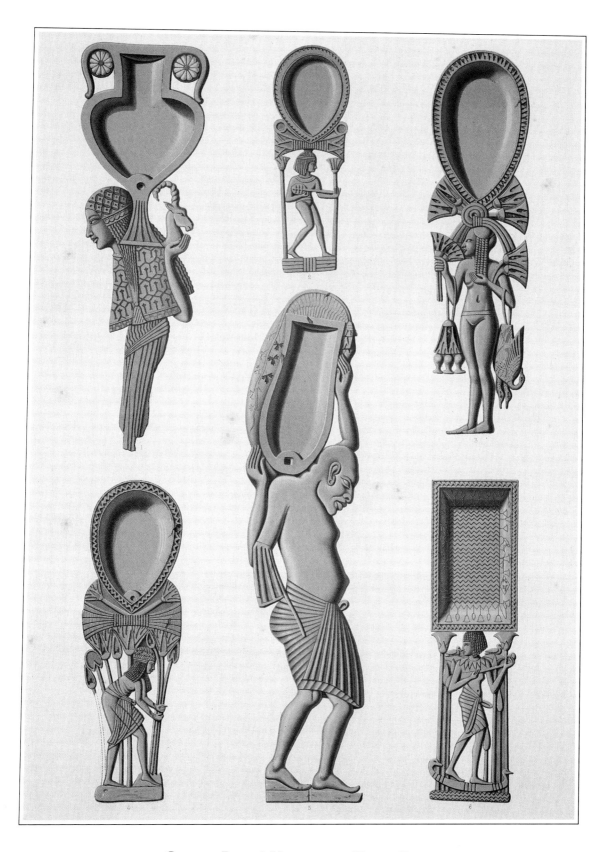

COSMETIC BOXES & UTENSILS WITH HUMAN FORMS

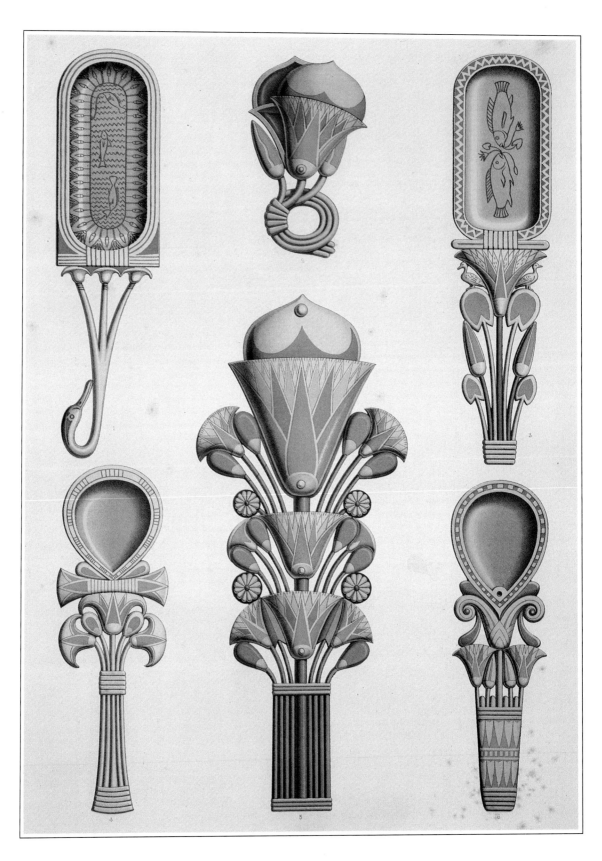

COSMETIC BOXES & UTENSILS WITH VEGETAL FORMS

SPOONS OF PAINTED WOOD (Utensils for perfume)

Vases in Enameled or Inlaid Gold (Thebes—20th Dynasty)

VASES IN ENAMELED GOLD (19th & 20th Dynasties)

OFFERINGS OF SETI I AND RAMESSES II (Thebes—19th Dynasty)